D1450611

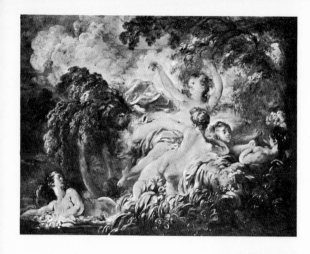

JEAN HONORÉ FRAGONARD

LES BAIGNEUSES

PIERRE AUGUSTE RENOIR

LES BAIGNEUSES AUX CRABES

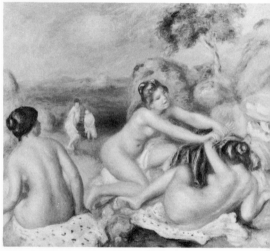

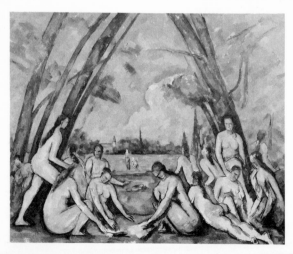

PAUL CÉZANNE

LES GRANDES BAIGNEUSES

STYLES
in Painting

A COMPARATIVE STUDY

BY *Paul Zucker*

Dover Publications, Inc.

NEW YORK

Published in Canada by General Publishing Company, Ltd., 30 Lesmill Road, Don Mills, Toronto, Ontario.
Published in the United Kingdom by Constable and Company, Ltd., 10 Orange Street, London WC 2.

This Dover edition, first published in 1963, is an unabridged and corrected republication of the work first published by the Viking Press in 1950. The frontispiece was reproduced in color in the 1950 edition.

In addition to the sources credited in the captions, thanks are due the following for photographs provided: Braun & Cie., British Information Service, French Embassy Press and Information Service, Institute of Fine Arts of New York University, Sidney Janis Gallery. Metropolitan Museum of Art, Ernest Nash, Netherlands Information Bureau, Philadelphia Museum of Art, Raymond & Raymond, Inc.

International Standard Book Number: 0-486-20760-9
Library of Congress Catalog Card Number: 64-9083

Manufactured in the United States of America
Dover Publications, Inc.
180 Varick Street
New York, N. Y. 10014

Preface to the First Edition

Enough general histories of art exist; and innumerable studies of individual artists, specific art works, and periods offer a wealth of factual information and grand historical perspectives. In addition, the problems of art have been analyzed from the aesthetic point of view by philosophers, artists, and art critics. This study, by contrast, tries to combine the historical and the aesthetic approaches through comparison of the various ways in which certain similar themes have been approached by artists of different epochs. The intent is to present the common visual experience of various periods and areas, tracing the shifts in visual patterns from generation to generation, stating what is constant in Western art and what is changing. By the very choice of examples a history of styles in painting is presented.

Any selection implies many omissions, and probably every reader, or at least every expert, as he scans these pages, will miss certain of his favorites or differ as to their proportional representation; there is, for instance, no Grünewald, no Tiepolo, no Degas, and just one Michelangelo. But great as those highly individualistic masters are, the works of other painters may demonstrate the trends of their periods more clearly. Also, the intention is to present, not the "three hundred best paintings" or even the best-known works of each artist, but those works that are most characteristic of the development of various styles. Each topic discussed, also, was selected for its particular significance.

No bibliography has been included because any list of publications on individual artist or specific periods would be too voluminous in relation to the compass of the study. For similar reasons, no books on aesthetics or general philosophy of art have been quoted.

In completing a work covering so broad a field, the author is indebted to many friends and institutions. The acknowledgments indicate the generous cooperation of museums, private collectors, and art dealers. Beyond that, the staffs of three New York institutions proved endlessly obliging in making available a wealth of material and information indispensable in the selection of illustrations: The Metropolitan Museum of Art, and in particular Ruth J.

Terrill and Alice D. Franklin of the Lending Collection of Photographs; The Museum of Modern Art, and Pearl Moeller of its Library; The Institute of Fine Arts, New York University, and Guido Schoenberger. Hans Tietze read the manuscript and gave me most helpful suggestions for which I feel much obliged. For editing and preparing the manuscript for publication I am most grateful to Isabella Fey and Milton Rugoff, and to all members of the editorial and production staff of the Viking Press I want to express my deep appreciation for the tireless care given to the countless complex details of preparation. Finally I owe my deepest gratitude to Lotte Pulvermacher-Egers for her understanding cooperation from the beginning of this work to the end.

New York PAUL ZUCKER
March 1950

Preface to Dover Edition

The original printing of this book was exhausted soon after its publication in 1950, and while numerous requests were received for a second edition, such an edition was, for technical reasons, impossible at that time. The author is therefore extremely grateful that Dover Publications and its president, Mr. Hayward Cirker, have now made *Styles in Painting* once again available to the public.

It is the premise of this book that the best way to reveal characteristics of successive styles in painting is to juxtapose paintings of similar subject matter, a comparative method which combines the historical with the aesthetic approach. Differences in painting caused by the individual artist's personality can thus be overcome and true historical trends be revealed. Art history, after all, should be more than the revelation of how improved means of depiction brought us closer to "reality;" it is the revelation of the continual change in each era of significant visual forms.

The topics selected to illustrate this development are basic ones, ranging from the nude figure to religious allegory, from the interior scene to the landscape, from the still life to the genre painting. Only minor changes have been necessary in this edition, most of them concerned with biographical data for artists recently deceased.

It is to be hoped that this edition of the work will lead to an increased interest in art and enthusiasm for it. Emotion and understanding should, after all, complement each other, and there is no reason why enlightenment and pleasure cannot be combined.

New York PAUL ZUCKER
December 1962

Contents

List of Illustrations

I. *Art and Style*

To grasp the significance of an individual work of art, two things are essential: an immediate unspoiled awareness of forms and colors, and an understanding of how the people of other times and places saw their worlds. Thus it is the aim of this book to give the reader both the historical and the aesthetic background for a more comprehensive response to art. Therefore, Part I deals with the principles of the historical approach and with basic aesthetic ideas. The comparisons and juxtapositions of individual works which constitute the main body of this book, Part II, reflect in their totality the development of painting in Western civilization. The general history of styles in painting is given in Part III, and is presented with full consciousness of the limited validity of all generalizations. This condensed historical survey is intended especially for laymen and students who are interested in a view of the individual works of art discussed here in the context of history and of artistic development.

There are adult eyes and adolescent ones, just as there are mature and immature minds, but the discerning eye achieves its maturity only through an abundance of conscious impressions. The trained vision alone will find its way through the confusion of vague shapes and ambiguous images that are so often the only reward of those who seek the enjoyment of art.

The painter Boudin said, "Perfection is a collective work." With each generation the direction of this collective effort changes, and therefore we need historical knowledge of the shifts in vision from generation to generation. To follow the change, we must compare art works typical of each period; their common traits will define the visual concepts governing each generation. The sequence of these concepts is the history of "styles."

The examples selected from innumerable interpretations of such recurrent themes as the Adoration of the Magi, the Judgment of Paris, the Artist in His Studio, or of categories such as Landscape or Still Life, illustrate the decisive steps in the evolution of styles. The examples have been selected chiefly from works of the Christian era, since the art imagery of classical antiquity springs from very different concepts, and the explanation of these concepts would

1

only complicate the main task of this book, which is to guide the eye in learning to SEE. The same consideration made it advisable to leave out Far Eastern, Mohammedan, and primitive art, although certain influences and relationships had of course to be discussed.

Eschewing accumulated data and the dead weight of abstractions, the text concentrates on comparable art problems and their solutions in various periods, as well as on the change in the problems themselves through the ages. By such comparative study one may arrive at a clearer view of art and achieve at last the fullest understanding of its historical and aesthetic structure.

THE DUAL NATURE OF ARTISTIC CREATION

Every work of art, whatever its quality or period, has a dual nature and exists on two distinct levels.

On the first level, a painting or sculpture is evidently a record of the artist's plastic vision. It transforms something he has seen and felt into an arrangement, a design, in color, line, or mass. As such, it belongs to the field of aesthetics and may be studied for its purely formal composition, movement, spatial effects, and other expressions of plastic sensibility. It can thus be enjoyed "for itself alone" and analyzed for what it tells about the artist's special talents, his technical and emotional gifts. On this level, a painting or sculpture may be regarded as an independent work, the product simply of its creator's unique personality. Such an approach centers on the isolated artistic problems of each canvas, sculpture, or carving.

But it is not quite enough to study works of art only as experiences in aesthetics. It is true that by exposing our eyes and our sensibilities to the immediate qualities of a painting, we may distinguish its original and characteristic traits as well as the technique through which such originality is achieved. But in order to grasp the full meaning of a work of art we need to know a great deal more about the sources of its theme and style than can be learned by the merely aesthetic approach. For when the artist records his vision in paint, wood, stone, or bronze, he records at the same time, along with his original creation, some inescapable part of the general vision of his times and surroundings.

For this reason, the individual work of art must be considered from another point of view as well. It is impossible to ignore the fact that environment, traditions, national traits, political and economic circumstances, religious beliefs, and even climate exert a powerful influence on the nature of all human beings. The relative importance of each of these factors has long been discussed and argued; there is no doubt that taken together they underlie and modify all cultural activities. The artist, like everyone else, is exposed to the civilization

of his environment, and his work reflects such external influences in varying degree.

Of course, the artist is not simply the "social agent" consciously expressing his time, and art is not at all the mere by-product of an age. The greatest works of art cannot for a moment be understood merely as condensations or summaries of a civilization. They do "sum up" the essence of a culture, but they also transcend their cultures in the degree that they are works of art and not simply transcriptions. The relationship between creative genius and the *Zeitgeist*—that is, the sum total of spiritual, emotional, and intellectual concepts held by people within a given period—is far too complex to be reduced to any formula. What must be understood is that each work of true art represents simultaneously the individual genius of its creator and the general character of the age in which it was born.

Clearly then, there is a distinct, traceable correlation between the special artistic values of painting, sculpture, and allied arts, and all the other expressions of a civilization. This correlation is the second frame of reference in which every work of art exists and makes the history of art actually the history of two different realities. Even the most personal artistic expressions are not isolated, although they appear wholly subjective and private in their picture of the world. They always reveal at least a few visual and psychological attitudes that are characteristic of their times. Art history is part of general history. More exactly, it is part of the history of ideas, for art conceives of the thought and emotion of its time in visual terms. Art transforms what men think into images and pictures. A walk through a well-arranged gallery of painting and sculpture becomes as much a journey through a sequence of historical ideas and concepts of life as a review of art works by independent and original artists.

Aside from his aesthetic sensitivity and his skill, the artist conveys his vision chiefly through the kind of selection he makes from the contradictory and changing appearances which make up the real world. In fact, this very selectivity is what makes him an artist. Through it he projects his most profound understanding of those things in the world which appear to him vital and urgent. His field of choice is wide, and since he cannot possibly record everything he sees, and since his private associations and his temperament lead him to see differently from other artists, his choice becomes an intrinsic part of his personal style.

In each period, however, there are certain common denominators of visual choice and aesthetic emphasis; they appear and reappear in the works of artists in certain groups and epochs, and they characterize what may be called the general style of a time, a country, or even a class. This general style is historically as real as wars, economic developments, or religious movements. Thus every genuine work of art consists not only of emotional, topical, or decorative

qualities but also of visual images that tell us something of the spiritual life of the age that produced it. The artist's personal style communicates elements of a bygone or contemporary age which cannot be transmitted by historical documents, statistical reports, diaries, or letters. The painting, sculpture, or print preserves something essential of the original group experience. Where the impressions of his fellow men are only vague and half-realized, the true artist crystallizes his vision in a doubly real picture, in which the beholder may read two distinct images: a collective truth and a personal experience.

THE MEANING OF STYLE

One of the real enigmas of history is the ubiquitous power, nameless yet clearly recognizable, which underlies every human act and created object in a given age. All forms, from handwriting to greeting, from dancing to costume, from table manners to courtship, have one quality in common: style. The arts, which are the subtlest human expression, are the supreme embodiment of style on the most meaningful level.

It is this common denominator which accounts for the similarity of certain forms in all the arts within a given period, including literature and music as well as the plastic arts. The similarity makes possible the so-called "mutual elucidation" of one art by another art; that is, for example, the attempt to throw light upon a painting by comparing it with a contemporaneous artistic creation in another realm of art such as music or literature. An instance of this is the parallel between the cool classicism of the tragic dramas of Pierre Corneille (1606–1684) and the cool classicist landscapes of Nicolas Poussin (1593–1665). The baroque polyphonic music of George Frederick Handel (1685–1759) has its counterpart in the grandiose façades of the great Austrian architect Johann Bernhard Fischer von Erlach (1656–1723). The spectacular violence that marked the life and narrative poems of Lord Byron (1788–1824), and made "Byronic" the term for demonic struggle and discord, appears also in the painting of Eugène Delacroix (1798–1863) and in the music of Hector Berlioz (1803–1869). The parallelism is certainly not complete, but it occurs often enough to suggest a certain community of feeling in the leading spirits of an age.

This interaction between the spiritual trends and the artistic style of a period has been explained in many ways and by many theories. Though the theories differ, sometimes even excluding one another, they convey one insight: there is no such thing as "progress" in the arts, no Spencerian straight line of improvement. There is undeniable progress in plumbing, in the design of locomotives, the treatment of disease, the improvement of slums—that is, in tech-

nical, scientific, and social realms. But not in art. A later style is not necessarily better or worse than an earlier style. If there were "progress" in art, each century would produce works greater than those of the preceding century. Obviously this does not happen. Styles can be compared, not graded. Today we realize how the nineteenth century mistakenly judged all art by the "classical" standard, using a single phase of style to measure the art of other times and other people. Any theory that measures all creative works by a single canon of value must end by failing to understand more than a fraction of art. Even the concept of a life cycle in art, with inception, efflorescence, and decline, is scarcely more than a figure of speech, as is the comparison between art and organic evolution from lower to higher forms. There are too many instances in the history of art in which neither of these biological parallels can be applied. If the general style cannot be outlined in biological terms, still less can the artist's personal style be thus simplified.

At the start of his career, the artist, however original he considers himself, usually follows a path trodden by some older artist who might have been an innovator in the preceding generation. Witness, for example, the younger painters of the present day, all influenced by Matisse, Picasso, Braque, masters now between sixty-five and eighty years old. Originality develops only with growth. The young Raphael conformed entirely to the tastes of his time and was distinguished only by his native skill and the higher quality of his work. It was in his last works that he anticipated the baroque tendencies which became general thirty years or so after his death. Rembrandt's development followed a somewhat different pattern. He began his work in the established tradition, but the personal style that he later developed, though it influenced a few Dutch painters, was not really carried on by a school. There is no rule by which to anticipate the direction of personal style. Raphael started as a Renaissance artist, proceeding from well-balanced and strict compositions toward strongly accented and dramatic schemes. Rembrandt, artist of the baroque, abandoned his dramatic, almost theatrical effects and developed the greatest introspective simplicity. This contrast proves that there is no typical pattern for the development of individual style.

But if there are no fixed laws governing the development of style, whether personal or general, it is still possible to follow its evolution from generation to generation, at least in the plastic arts. In oratory, acting, music, and dance, we naturally have no direct experience of changes in the style of interpretation from age to age. But the original substance of poetry and drama, songs and symphonies, paintings and sculptures, and of the works of other arts survives, and when studied and compared reveals a rich variety of artistic values.

THE FACTORS THAT SHAPE STYLE

Compared with the average man, the artist possesses a heightened and more direct perception of natural forms. He cannot, and of course need not, put down every last detail of an object or scene. When he selects what he considers the compelling elements and organizes them into a pictorial or plastic composition, he does so in terms of his own urgent sense of the "truth."

This truth may be stated in a naturalistic way, or it may undergo translation into abstraction. In both cases there is a transformation of the thing seen. The result is always a statement about some aspect of the world filtered through the artist's psychological associations and through his particular visual awareness. Even when he searches for new ways of seeing, that is, new perceptions, or fresh principles of discrimination, he is tied to the world around him; should he ignore the tie, or lose it, he will become unintelligible. (When a genuine artist's work is not understood either by his contemporaries or by succeeding generations, he may be a forerunner in style, or he may be merely an isolated "original," an interesting solitary in the stream of history.)

There are five major factors that lie outside the artist's individual intent and that decisively influence the range of choice open to his genius. A glance at these will make clear the affinity between his creative imagination and his time-locale. The five factors are: period, country, social and political systems, spiritual movements (religious or cultural), materials and techniques.

Period. All the productions of any one period, whether architecture, sculpture, paintings, or furniture, have certain typical forms in common. This classification by period is further modified by geographical and national differences. For example: when used with reference to French art, early Gothic signifies a period beginning about 1150; with reference to German art, a period beginning about 1230. The Renaissance in Italy starts about 1400, some eighty years earlier than the corresponding movement in Germany. Though the period in which the artist lives is the most distinctive style-determining factor, it is by no means the only one.

Country. This term is sometimes but not always synonymous with nation. Many patterns of group behavior are national; one may speak of forms of expression as typically Dutch, English, or French. Still smaller geographic divisions can be also defined and are of great importance in art history. In Italy we distinguish Florentine, Roman, Venetian, and other schools; in Germany, Swabian, Rhenish, Tyrolean, and Saxonian schools.

National characteristics, most extreme in literature, because of differences in language, change slowly from generation to generation. There is no such single concrete explanation for the variation from country to country in the visual arts.

We can only note certain native feelings for space, rhythm, and line, and certain concepts of color or light. These vary nationally, and mold the art forms of successive periods into unmistakable national idioms. Even when the influence of a single school spreads beyond its local or national boundaries, the countries or areas receiving the influence adapt it to their own national character. The Italian, German, and French churches of the eleventh century can be told apart at a glance, and so can French and Dutch landscape paintings of the seventeenth century; yet all the churches are "Romanesque" in style, and all the landscapes "baroque."

Social and Political Systems. Social patterns and political systems contribute enormously to changes in style. Ancient Egypt affords a perfect example. Here the sacred art was predominantly abstract. It was controlled by the Pharaohs and a small but powerful ruling class of priests who approved the use of symbols and discouraged naturalistic depiction. The hierarchy and the Pharaohs had one purpose, that of self-perpetuation. Absolutism is best maintained through ritual and tradition. Naturalism of any kind reflects the elusive and ever-changing aspects of natural life, and therefore gives emotional support to the idea that social change is possible too. Hence naturalism was considered a threat to the stability of priesthood and throne, whose ultimate aims were static. So the native descriptive powers of the people were suppressed or directed toward a kind of visual folklore. For a brief period there was a merging of these two trends, the abstract and the folklorist, when the religious and social structure of the empire was temporarily shattered by the Pharaoh Ikhnaton (Amenhotep IV, 1375–1358 B.C.).

Another example of the influence of a political system is that of French absolutism on the sequence of styles from the middle of the seventeenth century to the end of the eighteenth. During this period, art was practically the servant of king and court. Painting, sculpture, furniture, interior decoration, china, jewelry, buttons even, were created by competing artists for the sensuous pleasure of the "happy few," that society of noble lords and ladies and their protégés, who received titled patronage or the king's bounty as a reward for being witty, wicked, talented, or in any way amusing. To be entertained and to be flattered—these were the twin social pursuits of the king and his court. We can understand how, in the eyes of such a society, fine arts and applied arts had equal value and some *ébénistes* (cabinet makers) received as much money for marqueterie commodes and elegant cabinets as Watteau or Fragonard received for paintings. While the taste of this society was often excellent, and a gentleman was expected to be a connoisseur, yet personal vanity or frivolous rivalry were often the motives for commissioning a work of art. The deeper emotional and spiritual connotation which distinguishes the work of an artist from that of a craftsman was seldom sought during this period.

With social and economic change, the groups in a society which sponsor art also change. Art has been sponsored at different times by the Church, by nobility, by wealthy merchant princes, by public institutions, by corporate industrial enterprises, by academies and governments. All these expect different content, and so indirectly foster differences in visual approach. In the early Middle Ages, when the Church required altarpieces and sculptures representing Christ, the Virgin and saints, or Scriptural stories, the essentially spiritual tendency of the creed led to a rejection of naturalistic forms and detail. At the opposite pole, the burghers of seventeenth-century commercial Holland delighted in canvases that reproduced their own faces, their tiled floors and fine carpets, their good furniture and glistening tableware, their platters heaped with fish and seafood, and their bowls of fruit. They demanded of their artists an exact transcription of the full beauty, the glowing lights and colors, the interplay of forms, and the luminous atmosphere of their bountiful world.

Social structure, then, determines the group which sponsors the art of a society, each group demands and encourages a specific range of imagery, and the imagery begets appropriate forms of visual presentation. These forms, finally, become elements of style.

Spiritual Movements. Such spiritual movements as Christianity, the Renaissance, humanism, the Counter Reformation, the Enlightenment of the eighteenth century, not only brought about striking changes in social and political structures, but exerted also a direct influence on the development of art styles.

The rise of a new philosophical or intellectual outlook among a people naturally calls for a new imagery. But the new imagery does not appear overnight. Society is everywhere surrounded by art forms expressing earlier concepts. A new religious or cultural attitude is visualized at first in the forms of the previous period, and only gradually does the new idea win wide acceptance and so become free to generate its own appropriate stylistic expression.

The figure of Christ in the third century, for example, was still represented as that of an ancient god, for Graeco-Roman tradition still dominated the arts. Two centuries later, Christ and the other sacred figures had been spiritualized into genuine Christian images reflecting the drama of redemption and man's yearning for divine grace. The forms of art had now caught up with the content, as it were, and discarded most pagan externals, whether Greek or Roman. Thus it was not until the fifth century that a complete new imagery of symbolic and nonrepresentational character appeared and a new style was established.

Materials and Techniques. The importance of materials and techniques as style-creating factors, while considerable, has sometimes been overemphasized. The rock formations of Egypt, the hard granite, basalt, and other unyielding stone, for instance, may have fostered the abstract stereometric shapes of

Egyptian architecture; yet mere hardness of material could not have been the primary cause of those rigid forms, since some figures of sacred or royal art executed during the same periods in the more manageable limestone are scarcely more naturalistic.

Although technique and material do have influence on style in painting, they are much less important there than in sculpture, architecture, or prints. That is why little space has been given in these pages to the possible effect of the earlier casein colors, egg tempera, fresco techniques, oil-glazing, pure oil paint, or finally of manufactured oil paint in tubes. Of course, the use of oil paint, for example, made possible nuances, textures, and transitions in tonal value which had been impossible in tempera and earlier media. These richer effects were explored in fifteenth-century painting, and doubtless the new color carrier, oil of linseed, had its effect on the style. But even here the question remains: did the new medium cause the change in style, or did a new concept of color send Flemish masters searching for a fresh, more flexible medium? Or, to mention another example, paper and silk as backgrounds in Chinese painting naturally led to other forms of artistic expression than did the plaster walls, wooden panels, or canvas of the West. Again, plein-airism, for example, became possible only after canvas and transportable ready-made oil paints in tubes had come into general use. But on the whole, these material and technical influences in painting are almost negligible as compared with the tremendous influences of the other style-shaping factors.

These examples chosen at random illustrate the important truth that technical discoveries and inventions do not in themselves create a new style. Original forms of expression will arise under pressure of some urgent spiritual need. Only then will new techniques appear and be utilized.

Such, in brief, are the five major factors that have shaped historical styles. It is impossible to make a flat generalization on their relative importance. Their influence varies with every period, and even within a period. For Italian Romanesque architecture, for example, the national element appears decisive in setting Italian structures apart from other Romanesque creations. On the other hand, the styles of the periods of Louis XIV, Louis XV, and Louis XVI reflect trends fairly common throughout most of Europe, and while national idioms can readily be identified, an international common denominator of style is manifest throughout the eighteenth century. Again, during the sixteenth and seventeenth centuries, the age of the Counter Reformation, we see universal spiritual movements supplying the impulse for closely related styles in Mediterranean and some Central European countries.

It should be clear from these instances that the style-creating factors are not subject to exact assessment. The tangled threads of each historic style cannot be combed straight, counted, and measured. A theory or a scholarship that

attempted to do so would quickly destroy that vital essence for which works of art are treasured: their unique and inimitable reflection of a human personality. The factors which mold style should not be examined as one assembles statistics or calculates percentages. They must simply be recognized, studied, and understood.

THE IMPORTANCE OF CONTENT

The question of content, that is, of themes and subjects suitable for artistic treatment, has been of the greatest importance throughout art history.

Inevitably, each period has preferred different subject matter in its painting and sculpture. The causes of these shifts in theme may be traced in the history of ideas and social institutions.

Nearly all the art of the Middle Ages was occupied with religious themes; landscape and interiors became important only in the seventeenth century. The eighteenth century gave portraiture a new position of prominence. Only since impressionism has the "what" of a picture apparently been subordinated to the "how." Such specific artistic problems as composition, color, light effects, methods of rendering, together with the cultivation of new and deliberate theories about how to look at the world, have become paramount. Yet even here content plays a dynamic part. The cubists certainly were not interested in illustrative or narrative effects, yet they made repeated use of certain groups of objects. Over and over again they painted playing cards, tobacco pipes, grapes, newspapers, and fragments of musical instruments. Though these objects formed a limited part of their visual world, their repeated use by different members of the school indicates that even cubists reacted selectively to environment, which is a roundabout way of saying that they, too, sought content for their paintings.

Design, color, mass, and other pictorial elements can seldom be made the only criteria for judging works of art. Subject matter has always been of the greatest importance, both for artist and beholder. Since the content influences the means of expression, it is a factor in the creation of a style.

Content must be regarded as an element of art, though it is by no means what is popularly regarded as the "story." Frans Hals painted certain types of people, Jan Steen delighted in special situations, Käthe Kollwitz most often depicted victims of social tragedy; and with each artist the choice of theme was an essential and determining element of style. The content is as decisive in a work of art as form. Indeed, form and content are so interlinked in all great works of art that separating them might lead to artificial distinctions.

The often-repeated statements of philosophers and aestheticians that the enjoyment of art represents a disinterested pleasure does not imply that content

cannot create associations which definitely play their part in the elemental enjoyment of a work of art. For medieval men it was impossible to admire a painting or sculpture of the Virgin and Child merely aesthetically, without thinking of the spiritual meaning of the figures of the Madonna and the Saviour, and the courtier of the eighteenth century could hardly look at a *fête champêtre* by Watteau without identifying himself with one of the participants. There is no need to be ashamed of an interest in content as long as it does not dull our visual sensitivity. Only when such an interest becomes so overpowering that the story monopolizes the beholder's attention, does the approach become definitely unartistic.

Seventeenth-century Dutch painters of peasants' riots would have been astonished indeed if their public had not enjoyed the drolleries and grotesque scenes beyond and besides the values of color, light, and atmosphere. The great masters of the Renaissance took it for granted that their princely sponsors commissioned reclining Venuses and mythological scenes partly because they liked to admire beautiful female bodies. And the distinct circumstantiality and fondness for details shown by the Flemish painters of the fifteenth century is only partly explained by pride in their capability to describe such details by means of color and form: their certain knowledge that the beholders would have an almost technical interest in these minutely described environmental objects certainly provided an additional stimulus for depicting them.

It follows that the arrangement of works of art according to subject matter is not so arbitrary as it might appear to those whose chief associations are with the art of the past seventy years.[1] There are far more periods in history that were "content-conscious" than those that were not; and already we see signs, especially in America, of a renewed interest in subject matter as a shaping force in the creative process. Pope's famous line, "The proper study of mankind is man," applies especially to content. Content expresses the human values attached to themes, whether these themes be the formal symbols of religious periods, or the looser poetic symbols of portrait, landscape, or still life of more secular epochs.

The discussion up to this point has necessarily been somewhat theoretical and abstract. To give it meaning and life, we must study the individual works of art in their logical sequence, unbiased by preconceived notions and preferences.

[1] Placing a given work of art under a single heading may sometimes appear arbitrary. The theme of the Birth of the Virgin, for instance, can be analyzed under Religious Figure Composition, as well as under Interior. The Three Graces and Bathers are studies in the Human Figure and also in Group Composition. The choice of classification depends on many factors, historical and technical, and in each case the decision rests on the most relevant factors.

II. *The Basic Categories of Painting*

The Human Body

As far back as the Paleolithic or Early Stone Age, human beings appear along with animals as a theme of drawing and painting. Anthropologists are not yet decided on the chronological sequence of these early art phases, but they agree that the chief concern of paleolithic draftsmen was not in the form of the human body as such. It was rather in the activities of their fellow men—hunting, dancing, fighting, and other tribal occupations. Their astonishing accuracy in capturing movements of the hunt and the dance suggests that prehistoric artists were primarily interested in imitating natural forms, and certainly not in consciously creating something "beautiful."

On the other hand, in some examples of very early statuary, especially of female figures, the emphasis on definite physical details stems from the desire to conjure fertility by magic, not from artistic naturalism as we conceive it today. Again man's attempt to portray the human body does not of itself prove a purely artistic intention.

So men have been led by different motives, direct and indirect, to picture the human body in a variety of ways, through color, line, or volume, with correspondingly varied approaches. Sometimes the work of art clearly reflects a single intention; sometimes a combination of intentions is evident.

The Magic Intent. The delineation of the human body for magic purposes may be found in many prehistoric periods, in the early sacred art of Egypt, in the opening stages of Near Eastern civilizations, in the work of present-day primitive cultures. Some European peasant art also betrays this magic motive, when such features as the hands, breasts, or nose are singled out for exaggeration. Neither shape nor movement shows realism. The form is static; the purpose, magical. By making an effigy of some man or animal, the maker believed he

12

had gained control of the subject and so was able to destroy or preserve the spirit. The aim was entirely practical, akin to witchcraft and the power-magic of primitive societies. The effigy is not merely a symbol of the subject, it shares his life, and a needle passed through the chest of the figure is presumed to kill also the man of whom it is an image.

The Narrative Intent. Here men are depicted only in order to convey what they are doing. The realism of such scenes of action depends on the technical

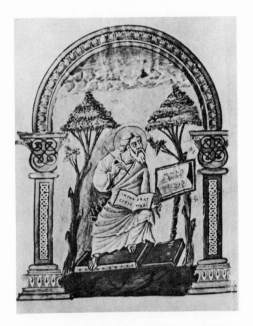

CAROLINGIAN MANUSCRIPT: ST. JOHN.
From the Evangelistary of Francis II. Ninth
century. *Bibliothèque Nationale, Paris*

abilities of the period. Most cave paintings, as well as Egyptian, Babylonian and Assyrian reliefs, very early Greek vase paintings, and some medieval manuscript illuminations, belong to this class. They are often characterized by a startling freshness of observation, and an accuracy suggesting a visual memory that is almost photographic. Yet the figures are standardized; the bodies have no individuality. The artist's sole purpose is to record an event: the hunting of beasts, a fight between two tribes, a ritual. The human beings depicted are anonymous, and differ only through their accidental roles in the group action, not through the artist's feeling for individuality.

The Spiritual Intent. Here the body is thought of as the mere outer garment

of the soul, or, on another level, as a vehicle of specific emotions. The actual form of the body, its anatomy and perspective, are more or less ignored by the artist. The spiritual message can be given in two dimensions; therefore the three-dimensional reality of the body seems superfluous, and its sensory qualities are sublimated. The forms tend to be abstract. They follow a decorative rhythm, or a dogmatic theological scheme, or occasionally both. This concept ruled

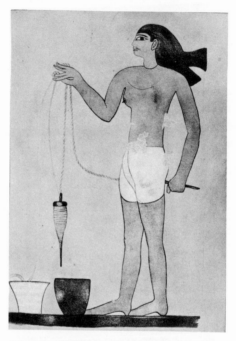

EGYPTIAN TOMB PAINTING: SPINNER.
Middle Kingdom. *From Tomb 3, Beni Hassan*

Christian art from its beginnings and extended almost to the close of the Gothic period (see illustration on page 13).

The feeling for naturalistic description of the human body, universal throughout classical antiquity, did not reappear generally before the fourteenth century. The brief "Renaissance" under Charlemagne in the ninth century was an attempt to fuse Christian thought with classical, Graeco-Roman aesthetics; but despite the Emperor's vigorous patronage, the movement remained limited to the scholars and artists at court.

The Aesthetic Intent. Since the beginning of the Renaissance, about 1400 A.D., the tendency has been to glorify the nobility of the human body, and this atti-

tude has become so ingrained that it seems to be almost the only possible one. After 1400, the artist began to strive for objective truth and for beauty, as these were understood by his period. Since that time the conception of truth, like that of beauty, has been unstable and unobjective, but the search for both has constantly increased man's desire to know and delineate nature. The illusion of reality was sought, first by developing an understanding

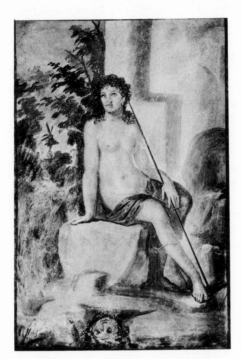

POMPEIIAN MURAL: NARCISSUS.
Fourth style. *From a house in Pompeii*

of anatomy and perspective, later by modeling with light, shadow, and color. It was the ideal of Greek art from 600 B.C. onward, continued to be important in Roman art, and became the central theme of art in the Renaissance. It was then that artists like Leonardo da Vinci (1452–1519) and Albrecht Dürer (1471–1528) wrote their treatises on human proportions, the *Trattato della Pittura*, and the *Four Books on Human Proportions* respectively. Right down to the beginning of the twentieth century, this naturalistic ideal remained fixed, though its embodiments changed with the constantly changing concepts of truth and beauty.

In the Egyptian painting on page 14, the action of the woman is faithfully ob-

served and rendered, even to the movement of the fingers, and each part is shown in the clearest and most recognizable way. But the woman herself is much less realistic than her action. The head, arms and legs, hands and feet, and the breast are all in profile, while trunk and eye are rendered full view. Despite the clarity of action, the body's form does not command the artist's effort, and the figure is standardized and conventional. In contrast, the Roman artist of the mural on page 15 tried to suggest actuality by means of perspective, light and shadow, and anatomical accuracy. Further, the Roman strove to beautify, that is, to "idealize," by aiming at certain desirable proportions of body and face. This work is immediately understandable to us, since for the last five hundred years we, like the Romans, have exalted the human frame. Thus, the central artistic problem of the mural is the body itself. There is no magic motive, no action narrated, no spiritual revelation. The theme is simply the human figure as an object of inexhaustible plastic interest.

It must be stressed again that the aesthetic intent of antiquity and of the Renaissance is by no means the only right one. It has no claim to be regarded as better or more progressive than other art concepts, all of which may, in the hands of creative masters, convey the profoundest truths.

The aesthetic intent is seldom so clearly embodied as in the painting from Pompeii. More frequently the aesthetic approach combines with one or another of the other artistic concepts just set forth, in Greek and Roman times as well as in Renaissance and later periods. Any of these intentions—magic, narrative, spiritual, or aesthetic—may be blended in a given work of art.

ADAM AND EVE

The human body itself held no artistic interest for the people of the Middle Ages, since the Christian religion considered it part of the materialism of temporal life. The one exception was the innocent nudity of Adam and Eve in Eden. But even the bodies of Adam and Eve, when they appear in the pictorial narratives taken from the Old Testament, were treated simply as story elements without aesthetic significance. The narrative alone mattered. The beholder, as a faithful believer, was expected to know the story of Creation and man's subsequent lapse, and the actual images of the parents of mankind were of no more importance than their position in space or the details of their environment. It was enough if Adam and Eve, the tree and the snake, were recognizable. Any feeling for the beauty of the human body or a realistic description of it, both characteristic of ancient Greek and Roman art, was completely suppressed from the very beginnings of truly Christian art.

With the coming of the Renaissance, the human body regained its value as an object of aesthetic delight and significance. The dramatic events of the Temptation, Fall, and Expulsion from Paradise became progressively a mere excuse for depicting the nude body in all its beauty.

This revived humanism, however, took very different directions in the North and the South. In the South, the revival of ancient traditions led artists to a deliberate idealization of the human body. In Northern Europe, where the classical tradition had no indigenous roots, the artist reproduced individual bodies as honestly as he painted his portraits, landscapes, or interiors. He put down his models as he saw them, whether imperfectly proportioned, pathetic, or even ugly, making no attempt to achieve any standard of physical perfection. It might be said that the Southern artist painted nudity, while the Northern artist painted nakedness. But both the Northern and the Southern artists of the Renaissance, unlike their medieval precursors, studied the human body for its inherent interest as an aesthetic experience.

Between the fifteenth and the seventeenth century the new development was characterized by two trends: first, an increase of natural movement and action which led to the complete dramatization of human figures, and second, an increase in the relationship among the separate figures and between the figures and their surroundings, resulting in true spatial unity and composition.

After the seventeenth century, the special interest in Adam and Eve as a subject of painting gradually declined and was replaced by the fashion of human

17

nudes posturing as figures from Greek and Roman mythology. This approach was by no means new, since Italian painting of the fifteenth century had presented a whole galaxy of classical gods and goddesses. In the seventeenth century, Biblical and classical subjects shared the limelight, and when the Biblical painting presented nude bodies, the more sensuous figures of Bathsheba, Susannah, and Salome often displaced those of Adam and Eve.

Gradually the story interest died out; nudes were no longer Eve or Venus, Adam or Adonis, or other sacred and mythological personages. Artists painted "nudes"—studies of human figures interesting entirely for their self-contained aesthetic qualities.

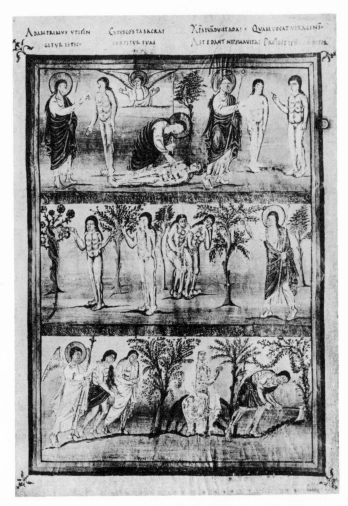

1. FIRST BIBLE OF CHARLES THE BALD: ADAM AND EVE. *Carolingian Manuscript*. Ninth century. *Bibliothèque Nationale, Paris*

The sole aim of this illuminated page is to relate the story from Genesis of the Creation, through the Temptation and Fall, to the Expulsion from Eden. As so often in early Christian, Byzantine, and medieval art, sequences of scenes are told within one frame, unfolding almost as in a modern comic strip. The flat figures are mere symbols; there is no attempt at realism or placement in space. Their form of representation derives from Byzantine art, so highly evaluated at the court of Charlemagne and his grandson, Charles the Bald. The artistic values of this medieval illumination lie wholly in the rhythmical arrangement and in the strength of emotional expression in attitude and gestures.

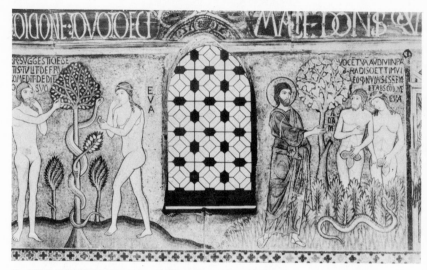

2. BYZANTINE MOSAIC: ORIGINAL SIN. Twelfth century. *Palatine Chapel, Palermo*

These mosaics on the walls of the palace chapel in Palermo, depicting scenes from the Old and New Testament, were executed by artists from Byzantium. As everywhere in Sicily, Norman and Moorish elements fuse into the Byzantine tradition. Though monumental in character and of large dimensions the mosaics show a close affinity to Byzantine book illumination, a branch of art of most intimate character. The principles of visual presentation are almost identical. Lack of perspective and flatness of figures alike bind the scenes to the wall, so that the effects of architecture and wall decoration supplement each other. The treatment of the human body reveals traces of Roman tradition, which often survived in Byzantine art. Movements are free and emotions clearly conveyed, in striking contrast with the environment, where the strict formalism of Byzantine tradition still prevails.

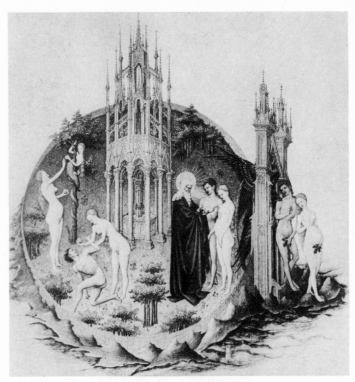

3. POL DE LIMBOURG AND HIS BROTHERS: TEMPTATION AND
EXPULSION. *From Les Très Riches Heures du Duc de Berry. 1411–16. Musée
Condé, Chantilly*

This miniature from an illuminated manu-
script marks the beginning of a new pe-
riod. A new concept of the human body
here appears in a framework that is still
medieval. Four scenes from the Creation
cluster in a restricted space around a fan-
tastic Gothic structure. Adam and Eve,
no longer spiritual symbols, are quite
earthly, the kneeling Adam reminiscent of
some ancient sculpture. Note the use of
the third dimension and the groping at-
tempt at perspective. The medieval solem-
nity of earlier miniatures has here given
way to a fairy-tale atmosphere.

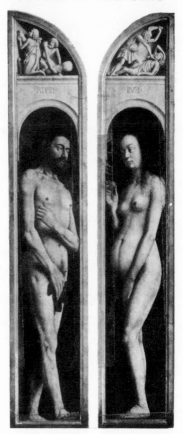

4. JAN VAN EYCK: ADAM AND EVE. *From the Ghent Altarpiece.* 1427–32.
St. Bavo, Ghent

Although early Renaissance works in the North and South differed in cause and expression, they appeared in the same decade, introduced by the revolutionary art of the van Eyck brothers in the North and of Masaccio and Masolino in the South. The break with medieval forms is evident in Jan van Eyck's two panels of Adam and Eve, a part of the Ghent Altarpiece. Here objects are felt concretely in real space, an aesthetic aim which distinguishes this Adam and Eve from such late French Gothic illuminations as the Paradise scene in the Duc de Berry's Book of Hours. The French artist uses realistic details but still composes his figures in the Gothic manner. Van Eyck's Adam and Eve are awkward and almost crude, and yet, modeled by real light in real space, convincing.

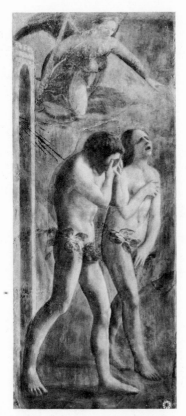

5. MASACCIO: EXPULSION. Ca. 1426–27. *Brancacci Chapel, Santa Maria del Carmine, Florence. Photo ENIT*

The panel by van Eyck and the fresco by Masaccio contrast North European and South European conceptions of the human body. Although they took part in the general Renaissance search for realism, Flemish artists were still checked by medieval restraints and physical inhibitions. Italian artists moved their figures more freely in space and modeled them with richer and therefore more effective transitions of light and shade. Masaccio's gestures are naturally forthright, reflecting the Italian ease of movement, where van Eyck's show typical Northern reserve. The Northern figures are "naked," and seem to miss their garments, while the Southern figures are "nude," as if unaware of being unclothed. Note the tremendous force of Masaccio's figures and composition, dramatized by the gesture of the Angel pointing the way out of Eden to the stricken pair. The revival of ancient, indigenous traditions gave Italian artists a freedom of expression that had not yet been reached in the North.

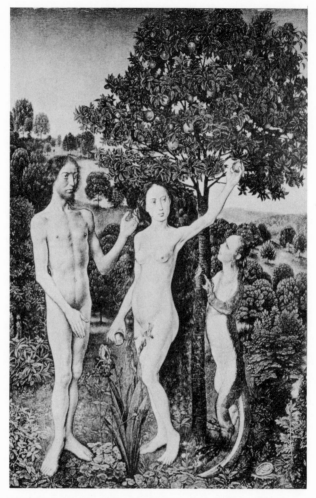

6. HUGO VAN DER GOES: THE ORIGINAL SIN. Before 1473. *Kunsthistorisches Museum, Vienna*

It is hard to believe that this little tablet, 13¾ by 9⅛ inches, was painted no more than forty years after van Eyck's Adam and Eve. The snake with a girl's head, not at all unattractive, and the scene's poetic intimacy recall the Duc de Berry's Book of Hours but reveal a fully developed realism. The chief stylistic element is the unity of man and nature: the lovely landscape is no mere background but a living environment for the figures.

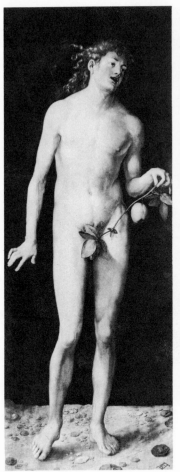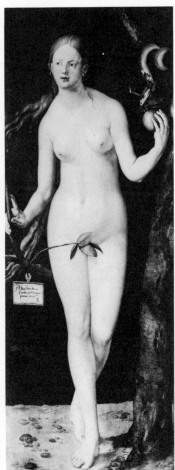

7. ALBRECHT DURER: ADAM AND EVE. 1507. *Prado, Madrid*

In 1504, Dürer had made a copper engraving of Adam and Eve. Although that engraving differs from this painting in its approach to the human body, in both Dürer succeeded in combining the spirits of the Northern and the Southern Renaissance. The artist captures much of the Italian grand manner, but the painting remains essentially German: the perfect bodies realize the classical ideas of the South, but gestures and facial expressions belong to the more inhibited North. The figure of Adam in particular reflects Dürer's persistent search for an ideal scheme of human proportions. To appreciate the development, compare this work with Jan van Eyck's panels.

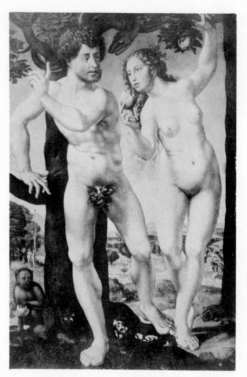

8. MABUSE (JAN GOSSAERT): ADAM AND EVE. Ca. 1515. *Kaiser-Friedrich Museum, Berlin*

Some years after Dürer attempted a fusion of German and Italian art, the Fleming Mabuse, returning from travel and study in Italy, tried to fuse Flemish and Italian art. Under Italian influence, the Flemish traits of quiet simplicity and static clarity were replaced by overdrama-tized action. Each limb, finger, each muscle even, strains for utmost movement, as if the figures were about to dance. The purely surface life of the bodies is over-accented with lights and shadows. Forgotten is the mystic wonder of the earlier Biblical representations.

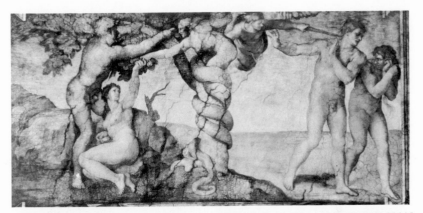

9. MICHELANGELO BUONAROTTI: ORIGINAL SIN AND EXPULSION.
1508–12. *Sistine Chapel, The Vatican, Rome*

Michelangelo's grandiose composition of the Sistine Chapel ceiling was designed to be seen from a considerable distance, and since each scene is an independent unit as well as part of the whole, it demanded extreme condensation in each narrative scene. Thus the Original Sin and the Expulsion are shown in one area and are separated only by the tree with the snake. In contrast to the straining for motion that marks Mabuse's work, each movement in this fresco is dictated by the story itself and lends interpretive force to the visualization. Like most of Michelangelo's later work, this fresco represents a transition from Renaissance ideals to the trends which initiated the baroque. The clear plasticity of the figures and the compositional structure anchor it in the Renaissance, while its sweeping movements point toward the baroque. Note the difference from Masaccio's representation of the Expulsion.

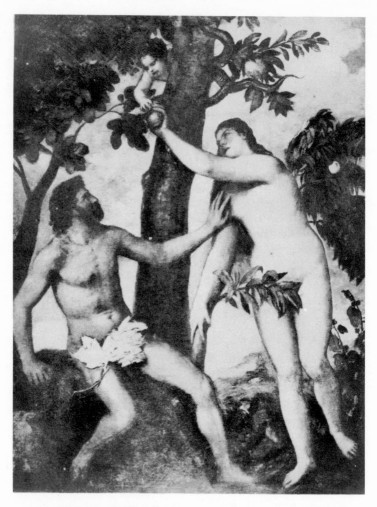

10. TITIAN: FALL OF MAN. Ca. 1565–70. *Prado, Madrid*

This painting is typical of the Venetian High Renaissance. Despite surface resemblances to Mabuse's treatment of the same theme fifty years before, Titian's composition differs from the earlier work in its Latin monumentality. Mabuse's work is a tour de force that uses the idiom of the Italian Renaissance without conviction. Where Mabuse had used artificial contorted lines, the movement in Titian's canvas is mellow and fluid. Titian's light creates the atmospheric effects typical of the Venetian school; Mabuse's light is a mere device for stressing anatomy. Titian allows the drama to determine each movement; the movements in Mabuse's work are arbitrary and therefore without true significance.

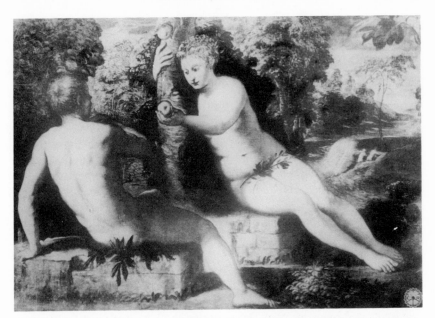

11. TINTORETTO (JACOPO ROBUSTI): ADAM AND EVE. Ca. 1550–53.
Accademia, Venice

The movement in Titian's Adam and Eve is well balanced and lyrically natural; in the canvas of his pupil, Tintoretto, it is strenuous. Titian's figures actually move on one plane; Tintoretto's Adam and Eve cut diagonally through the picture space, their arms and legs drawing the eye into the picture's depth. The decisive step from Renaissance to baroque has here been taken: the third dimension is realized not merely in surrounding space and background but, by the use of sharp perspective, within the group itself. The body surfaces are dramatized by strong contrasts of light and shadow.

THE RECLINING NUDE

The full story of Greek art from the eighth century B.C. to the third century A.D. can be, and has been, told simply by juxtaposing two figures from the sculpture of successive periods, the male, Apollo (Kouros), and the female, Aphrodite (Kore). A simple work often affords us as much insight as a complex one, and the changing concepts of Western painting through the centuries can be clearly traced in examples of the nude in repose, which is a leading motif in painting and sculpture. Before the Renaissance, of course, such a comparison would not have been possible, for the religious art of the Middle Ages rejected this theme as sinful and therefore unsuitable for Christian painting.

The names of such reclining figures, whether Venus, Danaë, Abundantia, or, as during the last two centuries, just "Nude," matter little, since the story content is of secondary importance. The figure itself—its forms, its proportions, its poise—is the real problem. The countless Renaissance interpretations of Venus were followed by as many of Danaë during the later mannerist and baroque periods. The story of Danaë, who was visited by Zeus in the guise of a shower of gold, obviously furnished the artist with a fine pretext for describing lively movements and animated facial expressions, but the artistic task remained essentially the same, and the title "Nude" plainly stated the problem without mythological or anecdotal detours.

Since about 1450, the intent of all such figures has been purely aesthetic—neither magic, nor narrative, nor spiritual (see page 12). The obvious changes are not changes in meaning but in appearance, in form and proportion, in ideals of feminine beauty, in posture, carriage, and gesture, in historical influences, social habits, and literary association. Finally there has been the change in the implied relation between the spectator and the figure itself, that is, in psychological approach. By careful reading of these factors, we can trace the stylistic evolution through all its characteristics and variations.

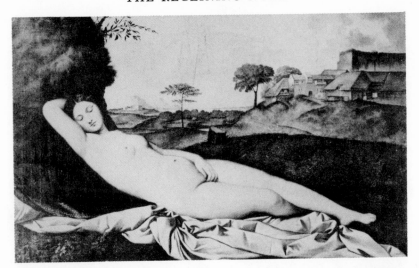

12. GIORGIONE: SLEEPING VENUS. 1505–10. *Staatsgalerie, Dresden*

This figure of Venus asleep seems to be the first full-length nude to appear in Venetian painting. In it Giorgione introduced a new approach to a new pictorial theme, an approach taken up and varied by other artists throughout the High Renaissance. The goddess reposes in front of a gentle landscape of rolling hills whose atmosphere is typically Venetian. The principle of repeating the contours of a human body in the curves of the landscape background is one that was often employed in the High Renaissance. Also typical of the Venetian school is the co-ordination of forms through warm, soft colors. Titian, Giorgione's contemporary, completed this canvas, working particularly on the landscape, and adding a cupid, which was later covered by the white cloth in the foreground.

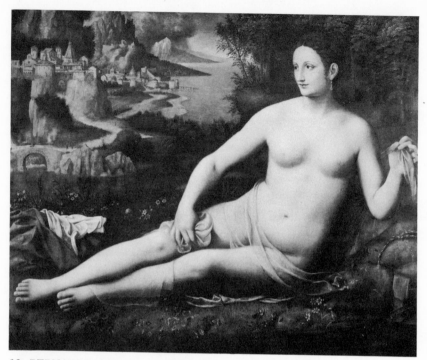

13. BERNARDINO LUINI: VENUS. 1530. *National Gallery of Art, Kress Collection, Washington, D.C.*

This reclining Venus by the Milanese painter Luini reveals strikingly the influence of Leonardo da Vinci in its clear plastic values and its emphasis on line. There is no echo here of melodious Venetian color. Luini projects his nude by means of firm structure and an almost hard, Olympian quality, but without sensuous, tactile appeal or color nuances. The landscape reproduces an actual scene near Lake Como in northern Italy. As scenery it is more interesting than the landscape in Giorgione's "Sleeping Venus" but for that very reason it distracts us from the composition itself and is not fully integrated with the central theme of the reclining goddess. Luini has the north Italian artist's keen eye for detail, whether foreground flowers, anatomical elements, or small towns in the distance. Though such independent and realistic details reduce the unity of the picture, their realism certainly contributes to its clarity and visual definition.

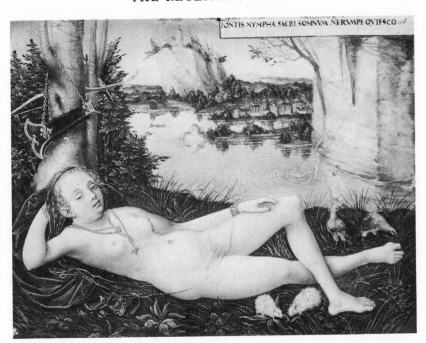

14. LUCAS CRANACH THE ELDER: THE NYMPH. Ca. 1520. *Robert Lehman Collection, New York*

During the High Renaissance, the Northern ideal of feminine beauty still differed from the Italian both in forms and in the manner of rendering. Although receptive to the mythological ideas of the Renaissance, the German Cranach remained provincial, presenting his Venuses and nymphs in what was still an almost Gothic spirit. Their bodies are stiff and angular, their gestures stilted, and there is a medieval lack of relation between figures and the landscape background. Though Cranach was apparently influenced by Giorgione's Venus, of which he must have seen a copy, his nymph is surely not presented in the typical Renaissance style. Yet his work possesses a kind of lyric charm not found in Italian paintings of the same period. This picture is one of ten known versions of the same motif which Cranach painted between 1518 and 1537.

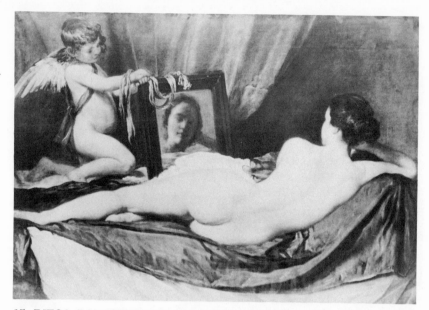

15. DIEGO RODRIGUEZ DE SILVA Y VELASQUEZ: VENUS AND CUPID.
Ca. 1657–58. *National Gallery, London*

Probably the first female nude in Spanish art, this "Venus and Cupid" seems less idealized and more individualized than earlier versions by Venetian painters of the High Renaissance. Venus's pose, no longer in static balance, is typically baroque. The turn of the body creates a lively outline; contrasting movements are pointed up by use of light; and the face is shown only indirectly—in a mirror. The result is a highly personal dramatization and one in which all the potentialities of the third dimension are exploited.

16. JEAN HONORE FRAGONARD: LA CHEMISE ENLEVEE. 1760–70.
Louvre, Paris

Fragonard's small masterpiece, a sketch only 14 by 16½ inches in size, exemplifies the transition from French rococo to the Style Louis XVI. The girl's eyes are closed, like those of Giorgione's "Sleeping Venus," and Cupid, in a surprise move, is seeking to pull off her chemise. She is no goddess, but a very real young French lady of the eighteenth century. Yet the seeming improvisation—actually a carefully balanced composition—with its diaphanous colors laid on almost impressionistically, its cloudlike pillows and gauzy curtains, produces an effect of ethereal vivacity and playful charm.

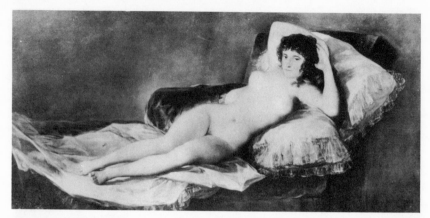

17. FRANCISCO JOSE DE GOYA Y LUCIENTES: MAJA DESNUDA. Ca. 1795–1800. *Prado, Madrid*

In its realism and even its partial anticipation of impressionism, this work reflects the eighteenth century as much as the nineteenth. The "Maja Desnuda" or "Nude Maja" (and its companion piece, "Maja Vestida," or "Maja Draped") is the first nude to have a face so personal and arresting that it becomes almost portraiture; at the same time its general scheme links it to the tradition of reclining nudes begun by Giorgione. It is this curious ambiguity which stimulates the beholder not only to perceive the beauty of the physical form as the primary topic of the picture but also to become interested in the psychology of the model—an intensely modern approach. The often-repeated anecdote that Goya portrayed in both versions of the Maja his beloved Duchess of Alba is, however, a romantic invention.

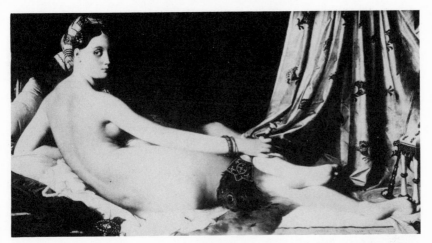

18. JEAN AUGUSTE DOMINIQUE INGRES: LA GRANDE ODALISQUE. 1814.
Louvre, Paris

Ingres shares with his classicist teacher David a passion for draftsmanship and only a limited interest in color. Chaste beauty of balanced line, the emulation of antiquity, and devotion to the great Renaissance masters, especially Raphael, produce a work of lucid composition rather remote from colorist or psychological ambition. It is therefore easy to understand how the version in grisaille (that is, chiefly gray tones) at the Metropolitan Museum of Art in New York can be as impressive as the color version in Paris. Here is idealization in the best, and all too rare, sense of the term: a perfection achieved purely through linear organization.

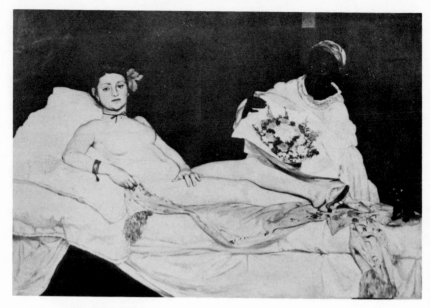

19. EDOUARD MANET: OLYMPIA. 1865. *Louvre, Paris*

When Manet exhibited his "Olympia" at the Paris Salon of 1865, he was accused of vulgarity and was derided. The pioneer quality of this work was recognized by only a few painters, by the poet Baudelaire, and, somewhat later, by Zola. The contrast of subtle blacks, grays, and whites with the vivid colors of the flowers, the accurate, luminous accents—betraying the influence of Goya—the visual and psychological truthfulness, and the firm linear structure resulted in a painting that became one of the masterworks of modern art.

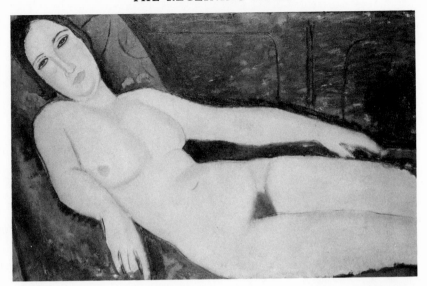

20. AMADEO MODIGLIANI: NUDE ON A DIVAN. 1918. *From the Chester Dale Collection, on loan to Philadelphia Museum of Art, Philadelphia, Pa.*

The Italian Modigliani, during the brief span of his life, never developed fully his unique, almost classical sense for the melody of forms. Like Picasso and his other Parisian contemporaries he was exposed to all the influences of postimpressionism, from the work of Gauguin and Cézanne to African Negro sculpture; nonetheless his trend towards organized simplification of the human form is still more strongly related to the Italian masters of the *trecento*, from Giotto to the Sienese school. Sometimes the structural clarity of his canvases comes close to mere posterlike decorativeness; sometimes it creates a persuasive balance of calm beauty, as in this example

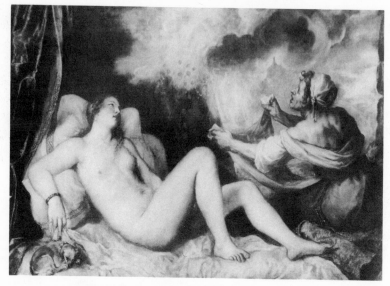

21. TITIAN: DANAE. 1554. *Prado, Madrid*

Inspired by Giorgione's "Sleeping Venus," which he worked on and finished, Titian painted four variations of that theme between 1538 and 1547. Later, the dramatic possibilities of the Danaë theme seem to have held even greater

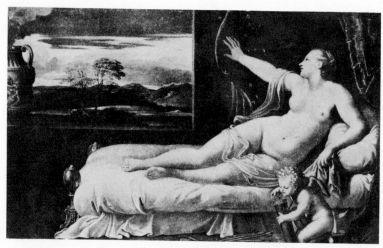

22. DOMENICHINO (DOMENICO ZAMPIERI): DANAE. First half seventeenth century. *Bridgewater Collection, London*

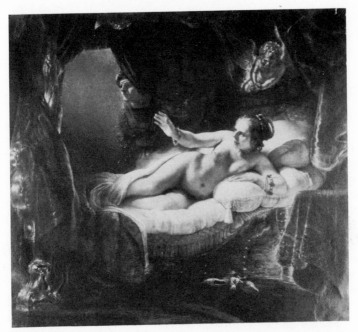

23. REMBRANDT HARMENSZ VAN RIJN: DANAE. 1636. *Hermitage, Leningrad*

interest for him. In this canvas the Renaissance scheme has become baroque: Danaë's posture and the old woman's gesture as she tries to catch the golden coins create strong diagonals that act as a counterthrust to the rays streaming from above and also contrast with the framing verticals of curtain and rock.

Italian painting at the end of the sixteenth century showed two entirely distinct trends. While Caravaggio (1569–1609) and his followers aspired to a greater and greater naturalism illuminated by the varied and sometimes theatrical light effects known as chiaroscuro, the Bolognese-Roman school, led by the Carracci, stressed rigid principles of composition and strove to continue the Roman tradition inherited from Raphael and Michelangelo. Domenichino, a pupil of Annibale Carracci (1560–1609), painted

this "Danaë" after one of his master's wash drawings. Though obviously eclectic and coolly statuesque, the general composition is nevertheless baroque. Danaë is conscious of the spectator; her movements are staged and almost formal.

As always, Rembrandt entirely transforms and humanizes his mythological theme. So little remains here of the traditions of antiquity and the Renaissance that this canvas might represent not Danaë but a real woman awaiting a lover. The play of light models her body—whose curves are everywhere repeated—with a wholly new and earthy reality, and light suffuses and actually builds up the room around her. The direction of Danaë's look counteracts the golden rays and so extends the picture beyond the left-hand boundary of the canvas—away from the spectator, whose existence is thus ignored.

THE THREE GRACES

The Three Graces, semidivine daughters of Zeus who are mentioned in Greek literature as early as Homer, have always been a favorite subject in the visual arts. As companions to the nine Muses, these three maidens, Aglaia, Euphrosyne, and Thalia (Brilliance, Joy, and Bloom) were cherished almost as patron spirits by the artists of antiquity, and have naturally provided a charming theme for a great many works of painting and sculpture. But their real interest lay less in the "story" behind them than in the opportunity they gave the artist for depicting a harmonious sequence of beautiful bodies. The problem of group composition too was almost absent, for these three figures were never shown in any characteristic action, but generally as simply standing casually together, and even this pose was influenced by a traditional arrangement. In fact, the motif of three female nudes standing parallel or with arms entwined appeared in Egyptian and Cretan art long before the Three Graces of Greek mythology.

The traditional scheme was essentially an arrested dance movement, and stylistic changes can be traced through the changing conceptions of this suspended dance figure. Early interpretations were almost static and perfectly counterpoised, while later treatments show the group in a more lively pose, the dance measure caught in transit and the whole scene dramatized. The bodies were at first shown almost as silhouettes in a vacuum, but gradually gained volume and depth of modeling. The physical types, always expressing the sensuous ideals of each period, changed constantly, evolving from the slender grace of the *quattrocento* through the fuller encurvements of the High Renaissance to the climax of Rubens' massively fleshed women in the seventeenth century.

Unlike the individual female nude, standing or reclining, the Three Graces theme permitted a panoramic treatment of the bodies, which were in effect one body seen from three different views, three variations on one theme. This was a conscious aim, for sometimes the very same artists have dealt with a similar topic, for example the Judgment of Paris (figs. 31 to 36), in opposite ways, seeking to individualize the three goddesses as definitely as their aesthetic means permitted. The Judgment, of course, is an actual story, a dynamic episode in a dramatic plot, not simply such a static visualization of general attributes as the Three Graces. Hence the pictorial solution of its theme gave rise to entirely new aesthetic problems.

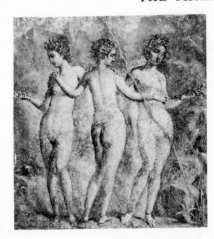

24. POMPEIIAN MURAL: THE THREE GRACES. Ca. 70 A.D. *National Museum, Naples*

A lost Greek work must have been the source of the Greek and Roman Three Graces repeated so frequently on vases, gems, and walls. Representative of this motif is this Pompeiian mural, which shows the goddesses linked by a single flowing rhythm. Gestures supplement and balance one another symmetrically. Each body is distinct in contour and plastically independent, yet each is essential to the design.

The fresco above was not known to Raphael, since the excavations at Pompeii did not begin until 1748, but he must have seen other ancient treatments of the theme. His "Three Graces," actually the three Hesperides, as established by the golden apples they hold, recalls strikingly the quiet composition of the Pompeiian mural, but in everything else the painting belongs definitely to the early High Renaissance: note the interrelation of figures and landscape, and the striking heads that tell of Raphael's devoted studies from life.

25. RAPHAEL SANZIO: THE THREE GRACES. Ca. 1500. *Musée Condé, Chantilly*

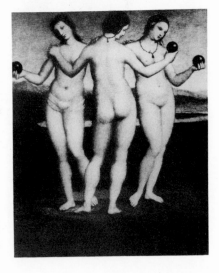

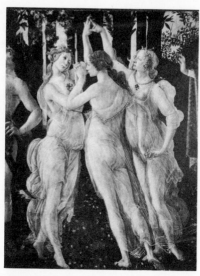

26. SANDRO BOTTICELLI: THE THREE GRACES. Detail from SPRING.
1478–81. *Uffizi, Florence*

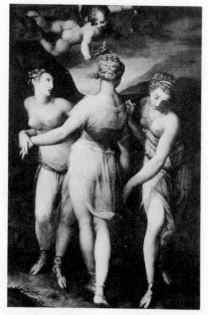

27. GIORGIO VASARI: THE THREE GRACES. Second half sixteenth century.
Museum of Fine Arts, Budapest

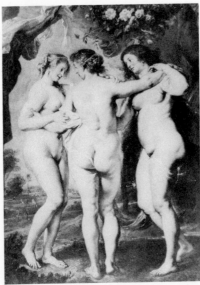

28. PETER PAUL RUBENS: THE THREE GRACES. 1635–38. *Prado, Madrid*

Botticelli's Three Graces are part of his famous allegory, "Spring." In contrast with Raphael's, the female figures are still typically early Renaissance. Their artificial angularity, rapt expressions, and ornamental veils echo an almost Gothic mood. The dance movement of the group recalls the intellectual humanism of Botticelli's day, and the fragile spirituality of the whole is a far cry from the solid sensuousness of Raphael and the Pompeiian mural.

The name of Giorgio Vasari, the architect-painter, lives chiefly because of his well-known *Lives of the Famous Painters, Sculptors, and Architects* (1550). Vasari's own work was typical of the style called mannerism. His "Three Graces" exhibits the mannerist exaggeration of movement and the body contortions inspired by the artist's study of Michelangelo. Such details as the joined hands

seem wholly affected, and we miss the sense of inner relationship found in Raphael's works and even in Botticelli's. The glances and movements of the three maidens are not significantly related. Their movements do, however, forcefully suggest space, creating a feeling of plasticity beyond the pictorial concepts of the High Renaissance.

Only with the work of Rubens did the deities of Greek mythology win in Northern painting the kind of importance as a subject and the kind of independent vitality that they possessed in Italian Renaissance art. Like Titian before him, Rubens thought in terms of color and surface luminosities. Although the theme of the Three Graces itself does not call for animation, this canvas abounds in intersecting diagonals, movements toward depth, and shifts of large masses and lighted areas.

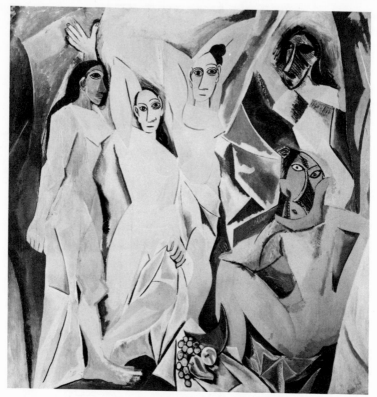

29. PABLO PICASSO: LES DEMOISELLES D'AVIGNON. 1907. *Collection The Museum of Modern Art, New York*

The five female figures in "Les Demoi-selles d'Avignon," Picasso's first cubist painting, are not in themselves related to the Three Graces theme, but the aesthetic problem is the same, namely, a composition of standing female nudes. This huge painting, 96 by 92 inches, is translated into the flat planes typical of cubist pictorial organization. The distance from reality increases as we study the picture from left to right. The third dimension is suggested by some shading, but not by any modeling, and the influence of African Negro masks is clearly apparent in details of the heads. The artist's basic concern is not visual realism but a structural pattern composed of flat, geometric areas of shaded colors.

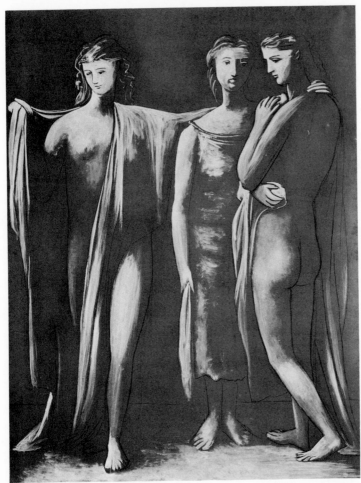

30. PABLO PICASSO: THREE GRACES. 1924. *Owned by the artist, Paris; photo courtesy The Museum of Modern Art, New York*

Picasso's conception of the Three Graces proper is shown in a later work actually called by that name. The Promethean and monumental character of his approach, manifested so often in his work, is fully evidenced in this neoclassic oil-and-charcoal painting. Everything is based on linear clarity and an almost architectural construction. For tranquillity and balance, this work compares with Raphael's "Three Graces." Both artists, each using the visual means of his period, strive for similar revelations.

Group Composition: Mythological and Religious

When a painting involves several figures, the artist's first problem is to compose these figures into a meaningful scheme. This scheme will clarify the relation of the figures to one another, to the surrounding space or background, and to the boundaries of the panel or canvas. Even in a fairly simple design involving only two figures, the logic of placement makes strong demands on the artist. When the pictorial space is filled with many figures telling a story, then group composition is of prime importance; and such a narrative pattern, aside from purely artistic considerations, influences design far more than a single-figure or two-figure theme.

The fact that the artist was telling a story did not mean that he intended it as a piece of news. Quite the opposite was true. Medieval artists presented stories from Scripture and from the lives of saints to a populace that knew such stories from childhood; and Renaissance artists depicted sacred episodes and Greek and Roman myths for men who were thoroughly familiar with both. The artist's task was to invest these scenes with immediacy and feeling. He sought to convey a clearer and more dramatically organized conception of events or legends already well known. A parallel can be found in the practice of the Chinese theater, where actors perform in a single evening selected acts from several different plays. The audience knows these plays, and especially the classic favorites, thoroughly and attends the theater to see what perfected or novel interpretation the actors can give to the familiar lines. This is also the attitude of true opera-lovers and modern Shakespeare audiences. When the subject is thus known in advance and more or less taken for granted, the artist clarifies and heightens our notion of it by the shapes and relationships he finds for it, and the subject becomes for him a mere "motif."

There are two ways to organize a group composition of a religious or mythological subject. The first renders everything within space; the single figure, the group, the landscape are given the depth illusion of three dimensions. This was the solution of classical Greek and Roman art, and of Western art between the Renaissance and the beginning of the twentieth century. The second solution ignores depth as an element of composition. The world's three dimensions are translated onto a flat plane. Figures and objects are organized into patterns within a two-dimensional surface. The result is an abstraction which makes

48

no use of illusion-creating means or organization to express the artist's dramatic or emotional idea. (This abstraction differs from the "abstract" painting of contemporary art, which is abstract in that it avoids imitating real objects or violently distorts them; the abstraction of former periods presented real—that is, recognizable—human figures and natural objects in an unreal space relationship and in unreal proportion.)

Such abstract design governed Early Christian, Byzantine, and early medieval art. The Christian spirit rejected everything material, everything "of this world," and so rejected in its art the third dimension and any visual suggestion of space as depth. Two-dimensional design became the visible symbol of spirituality in Early Christian ivory reliefs, Byzantine mosaics, illuminated codices, and murals. Theological concepts, not the laws of optics and perspective, determined how a three-dimensional reality was to be transformed into a two-dimensional abstraction. The sacred Trinity and holy saints were depicted on flat planes, with proplike symbols serving as the total foreground and background. The rediscovery and application of perspective and the principles of anatomy took almost two hundred years, from the beginning of the fourteenth century through the period which opened with Filippo Brunelleschi (1377–1446) and reached its climax with Leonardo da Vinci (1452–1519). Perspective and anatomy furnished the technique for a naturalistic portrayal of the human body. The two new sciences enabled the Renaissance masters to present human figures realistically and to simulate space convincingly, as had been done a thousand years before in late Greek and Roman painting; and this striving for illusion remained the prime visual intent right down to the beginning of the twentieth century.

But if the approach remained the same, the methods changed from generation to generation, and from one style to the succeeding style. The illusionistic aim dominated the artist's search, and each new style was but a fresh way of realizing the same underlying purpose. Consider how the static balance of Renaissance composition was followed by the increasingly dynamic movement of baroque art. The *concinnitas* (harmonious unity) and careful symmetry of the early sixteenth century gave way to a stronger and more emotional form of expression that prevailed until the end of the eighteenth century. Then "classicism," which had been an undercurrent throughout the seventeenth century, came up like a tide, and "classical" balance again became the accepted mode of expression.

Very closely associated with this shift from static balance to dramatic movement, from idealized types embodying generalized traits to highly individualized characters expressing complex emotions, were certain changes in the means of rendering and painting. In the fifteenth century, for example, solid forms were built up with definite lines. A hundred years later, so-called chiaroscuro (nuances of light and shadow) was used to model forms and give them substance. By the seventeenth century, the increased emphasis on light as a

visual element of the picture encouraged artists to create "atmosphere"; solid forms were suggested rather than firmly defined, and the eye of the beholder completed the image. In a parallel development, color lost its independence. Where earlier painters had applied pure or unbroken color to the well-defined surfaces of well-defined forms, seventeenth-century artists subordinated color to the play of light and shadow until it came to represent merely variations of light.

Naturally, this constant shift in the meaning of line, form, color, and light was accompanied by a parallel evolution in content and emotional emphasis. This evolution is most easily followed in paintings of religious and mythological groups; since the artist can here rely more and more on the spectator's previous knowledge of the subject, he is free to experiment with pictorial effects, including new characterizations of the standard types of myth and religion, and especially new aesthetic explorations in color and light. Within the framework of conventional themes we can follow the artist's ever-renewed attempt, through successive styles, to translate his personal vision into art.

THE JUDGMENT OF PARIS

The Judgment of Paris presents Paris, son of King Priam of Troy, judging the charms of three goddesses, Hera (Juno), Athena (Minerva), and Aphrodite (Venus), each of whom claims the fatal Apple of Discord on which the goddess Eris has written: "To the fairest among you!" Each goddess offers Paris a reward if he will judge her the fairest. The young prince naturally turns from Hera and Athena with their offers of great power and great wisdom, and gives the apple to Aphrodite, who has promised him the love of the most beautiful of mortal women. Since this turns out to be Helen, wife of King Menelaus, Paris's decision is the direct cause of the great ten-year Trojan War, and the depicting of the Judgment becomes part of a broad mythological perspective.

The plastic opportunities which have made the Three Graces a favorite theme for painters and sculptors (figs. 24 to 30), are also present in the Judgment, with its three splendid undressed figures parading in the first and most famous of all beauty contests. But unlike the Three Graces, who simply exist, these goddesses must act; so must Paris, their judge, and even Hermes (Mercury), the traditional messenger between Olympians and mortals; they are all playing vital roles in a story-plot which was presumably familiar to most Renaissance spectators.

The artist's initial conception will mold the bodies of his subjects; more, it will determine their pictured manner and attitude toward one another (a problem that did not arise in the Three Graces) and their reaction to the judge and his decision. The beholder may admire the beautiful or impressive bodies, but his real attention must fasten on the pictured episode, on one specific action. The problems of figure composition outweigh those of simple glorification of the body, and the effectiveness of the relationship of the figures, rather than any descriptive details or gestures, will decide the aesthetic quality of the painting.

31. THE PENTHESILEA PAINTER: THE JUDGMENT OF PARIS. *From an Athenian pyxis.* Ca. 465–460 B.C. *The Metropolitan Museum of Art, New York*

This small Greek vase painting, so perfectly adapted to the contour of the pyxis, a small boxlike jar with a cover, is typical of the classical period, when Greek art was becoming increasingly direct and naturalistic. The figures are limned with simple lines and in a variety of warm, subdued colors on a light ground. The story is unfolded in the procession of figures girdling the body of the vessel: Aphrodite with Eros gazing up at her, then Athena with helmet and spear, and Hera carrying her scepter and standing nearest to Hermes, who is presenting the three rival goddesses to the royal shepherd, Paris. Though simple, this composition perfectly conveys the story, familiar to all Greeks of the time, and not only characterizes the individual personages but even suggests by its solemn rhythm the semiheroic atmosphere of the myth.

32. FOLLOWER OF FRA ANGELICO: THE JUDGMENT OF PARIS. Mid-fifteenth century. *National Museum, Florence*

This birth-plate, the traditional gift to newborn infants in Florence, gives us some indication of the immense enthusiasm for antiquity felt by early Renaissance artists. Though painted by a close follower of Fra Angelico, who devoted himself almost exclusively to religious subjects, it is decorated with a scene from Greek mythology. With its fairy-tale landscape shown in two stages, the composition, in contrast to the content, suggests a medieval manuscript illumination. In the first stage the three goddesses are seen disputing their respective claims to the Apple of Discord, and in the second, the central scene, Paris is awarding the coveted fruit to Aphrodite. The goddesses are richly attired and their gestures are elegant, radiating a rather courtly atmosphere.

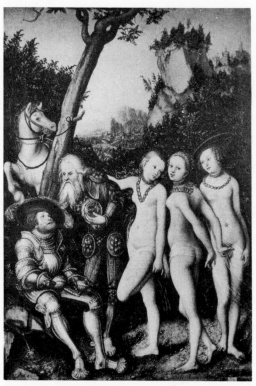

33. LUCAS CRANACH THE ELDER: THE JUDGMENT OF PARIS. 1530.
Museum, Karlsruhe

Among sixteenth-century German paint-ers, Lucas Cranach, a Saxon, exhibited the keenest interest in mythological sub-jects. Between 1512 and 1537, for ex-ample, he painted no less than thirteen versions of the Judgment of Paris, among them the well-known ones now in New York's Metropolitan Museum and the St. Louis City Art Museum. For all his attach-ment to classical themes, however, Cra-nach never shed the medieval spirit and never acquired any convincing feeling for the sensuous values of antiquity. Thus he presents Paris in the form of his own patron, Frederick the Wise, Prince-Elect of Saxony, dressed in full armor. Her-mes, who presents the three goddesses to Paris, appears as a dignified and faintly worried court chancellor. The three god-desses of Olympus appear to have been posed by three flat-chested German cour-tesans, whose self-conscious coquetry suggests a Protestant sense of sinfulness rather than pagan freedom. The stallion in the background is made to prance with a show of greater interest than the shep-herd-prince seems to be bringing to his agreeable task. Careful linear naturalism and a lyrical sense of landscape are com-bined with a clumsy attempt at cap-turing the "antique" spirit of the Ren-aissance. Though labeled German Ren-aissance, the combination more properly represents a belated blossoming of Gothic naturalism.

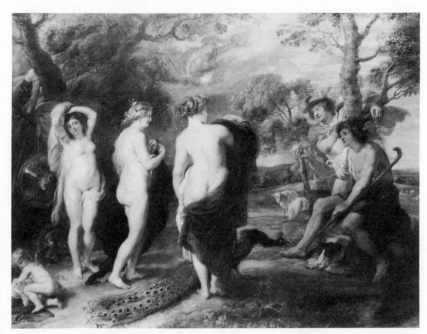

34. PETER PAUL RUBENS: THE JUDGMENT OF PARIS. Ca. 1635. *National Gallery, London*

Rubens' elemental sensuality shows up best in the mythological scenes of his mature period. The two groups, Paris and Hermes on the one hand, and the three competing goddesses with their attributes on the other, are completely integrated with the space occupied by the landscape. The forms and poses are fairly free and self-sufficient, fused with the lustrous harmonies of the chromatic display. The genius of Rubens has here created a work in which the baroque idiom penetrates and fully exploits the values of Mediterranean mythology.

35. FRANÇOIS BOUCHER: THE JUDGMENT OF PARIS. 1754. *Wallace Collection, London*

The Judgment by Boucher, the most representative painter of the French rococo style (the Style Louis XV), was conceived in essentially decorative terms. At first glance it suggests a ceiling composition in its emphasis on upward movement and the way in which, within a triangular scheme, female figures are shown ascending in the grand manner.

The composition is lush and elegant, answering perfectly to the taste of Madame de Pompadour, for whose boudoir it was painted. It uses typically rococo devices in the contrast between well-defined nudes and amorphous clouds and shifting draperies, in the decoratively curving contours, and of course, the charming play of light and shadow.

36. PIERRE AUGUSTE RENOIR: THE JUDGMENT OF PARIS. 1915. *Collection of H. P. McIlhenny, Germantown, Pa.*

All of Renoir's many versions of this theme, done in his last decade, exhibit the same sensuousness, the same nacreous shimmer and delight in rounded limbs. The fact that the grand master of impressionism could hardly have painted this picture if he had not been preceded by Rubens, Watteau, and Delacroix certainly demonstrates the continuity of the European tradition of painting. For Renoir, the myth was only a pretext for painting bodies in motion and capturing the effects of plein-air. His central problem was the harmonizing of countless color tones; to these he gave unity and a sculptural massiveness which in this work has already gone far beyond the limits of mere impressionism.

CHRIST AT EMMAUS

In the Gospel according to St. Luke, 24:13–35, we are told how Christ appeared to two of His disciples on the third day after the Resurrection. Meeting Him on the road to Emmaus, they did not recognize their Lord but thought He was some wanderer. In the evening they went with Him to an inn: "And it came to pass as He sat at meat with them, He took bread, and blessed it, and brake, and gave to them. And their eyes were opened, and they knew Him; and He vanished out of their sight."

This episode is generally presented as one of the most compelling proofs, to the believer, of Christ's divinity. It has always involved the difficult artistic problem of conveying a metaphysical experience by visual means; for, strictly speaking, nothing external happens in the scene. The disciples' eyes—that is, their spiritual understanding—were just "opened," and there is no characteristic action that might afford us a clue to the crisis of the spirit that has taken place. In a sense the theme of the Last Supper is more readily translated into visual terms, for the action of Christ and the psychological reactions of the disciples are truly dramatic even in the external sense. But the figures of the Emmaus theme offer no such visual clues. The event as such is of so entirely metaphysical an order that any attempt at visualization may easily destroy the inner meaning of the scene. Only Titian and Rembrandt, by the extreme simplicity of their compositions, have arrived at solutions whose aesthetic values correspond to the uniqueness of the event. So many artists, including some of those represented here and others, have concentrated either on a psychological analysis of the disciples or on a magical and picturesque illumination of the miracle; or, like some nineteenth-century and twentieth-century masters, have tried to "humanize" the event by translating the scene into contemporaneous naturalistic terms.

The story requires only Christ and the two disciples seated at a table, occasionally along with an innkeeper or servant. Since Christ is the central force of the revelation, He was placed in the center of the picture by some artists and even by the conventions of whole periods. This changes with the baroque period, which shifted the main accent to the periphery of the picture. The disciples in baroque interpretations show every possible kind of response, from mere physical stupefaction to the most devout understanding and realization. The bystanders, innkeeper or servants, are also shown in reactions ranging from complete indifference through curiosity to full participation.

The setting is generally neutral, without descriptive details and much less

localized than in the Last Supper (figs. 44 to 58). The lighting effects, changing with each period, are always expressive, since light is both a physical fact and a metaphor. Sometimes light is employed to dramatize the figure of Christ, sometimes it actually emanates from Him as a supernatural manifestation, and again it may be used realistically to reveal the reaction of the spectators.

So many factors are involved in the visualization of this scene that it is hardly astonishing to find a great number of solutions of it. Each artist within each stylistic convention felt he had finally reached the ultimate "true" interpretation. Along with this profusion of gesture-concepts, emotional delineations, lightings, and spatial notations went changes in the basic composition of the scene, even within the seventeenth century when there were many famous interpretations of this particular subject.

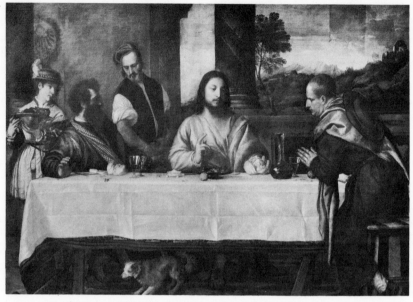

37. TITIAN: SUPPER AT EMMAUS. Before 1547. *Louvre, Paris*

Titian still envisioned the miraculous event with classical simplicity. The relationship of figures, background architecture, and landscape is governed by the use of strong verticals and horizontals in Renaissance fashion, and the composition is calmer than that of Titian's almost simultaneous "Last Supper" in the Palazzo Ducale in Urbino. The impact of the revelation on the disciples is shown in restrained gestures; one leans backward, terrified, while the other folds his hands in pious devotion; innkeeper and servant seem to be observing the event rather than participating in it. Light is not yet given a decisive role. The reticence in the coloring of Christ's figure distinguishes Him from the others.

Where the High Renaissance and mannerism had interpreted scenes from Scripture in a heroic and even formalized manner, Caravaggio turned back to the early Renaissance conception and gave

his Biblical characters features and background drawn from his own time and class. The high voltage, as it were, of his vision arises from the uninhibited realism of his types, which many of his contemporaries regarded as positively vulgar. Caravaggio's light and dark contrasts are dramatized to an extreme degree, and there is a greater emphasis on accessories than on the surrounding space. His aim, especially in his mature period, was not idealization, but characterization.

Honthorst's canvas shows clearly Caravaggio's influence on Northern painting. He has imitated the Italian's sharp contrasts in lighting and minutely described accessories. But by revealing the source of his light—a candle or lamp appears in most of his paintings—by stressing dark silhouettes and by exaggerating gestures and facial expressions, he produced mere theatricality where Caravaggio created genuine drama.

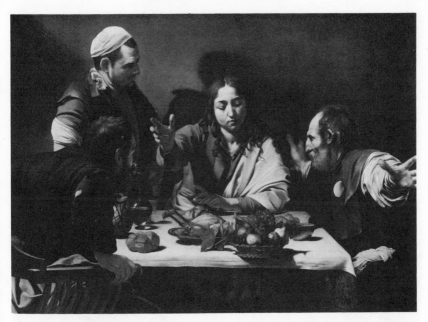

38. MICHELANGELO MERISI DA CARAVAGGIO: THE DISCIPLES AT EMMAUS. After 1600(?) *National Gallery, London*

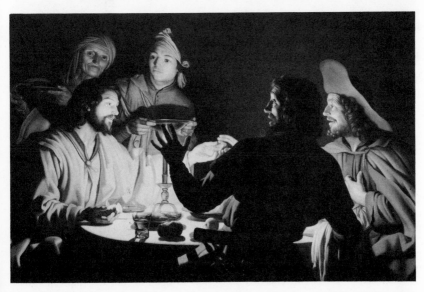

39. GERRIT VAN HONTHORST (GHERARDO DELLA NOTTE): THE SUPPER AT EMMAUS. Ca. 1610–20. *The Wadsworth Atheneum, Hartford, Conn.*

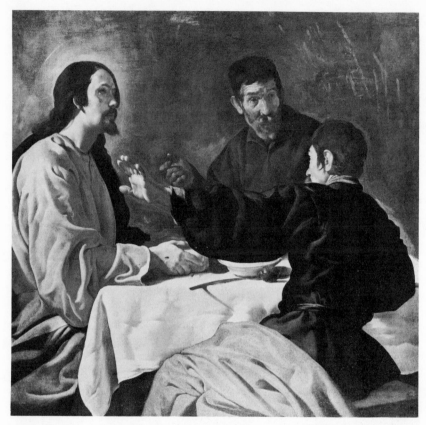

40. DIEGO RODRIGUEZ DE SILVA Y VELASQUEZ: CHRIST AND THE PILGRIMS AT EMMAUS. Ca. 1619–20. *The Metropolitan Museum of Art, New York*

Through Velásquez the art of Spain made contact with the broad stream of European art. The prevailing influences are those of Caravaggio and of Venetian painting. What is strange is that Velásquez, though court painter at the most Catholic court of Europe, concentrates so much on the still-life elements of the scene that he almost neglects its larger religious import. The gestures and the various responses of the disciples are emphasized in the anecdotal-psychological manner typical of the artist's early period. His light and shadow contrasts belong to the baroque style; the somber color is Spanish; but the impressionistic rendering of details carries his personal signature.

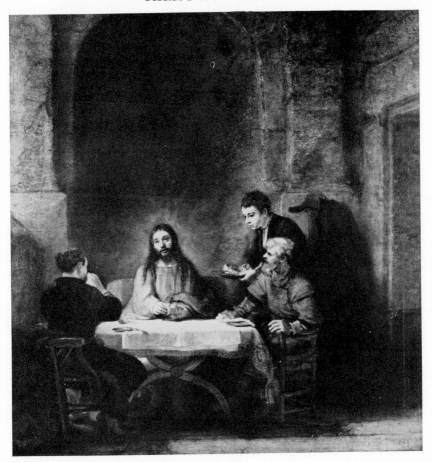

41. REMBRANDT HARMENSZ VAN RIJN: CHRIST AT EMMAUS. 1648.
Louvre, Paris

Rembrandt painted and etched the Emmaus theme several times. His pictorial aim here is tectonic organization of a quiet, almost classical kind, with subsidiary details suppressed. The light is subtly diffused, whereas in other versions it served to dramatize the story. The two disciples are clearly individualized, but the purely physical expression of their feelings seems more moderate. This version uncovers its contemplative depths slowly, but with a greater and more enduring intensity.

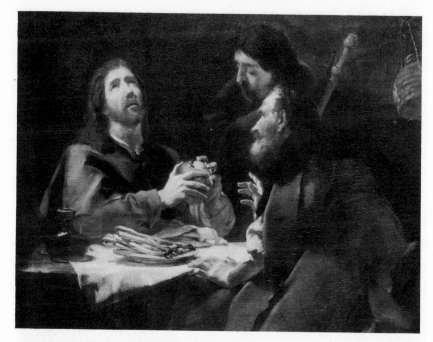

42. GIAMBATTISTA PIAZZETTA: SUPPER AT EMMAUS. Ca. 1740. *Courtesy of The Cleveland Museum of Art, J. H. Wade Collection, Cleveland, Ohio*

This Venetian artist is so very much concerned with the look and touch of what his eye beholds that he reduces the sacred qualities of his story to a minimum. He works with equal interest on the hands of Christ—they are expressively modeled—and the dish of asparagus in the foreground. All indications of space and locale are omitted. His diffused colors and heavy shadows almost seem to anticipate Manet. The dramatic force of baroque here makes way for a delicately tactual intimacy and painterly atmospheric effects.

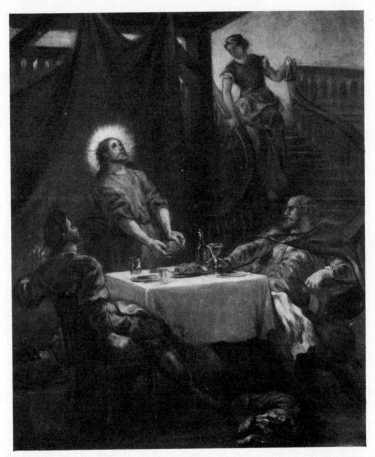

43. EUGENE DELACROIX: THE DISCIPLES AT EMMAUS. 1852. *Collection of Mrs. Watson B. Dickerman, New York*

There is something slightly theatrical in this typically romantic composition: the curtain behind the Lord, the sweeping staircase, the too attentive servant and the disciples picturesquely outlined. The composition recalls the grand baroque designs of Rubens, who influenced Delacroix greatly, although the dramatic use of light and shadow goes back to Rembrandt. Delacroix handles the problems of organization, light, color, and texture with the greatest virtuosity, obviously being less interested in the religious significance of the scene than in its aesthetic possibilities.

THE LAST SUPPER

From the very beginning of Christian art, the theme of the Last Supper has presented a great challenge to artists. A painter can scarcely select a more difficult composition than one which calls for the significant arrangement of thirteen figures around a table, with servants occasionally making the scene more complex. An additional difficulty resulted from the fact that the descriptions of the Last Supper in the four Gospels, Matthew (26:20 ff.), Mark (14:17 ff.), Luke (22:14 ff.), and John (13:21 ff.), were not exactly alike and had to be reconciled into a single, consistent pictorial presentation.

Two moments in the drama figure vitally in all four Gospels—first, that in which Jesus says, "Verily I say unto you, that one of you shall betray me," and again, the act of the Eucharist: "Jesus took bread and blessed it and brake it and gave it to the disciples, and said, Take, eat; this is my body. . . ."

The placing of emphasis in such scenes was influenced by broad spiritual movements in the history of art. The early Renaissance interpretations, for example, reflect the humanism of the period in their stress on the human drama. Leonardo da Vinci's "Last Supper," the most popular of all interpretations, is, in its emotional intensity, inconceivable except against the background of an age stirred by Savonarola's religious teachings.

Almost as influential artistically was the fact that most early Renaissance representations were executed directly in wet plaster on the walls of churches and monasteries. This *al fresco* method required speed, which resulted in broad, flowing figures and these in turn in a certain monumentality. On the other hand, the medium of oil on canvas or wood, used in Venice and in the North, encouraged more careful handling of surface and texture, and resulted in a certain realism of detail.

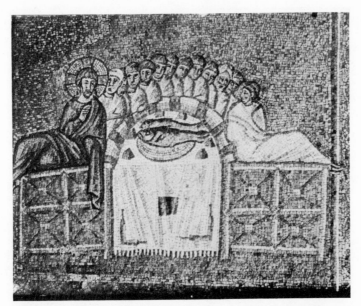

44. BYZANTINE MOSAIC: THE LAST SUPPER. Ca. 520. *San Apollinare Nuovo, Ravenna*

The composition here—part of a church decoration—follows a scheme common in Byzantine mosaics and illuminated psalteries. The disciples, with the Lord in the foreground, are reclining around the table, according to the custom of the time of Christ. Scarcely any perspective is used. The rhythmical order of the arrangement with its simple dignity is the decisive means of artistic expression.

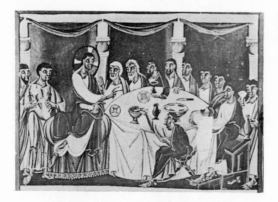

45. SCHOOL OF REICHE-NAU: THE LAST SUPPER. Early eleventh century. *From a manuscript in Staatsbibliothek, Munich*

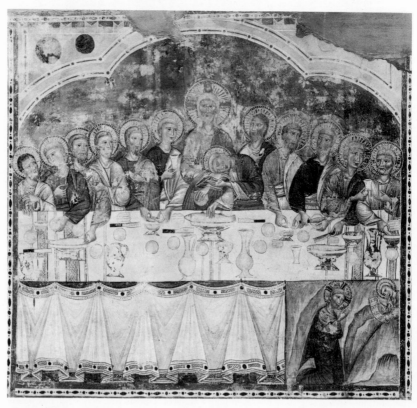

46. UMBRIAN MURAL: THE LAST SUPPER. *From Spoleto.* Ca. 1250. *Worcester Art Museum, Worcester, Mass.*

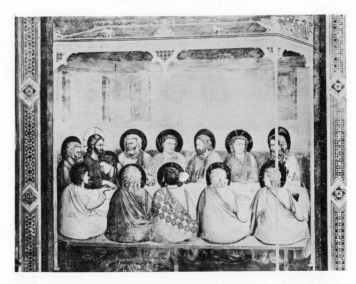

47. GIOTTO DI BONDONE: LAST SUPPER. 1305–1307. *Fresco from the Cycle in the Arena Chapel, Padua*

The realistic quality of the scene in the illuminated manuscript from southwest Germany characterizes Northern art of the early Middle Ages, in contrast to the tradition-bound Byzantine style. Further, illuminated manuscripts permit a more intimate approach and a freer rendering than do mosaics; Christ is clean-shaven, a type often encountered in early Christian art. In the sixth century mosaics of San Apollinare Nuovo in Ravenna, both clean-shaven and bearded types are used. The bearded Christ became general in the tenth century.

This Umbrian mural preserves many of the traits of Byzantine mosaics: for example, in the curve of the Apostles' heads which repeats the curve of the architectural frame. However, a certain tendency toward naturalistic description comes through, despite the total absence of perspective and the resulting flatness. The mural is characteristic of the transition from Byzantine concepts to the new independent Italian style which was to culminate in the works of Giotto.

A comparison of Giotto's work with the mural from Spoleto, only a few decades earlier, makes clear the tremendous progress achieved by the genius of Giotto. Here the complete freedom of organization heralds the dawn of a new era. The courageous realism of this fresco is astonishing: John leans upon Christ, and five of the Apostles are actually shown turned away from the beholder. The disciples have distinct individuality, their faces reflecting their personal reactions. All present are dismayed by the Lord's words, "One of you shall betray me."

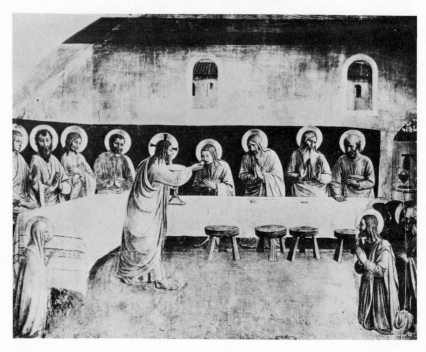

48. FRA ANGELICO: THE LAST SUPPER. After 1443. *San Marco, Florence*

Fra Angelico represents the transition from Italian late Gothic to early Renaissance art in Florence. Though the work of this monk makes obeisance to medieval religious attitudes, the artistic means he employs are those of the Renaissance. Space has become a challenge. His figures are three-dimensional and real, though less dramatic than Giotto's. In Fra Angelico's various versions of the Last Supper, the reactions of the several Apostles are more strongly emphasized than the tragic import of the scene as a whole. The San Marco fresco shows Christ offering the Host; four Apostles have left their seats and kneel for prayer in the right corner. The surroundings are barely indicated. Though the table is curved, the heads of the eight seated Apostles are in line, much as they might be in a medieval representation.

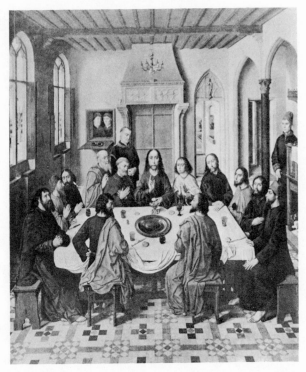

49. DIRK BOUTS: THE LAST SUPPER. 1468. *St. Peter's Church, Louvain*

This center panel of a large altarpiece is the chief work of the artist, who was Dutch-born but belonged to the Flemish school. Despite errors in perspective, the scene is extremely realistic, presented as if set in a Flemish bourgeois home of the period. Undoubtedly the artist's conception was strongly influenced by similar scenes in medieval mystery plays. The moment selected is that of Christ blessing the Host. Judas is in the left foreground. The two servants, arbitrarily introduced into the scene, may be portraits.

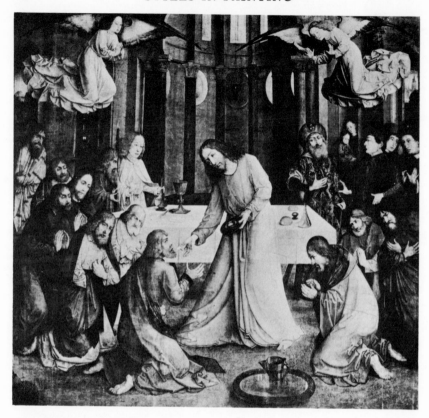

50. JUSTUS VAN GHENT (JOOS VAN WASSENHOVE): THE LAST SUPPER.
1474. *Ducal Palace, Urbino*

The easel painting of the Flemish artist Justus van Ghent, ordered by the Duke Federigo da Montefeltro in Urbino, Italy, reflects a conglomeration of influences. Yet it is wholly individual. His Grace, a Venetian ambassador, and other Italian figures, appear as bystanders. The feeling of the whole is rooted in the Northern, Flemish, tradition. Christ distributes the Host standing before the table. His expression and the attitudes of the Apostles are movingly real. The impact depends on the almost medieval expressiveness of the individual figures rather than on such an over-all mood as marks contemporary Italian treatments.

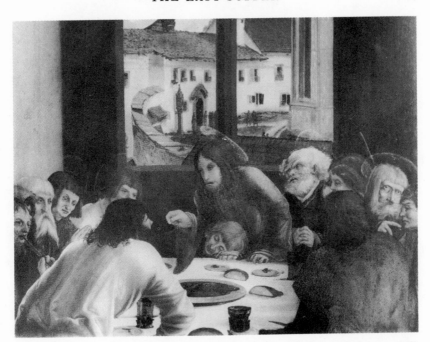

51. ALBRECHT ALTDORFER: THE LAST SUPPER. *From an Altarpiece.* 1517.
Municipal Museum, Regensburg

With merciless realism the German master contrasts Christ and Judas; the Apostles are mere onlookers, interested in Judas's reaction rather than impressed by the eternal significance of the event. Each disciple is a psychological study. Descriptive details are sacrificed to the immediate drama. The narrowness of the room, the wholly asymmetrical arrangement, the lack of interest in space, the compact grouping, are all typical of the Gothic feeling that survived well into the sixteenth century in Germany. It is scarcely credible that such a picture should have been painted at a time when the influence of Raphael and Titian had spread through Europe and when such German masters as Albrecht Dürer were already attempting to combine German intensity of expression with the balanced organization of the Italian Renaissance masters.

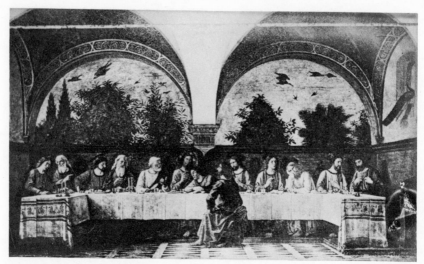

52. DOMENICO GHIRLANDAIO: THE LAST SUPPER. Ca. 1480. *Ognissanti, Florence*

Ghirlandaio's mural covers the back wall of a chapel, the painted vaults of the scene being framed by the actual vaults of the structure. Judas, isolated, seems to be defending himself before Peter, who sits beside Christ and speaks to Him, while John leans on His breast. This is an excellent example of early Renaissance work. The artist is enamored of each detail and describes birds and trees as explicitly as the features of Christ and His disciples. Yet the naturalism differs from that of the North. Ghirlandaio frames his figures architecturally within the horizontals of the wall, the table level, and the lower edge of the tablecloth. The correct perspective shows how much more ably the Italians grasped the new techniques of pictorial realism.

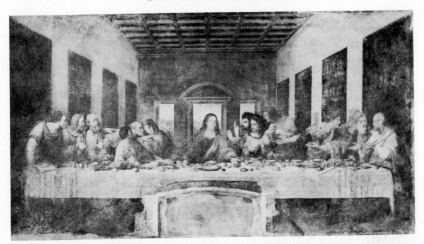

53. LEONARDO DA VINCI: THE LAST SUPPER. 1494–97. *Santa Maria delle Grazie, Milan. Photo ENIT*

Although Leonardo's fresco in the Refectory of Santa Maria delle Grazie in Milan unfortunately began to deteriorate in the sixteenth century, it remains to this day the supreme image of the Last Supper in the mind of the world. Painted only about fifteen years later than Ghirlandaio's detail-filled mural, this masterpiece rejects all minor descriptive detail. The pointedly unadorned tableau of Christ and disciples carries the full weight of the religious and human import, illustrating Leonardo's unparalleled genius. In composition it also illustrates the High Renaissance concept of a nearly symmetrical scheme. A simple architectural background frames and underscores the drama. As in Ghirlandaio's fresco, the moment portrayed is that following Christ's announcement that one among the disciples shall betray Him. The Apostles have each a depth of characterization never reached by earlier treatments of the theme. They are arranged in four groups of three. Judas, third from Christ on the left, is no longer isolated but set apart merely by a prophetic shadow on his face. The Lord is placed against the light of the central door, and His simple gesture expresses both the magnitude of His coming sacrifice and His infinite capacity for forgiveness—the true double meaning of redemption.

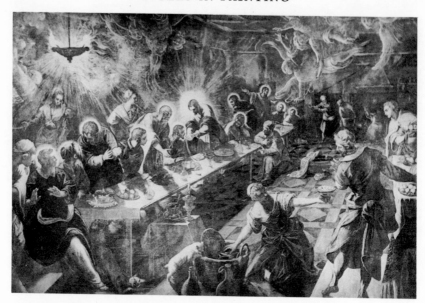

54. TINTORETTO (JACOPO ROBUSTI): THE LAST SUPPER. 1591–94. *San Giorgio Maggiore, Venice*

This mural by Tintoretto, like his other version in the Scuola di San Rocco in Venice, illustrates the change in the conception of the theme that took place toward the end of the sixteenth century. First to conceive the Last Supper as a night scene, Tintoretto employs a supernatural light to illuminate the sacred event. The scene is made tempestuous by the rushing together of the perspective lines of the table and by the postures of the disciples. The latter appear almost to have been flung into their positions by some overwhelming force, and the activities of servants and bystanders add to the effect of turbulence. In fact, the servants, angels, and spectators distract us from the main actors in the drama. Christ has risen to spend the Host, and the celestial light radiating from Him mingles with the natural light of the lamp. Fluid action permeates the scene and makes us feel we are participating in the drama rather than contemplating its inner meaning.

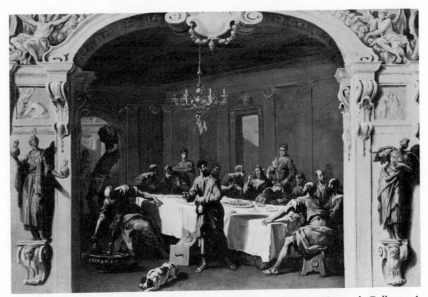

55. SEBASTIANO RICCI: THE LAST SUPPER. 1720–30. *National Gallery of Art, Kress Collection, Washington, D.C.*

In the manner of eighteenth-century Venetian artists, Ricci presents this sacred episode as a stage scene, framed by a proscenium arch, with the allegorical figure of Divinity on one side and Patience on the other. Set in a room in an eighteenth-century Italian palace, the overdramatized scene attributes to the Apostles a whole range of exaggerated, characterizing gestures: at one extreme one of them calmly helps himself to wine; at the other, Judas, virtually in flight from the chamber, overturns his seat in his agitation. As is customary in Venetian painting from Tintoretto on, subordinate figures are introduced: the innkeeper and two servants in the background and the dog in the foreground contribute to making the scene as realistic as possible. The typical eighteenth-century colors, suggesting pastels for all their freshness, are laid on loosely, playing impressionistically with the fleeting light effects that mark the passing moment.

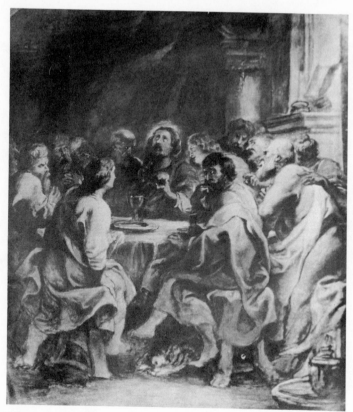

56. PETER PAUL RUBENS: THE LAST SUPPER. 1620–35. *Hermitage, Leningrad*

Rubens' thoroughly baroque approach is a far remove from Italian conceptions of this scene. A single circular movement unites the composition. From Judas peering directly out of the picture, through the group of disciples at the right, the circle moves swiftly, is broken up by the isolated figure of Christ, taken up again by the group at the left, and completed by the young Apostle in the foreground. The baroque architecture serves merely to frame the circular sweep of the piece. Since Rubens was acquainted with Leonardo's serene "Last Supper" (he made drawings after that Renaissance fresco), the dynamism of this painting illustrates all the more the irresistible baroque trend toward dramatized movement.

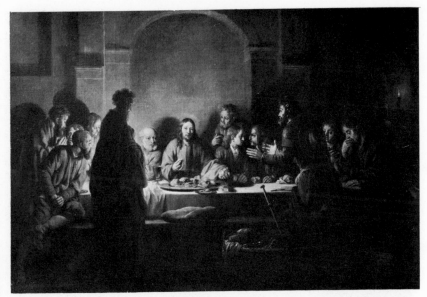

57. GERBRANDT VAN DEN EECKHOUT: THE LAST SUPPER. 1664. *Rijks-museum, Amsterdam*

In this canvas Eeckhout is influenced by his master Rembrandt but also borrows from Leonardo da Vinci. From Rembrandt he took certain principles of lighting which he turned to rather theatrical effect. Further, the group surrounding Christ, and His position before a rounded niche, are taken over almost literally from Rembrandt's "Christ at Emmaus" (fig. 41). Eeckhout combines this arrangement with certain elements from Leonardo's composition, especially the relation of the Apostles and the gesture of Philippus. The work is an example of an art that is bound by tradition and develops no original idea—in short, of eclecticism.

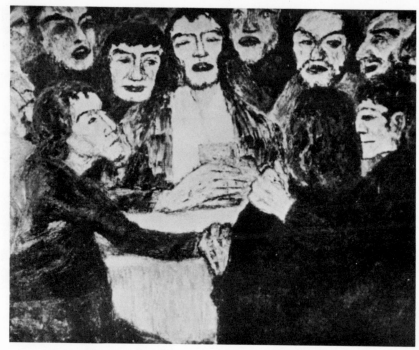

58. EMIL NOLDE: THE LAST SUPPER. 1909. *Museum, Halle*

The sense of religious mystery faded from eighteenth- and nineteenth-century presentations of the Last Supper, only to reappear in the twentieth century. Nolde, most visionary of the German expressionists who founded the movement called "Die Brücke," revives the miraculous tone of the scene by the tense, crowded array of figures, their masklike faces, and the darkly glowing colors, recalling stained-glass windows. His conception is closer to the medieval than any other interpretation since the Renaissance.

THE ADORATION OF THE MAGI

While the Christ at Emmaus theme appears comparatively late in Christian art, the Adoration of the Magi, like the Annunciation, the Nativity, the Last Supper, and the Crucifixion, is among the oldest and most popular themes of Christian iconography. The story (Matthew 2:1–12) relates how the star appeared and guided the "wise men from the East" first to Herod and then to Bethlehem, where they worshiped the Child and gave Him rich gifts.

Early accounts regarded the Three Kings as priests of Mithras, whose cult at the time of Christ had already spread beyond its Persian center, and by the time the Gospel according to St. Matthew was written had been carried into the Mediterranean area by Roman legions. Oriental astrology also played a part: the guiding star, the gifts of gold (sun symbols), and the offerings of spice and myrrh (which were linked with certain planets). Later the Three Kings were often explained as the three continents known to the ancient world: Europe, Asia, and Africa, bowing to the newborn Savior. Such changes indicate that folklore additions to the story of Epiphany continued to be made almost to the end of the Middle Ages.

Actually, the Feast of Epiphany, or of the Three Kings, celebrated on January 6, was not always distinguished from the Christmas feast, which was established in the fourth century by Pope Julius I. Whenever the three Magi are shown as approaching or as having arrived at the stable where the Virgin rests with her child, we are in the presence of this thematic combination. The pictorial conception of the Epiphany itself, or "showing forth of our Lord to the world as symbolized by the Three Kings," was definitely influenced by the Epiphany plays staged annually throughout the Middle Ages by the Church, first with the clergy performing alone and later with laymen assuming the devotional roles. The first Latin plays originated in France about the eleventh century, developing out of liturgical rites, but about 1250 Latin gave way to the vernacular, the performances were transferred from church to marketplace, and splendid processions accompanied the Three Kings. Here in the bright costumes, banners, and glittering panoply of men and horses was rich inspiration for painters. Indeed, in these presumably sacred paintings the processions were reproduced so faithfully that we can almost reconstruct the action of the Epiphany plays from them.

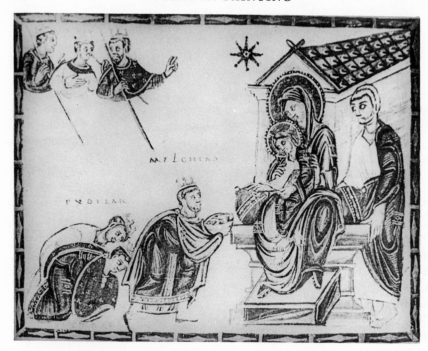

59. SCHOOL OF REICHENAU: ADORATION OF THE MAGI. *From the Codex Egberti.* Ca. 980. *Municipal Library, Treves*

This picture, typical of the Rhenish schools of miniaturists flourishing in the tenth century, combines two scenes. The half figures in the upper left are the three kings pointing to the star which will lead them to Bethlehem. The main scene in the foreground shows the Virgin seated with the Child, Joseph standing near by, and the three kings offering gifts. For all its two-dimensionality this small illumination is remarkable for its clarity and nobleness of form. Although late Hellenistic and Byzantine influences can be recognized, the entire composition, from the arbitrary proportions, exaggerated gestures, and rhythmical folds of cloth to the strongly emotional facial expressions, typifies the early Romanesque style in central Europe.

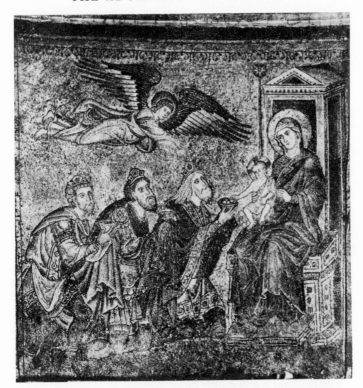

60. JACOBUS TORRITI: ADORATION OF THE MAGI. Between 1287 and 1295.
Mosaic from Santa Maria Maggiore, Rome

One of two known works of Torriti, thirteenth-century Roman painter and mosaicist, this Adoration belongs to a sequence of five scenes from the Life of the Virgin. The mosaic medium and the general conception are still definitely Byzantine, but the group movement and the mode of expression are far livelier than were allowed by the earlier Byzantine forms with their hieratic rigidity. This mosaic prepares the way for Giotto, although it is still remote from that master's dramatic intensity and humanizing naturalism.

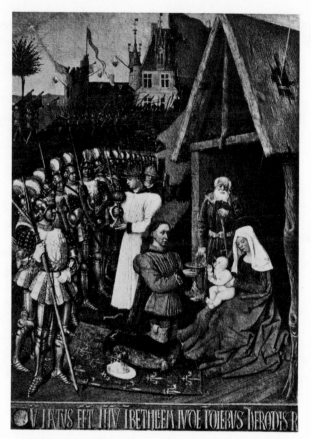

61. JEAN FOUQUET: ADORATION OF THE MAGI. *From the Livres d'Heures d'Etienne Chevalier.* After 1450. *Musée Condé, Chantilly*

The transition from medieval conceptions to an emergent naturalism, completed in Italy by the first *quattrocento* painters, becomes evident in the North in the work of such masters as Jean Fouquet, miniaturist and easel painter. Exceedingly French, this *peintre du Roy*—to both Charles VII and Louis XI—combines the delicacy of the earlier miniature style with the new trend. Despite faulty perspective, there is a new visual concept in the movement from the background, through the parallel diagonals formed by the soldiers and the approaching kings,

to the group seated in the foreground. One of the kings has the features of Charles VII, and lest we mistake his royal identity he kneels on a carpet decorated with the French fleur-de-lys. The introduction of a living likeness into a sacred scene is another parallel between Fouquet and his Italian contemporaries. Though this miniature is only a page from a prayerbook and necessarily limited in size, even a subordinate episode in the background, the Slaughter of the Innocents, is given full dramatic interpretation.

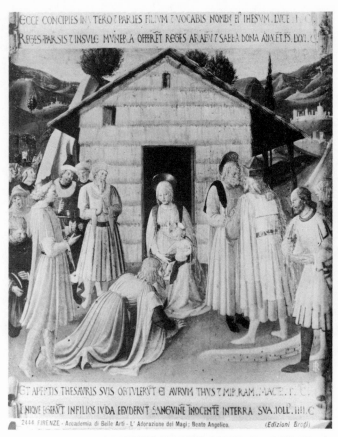

ECCE CONCIPIES IN VTERO Z PARIES FILIVM Z VOCABIS NOMEN EI IHESVM .LVCE .I .

REGES TARSIS Z INSVLE MVNERA OFFERET REGES ARAEV Z SABEA DONA ADVCET.PS .LXXI.

ET APETIS THESAVRIS SVIS OBTVLERVT EI AVRVM THVS Z MIRRAM. .MACE. I .

NIQVE EGERVT INFILIOS IVDA EFVDERVT SANGVINE INOCENTE INTERRA SVA .IOLL .IIII.C

2444 FIRENZE - Accademia di Belle Arti - L' Adorazione dei Magi; Beato Angelico. (Edizioni Brogi)

62. FRA ANGELICO: ADORATION OF THE MAGI. Ca. 1450–53. *Accademia di Belle Arti, Florence*

The tender, religious humility that the Dominican monk Fra Angelico brought to all his work appears equally in his approach to such a tragic theme as the Last Supper (fig. 48) and to such themes of quiet fulfillment as this Adoration of the Magi. Eight versions of this have survived from his brush. We find the same fairy-tale atmosphere charging the interpretation of New Testament stories in the thirty-five small wood panels he and his pupils executed for the doors of a cupboard in the Church of Santissima Annunciata in Florence. Like his murals, these small scenes achieve the simple definition of space and rhythmical order characteristic of the very beginning of the early Renaissance.

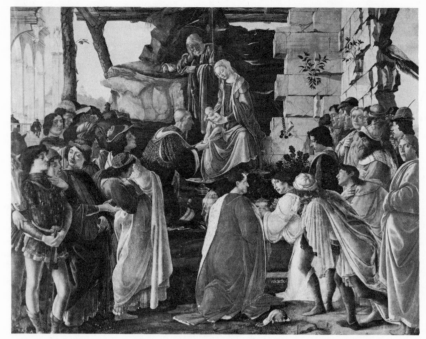

63. SANDRO BOTTICELLI: ADORATION OF THE MAGI. Ca. 1475. *Uffizi, Florence*

One of the innumerable *quattrocento* works dealing with this theme, Botticelli's Adoration is composed in almost hieratic order. Against a background of Roman ruins, the Holy Family is placed in a stable that stands upon ruins, the composition of the group inspired no doubt by Mantegna's "Adoration of the Magi" of 1460. The three kings and the members of their retinue represent contemporaries, mostly members of the Medici family. The figure shown gazing out of the picture in the right-hand corner is a portrait of Botticelli himself. The vivid expressions and gestures of the figures, together with the numerous naturalistic details, are characteristic of the third generation of Florentine early Renaissance painters, but the balanced composition, leading the eye into the center depth, anticipates the High Renaissance approach.

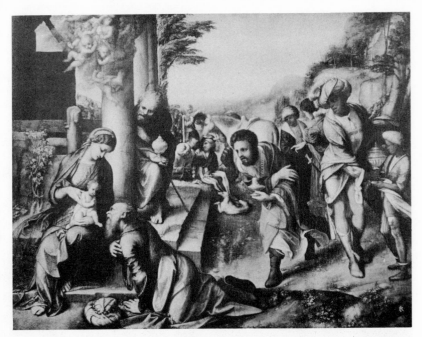

64. ANTONIO ALLEGRI DA CORREGGIO: ADORATION OF THE MAGI.
Ca. 1513–14. *Brera, Milan*

This early canvas by Correggio, who worked in Parma in relative isolation from the main stream of Italian art, reveals some of the qualities that made him a pioneer of the baroque style. Though this painting is separated from Botticelli's by less than fifty years, it seems much later by reason of its extreme dramatic subjectivism—its *sentimento*. Even more characteristic of Correggio's work is its *sfumato*, the soft gradation from light to shadow, a technique first employed by Leonardo da Vinci. Its heightened emotional approach separated Correggio's work no less from the Roman High Renaissance style of his great contemporaries than from his predecessors.

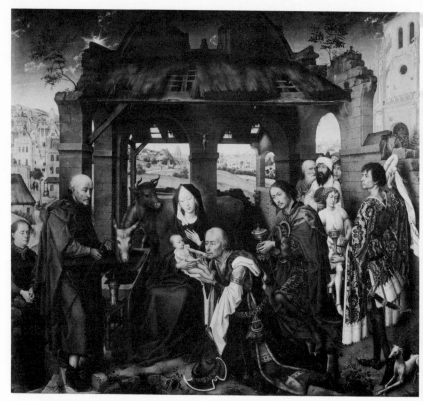

65. ROGIER VAN DER WEYDEN: ADORATION OF THE MAGI. Ca. 1450.
From the Columba Altar, Alte Pinakothek, Munich

The Adoration forms the central panel of an altarpiece painted originally for the Columba Church at Cologne. The organization of van der Weyden's triptych remained the Flemish prototype for treating the Adoration theme until well into the sixteenth century, and also influenced the German approach to the subject. The explanation of this strong influence lies in van der Weyden's simple and unconstrained handling of the human figure, resulting in unforgettable types and interrelationships. The popular Bible story is animated by warm colors and amusing sidelights on the main action. The typical Flemish town in the background and the tumble-down stable in the foreground—with the bushes growing on the roof and the crucifix on the pillar—add variety and interesting detail.

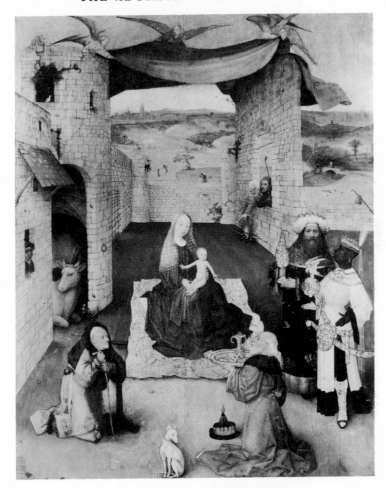

66. HIERONYMUS BOSCH: ADORATION OF THE MAGI. Ca. 1490. *The Metropolitan Museum of Art, New York*

Though Dutch by birth and trained by the Dutch master Ouwater, Bosch's work tends to be Flemish in spirit. His extraordinary imagination, which lends a medieval tone to his fantastic creations, obscures the fact that he actually employs the same methods of representation as his contemporaries. The figures on this panel exist in isolation, as unrelated as the characters in a medieval Nativity play. We cannot recognize any unifying principle of design. The artist simply recounts what comes into his mind. The dog in the foreground, the angels stretching a canopy above the Virgin, shepherds warming their hands at a fire, people in the fields—all these seem to be only footnotes on the main theme; but in their totality they contribute powerfully to the scene's emotional impact.

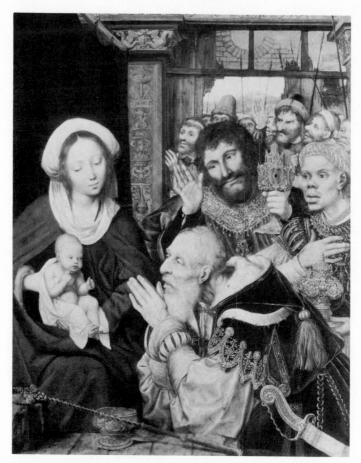

67. QUENTIN MASSYS: THE ADORATION OF THE MAGI. 1526(?) *The Metropolitan Museum of Art, New York*

Massys, unlike his artistic predecessors and most of his contemporaries, lived in an atmosphere that was relatively free, humanistic, and responsive to intellectual currents. He is one of the first Flemish painters to fuse Flemish trends with ideas from the Italian Renaissance. He took delight in typical Renaissance architectural details, in rich clothing, jewelry, and other accessories; even more significantly, he accepted that altered relation of human figures to space and that new approach to group composition by which the Italian influence may be recognized. This Adoration, unlike traditional Flemish and Dutch treatments, shows half-figures only, which allows more compact storytelling and greater scope for individualizing the characters.

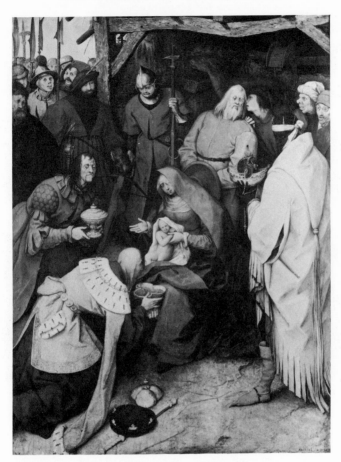

68. PIETER BREUGHEL THE ELDER: ADORATION OF THE KINGS. 1564.
National Gallery, London

Breughel has been compared with Hieronymus Bosch (fig. 66): in both we find the humorous and the nightmarish mixed imaginatively, a profusion of grotesque detail, and, most significant, great powers of naturalistic description. But in terms of composition, Breughel's work belongs entirely to the Renaissance, absorbed by him in his Italian travels. Without weakening his distinctly Northern vision, the Renaissance influence led him to give his Biblical, mythological, and genre scenes clear, legible composition. Space relations, the flow of movements, and the connection between separate figures are all precisely defined and used consciously for aesthetic purposes. In this Adoration, all the actors are so sharply individualized that they nearly overshadow the over-all narrative. Breughel's striking and sometimes almost aggressive truthfulness illuminates their features and, even more, their gestures and attitudes.

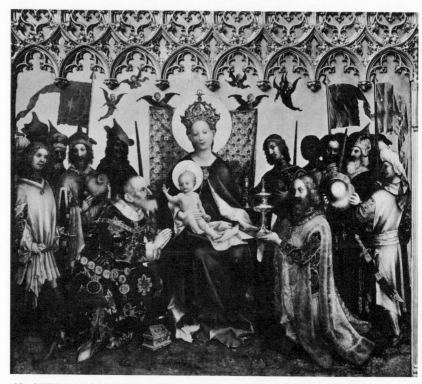

69. STEFAN LOCHNER: ADORATION OF THE MAGI. 1442–44(?) *Cathedral, Cologne*

Where Lochner's Flemish and Italian contemporaries, including Rogier van der Weyden and Fra Angelico, set their portrayals of the Adoration in front of a stable in Bethlehem, this German painter from Cologne set his scene before a symbolic background. Patrons and notables of the city of Cologne are shown on an equal footing with the mythical three kings in presenting gifts to the newborn Jesus. Their feet press down the grass of a very terrestrial meadow, but their heads are outlined against the timeless gold background characteristic of medieval painting. The center panel of this triptych, statically symmetrical, reveals a medieval quality lingering in Lochner's pictorial aim, to wit, to produce a formal, devotional altarpiece and not merely to narrate a specific Biblical story. Naïve lyricism and depth of feeling, characteristic of all of Lochner's work, here serve in the absence of any such conscious naturalism as marks his Italian and Flemish contemporaries.

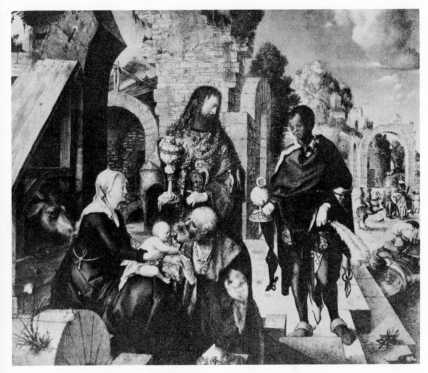

70. ALBRECHT DURER: ADORATION OF THE KINGS. 1504. *Uffizi, Florence*

Albrecht Dürer's Adoration tells its story with a clarity relatively rare in German painting of his period. The placement in space is carefully stated: the stable in the foreground, the ruins, the background landscape, all help to demarcate the planes of the picture. The Virgin and Child and one of the kings mark the first plane, the two approaching kings occupy the second, and so forth. Surprisingly enough, Dürer composed this Adoration with its almost Italian manner a year be-fore he actually visited Italy. The Renaissance influence evident in the composition is balanced, however, by the definitely Northern treatment of the figures. Each motif is fully developed, yet all are fused in the overriding unity of the entire composition. Though this painting belongs to the artist's early period, it is in every sense mature, an outstanding example of German art at the beginning of the sixteenth century.

Group Composition:
Contemporary Scenes and Genre

With the sixteenth century, a completely new problem faced the artist, that of painting a story entirely unfamiliar to the beholder. Until that time, scenes from religion, myth, and legend had been considered, with a few exceptions, the only ones worth reproducing.

As new social and economic classes, and particularly a powerful merchant group, arose, art became more secular, and began to concentrate on the new, unexpected, or transitory—as against the traditional, standard, or eternal—in human affairs. There was a demand for incidents from history or contemporary life, close-ups of types and individuals, and scenes of an amusing or anecdotal nature. While these types of painting in themselves created separate and even contrasting forms, they all centered on the attempt to present something new to the beholder. Each picture or sculptural group proposed an entirely fresh content, with no known elements to meet the spectator's expectations.

The artist's task was to discover new material of visual interest, then to organize it into a self-explanatory scene. If his work was to be more than mere illustration, it needed to show simultaneously the substance of his painted objects and the essence of his artistic thought. "Like the good novel," as some-one once said, "the narrative painting must show the substance of things and the substance of thought." A beggar's rags, an elegant face, a prancing horse, ruined buildings, and so forth, are all objects which evoke social and literary associations as well as purely visual ones. The artist, by skillful placing, subordination, treatment of color and values, translates all these literary associations into the visual elements of a single unified design. The qualities in a beggar's rags, in a proud face, in galloping horses, melancholy ruins, splendid or squalid interiors, calm or stormy landscapes, and so on, carry a heavy charge of meaning which must be transformed into pictorial values that are immediate and self-contained within the picture. When they are not so transformed and subordinated, the picture becomes simply a footnote to an imaginary or historical event, and therefore a mere illustration. And illustration differs essentially from pure pictorial art in this: that art creates a structural relationship to bind unconnected facts and realities. The original importance of those unconnected facts, individual faces and figures, colors, lights and shadows, move-

ments and details, is very great, but their artistic significance is derived from the visual counterpoint with which the artist endows them.

Aside from the religious and the mythological, the three main categories of group composition are: historical events and personalities, studies of contemporary life or social scenes, and genre.

Historical Scenes. The chief problem is to condense an event that took place in time, and give it simultaneity and visual unity. The essential facts are extracted from a confusion of detail and transformed into an organization in space. A good historical painting suggests everything that preceded the painted moment, without appearing to be excerpted—like a motion-picture "still"—from the continuity. The artist's over-all vision replaces the succession of happenings unfolded in the novel or motion picture. There exist so few examples of great historical paintings that a consistent stylistic sequence cannot be shown here; among the best known are: "Battle between Alexander and Darius," Roman mosaic, ca. 100 B.C., after a Greek painting by Philoxenus of Eretria, ca. 319–297 B.C., National Museum, Naples; Paolo Uccello's "The Battle of St. Egidio," 1423–25, National Gallery, London; Velásquez' "The Surrender of Breda," ca. 1634–35, Prado, Madrid; J. L. David's "Crowning of the Empress Josephine," 1805–1807, Louvre, Paris; Manet's "Execution of the Emperor Maximilian of Mexico," 1867, Municipal Museum, Mannheim.

Contemporary Scenes. In this type the subject matter is chosen not from myth, history, or religion, but from the artist's own environment. The choice, however, is neither random nor casual. The artist becomes what Shakespeare calls "God's spy," searching for the essential life beneath the accidents of costume, social condition, or the surface bustle of crowds. When the scene does not possess this suggestion of a deeper and seemingly inevitable reality, this "inner realness," then the artist's imagination must alter it, create a center of visual interest, stress the significant moment, throw out unrelated objects, add or exaggerate telling details, and move figures and masses until they are composed in a related whole. It is this creative act, and this alone, which transforms an incidental scene into a symbol of a social milieu, a cultural area, or an economic class. In masterpieces of this type, the specific and the generic are seen as aspects of a unified reality: local traits, dress, gestures, the perpetually changing customs of men and nations—all these are presented as manifestations of a single life force.

Genre. The distinction between genre and the broad scene from contemporary life previously discussed is easily felt, though not easily defined. Genre, too, draws upon the immediate environment, and, in fact, is so classified by most dictionaries. But in genre the incidental element is stronger, and the artist selects subjects and episodes precisely for their "local color." The danger in genre painting lies in a temptation to record something merely because it is

sensational or sentimental, or even "cute." Although at its best genre painting can be of a high order, it never achieves the level of symbolic value.

Genre puts a great deal of emphasis upon the accidental and the temporary, upon the moment's gesture, upon occupational or provincial types, yet even here the artist must select his amusing episode or odd character with an eye to some pictorial idea. The literary or nonvisual interest of the subject must be restated in visual terms. In other words, nothing should be painted that can be better expressed in writing. A genre piece is a limited interpretation of a limited portion of reality, but its movement and detail are intended to convince, and its presentation to make clear the whole sequence of an episode at a glance. Murillo's "Grape Eaters," Frans Hals' "Hille Malle," and Hogarth's "Shrimp Girl," all of them glimpses of "local-color types," need no verbal commentaries to help us know them. They exist both as individuals and as types, and are as eternally true as Shakespeare's Falstaff and Cervantes' Sancho Panza.

By contrast, the picture of a Hollywood star poised on a diving board or standing beside an expensive car is not conceived as an expressive element in a design. The only reason for such paintings is to stimulate daydreams or sell a product. The difference does not lie in the artist's means, which may be effective for his purpose, but in the motivating concept. The true artist sees the visually exciting elements first and interprets them afterward. The commercial illustrator starts with the story and then thinks of visually appropriate elements. He always remains the captive of verbal ideas. He has not made creative use of the pictorial medium; he has not created anything, he has made only a colored replica of something we might want to buy. This is the literary association at its very worst. In no type of painting is the borderline between art and mere technical skill so delicate and indeterminate as in genre.

The ability to respond first of all to the visual values rather than to the story content of these three types of painting is the first step toward an understanding of the true purpose of the artist.

BATHERS

Artists have always represented the Bathers theme in the perspective provided by their own age. Its aesthetic interest lies entirely in the human body, with no aim—symbolic, mythological, historic, or intellectual—beyond the plastic immediacy of torsos and limbs. If there is any social situation in which human conventions, repressions, vanities, or pretenses must be dropped, it is precisely this one. Unclothed, a human being cannot hide defects or play up natural graces; he must accept himself honestly, or get dressed.

In such scenes the body becomes elemental and takes its place with natural objects—landscape, clouds, water and meadows, trees and rocks. The force of this elemental assimilation is almost irresistible. While Boucher in the eighteenth century still had to borrow a mythological title, "Triumph of Galathea," as an excuse for his bathing scene, the theme emerged so quickly from behind such literary disguises that within the same generation Fragonard could use the simple title "Bathers" for similar scenes.

The artistic problem in all Bathers scenes is the complete and unforced harmony of human bodies and nature, the use of nature as a total presence and not as mere background. When the artist joins all the forms, curving or straight, the movements, colors, light, and atmosphere into a transparent and inevitable unity, we can share almost by empathy some of the sheer primitive joy or release which those depicted must have felt. The least irrelevant story element, a coy situation, a piquant stress on one of the figures, or any psychological characterization would shatter this natural unity of elementals. In an authentic handling of this theme, we see not persons but bodies, no more individualized than waves in the sea or trees in a forest.

Of course, the relationship of these bodies to nature changes from style to style, and from artist to artist. What does not change is the revelation of the essential unity between human bodies and other living and growing creations of nature.

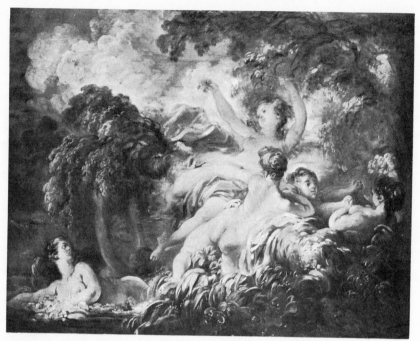

71. JEAN HONORE FRAGONARD: LES BAIGNEUSES. Ca. 1760. *Louvre, Paris*

Fragonard's "Bathers" is as typical of the transition from the Style Louis XV to that of Louis XVI as any exuberantly ornamented chest, table, or interior of the period. This canvas, despite its closeness to contemporaneous products of applied art, is a timeless painting. Here is a complete integration of human figures and landscape. The flowing curves undulate throughout the whole composition and unite all elements in a single aesthetic perception, and the flecks of light and shadow fall with equal vitality on human limbs, blades of grass, and splashed water. Compared with this, the landscapes in Boucher's somewhat earlier canvases, "Bath of Diana" and "Triumph of Venus," are still simply backgrounds against which mythological nudes are posed. In Fragonard's "Les Baigneuses" all the elements, equally alive, are woven together by light and color.

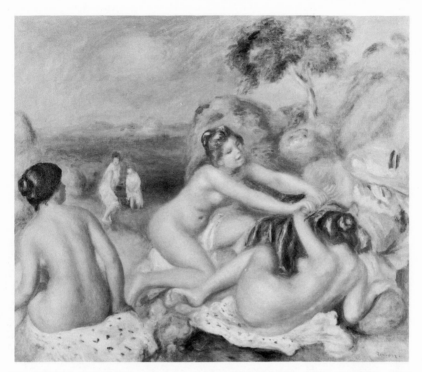

72. PIERRE AUGUSTE RENOIR: LES BAIGNEUSES AUX CRABES. 1885.
Collection of The Cleveland Museum of Art, J. H. Wade Fund, Cleveland, Ohio

Impressionist painting cannot be fully dealt with only in terms of surface, texture, light, and color. Renoir's "Baigneuses aux Crabes" reveals an interest in spatial organization and three-dimensional form that goes much deeper than mere surface. He explored the theme of figures bathing in the open air many times from 1884 on, gradually becoming interested in the language of line in addition to his earlier concentration on color and light. The flowing rhythms of the bodies recall such Venetian Renaissance artists as Giorgione; but the handling of light and the breaking of colors into countless transitional tonal values serve to merge bodies and surrounding nature far more intimately than any sixteenth-century representation had done.

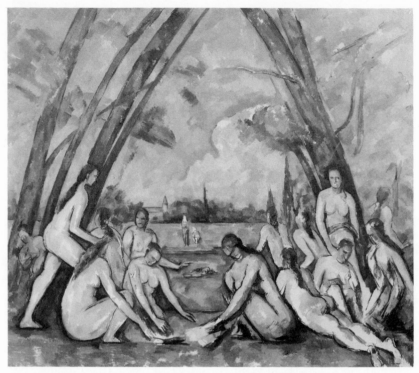

73. PAUL CEZANNE: LES GRANDES BAIGNEUSES. 1898–1906. *Philadelphia Museum of Art, Philadelphia, Pa.*

From 1864 onward, Cézanne created nearly a hundred versions of male and female bathers, mostly group compositions. This version, a major work of his maturest style, on which he is said to have worked about eight years, is an excellent example of postimpressionist tendencies. His preoccupation with structure and volume in space goes so far that he subordinates everything else to it: bodies become elongated, trees follow similar lines of force and bend from each side toward the center of the picture. The colors are cool and thinly laid on, with small portions of the canvas even left uncovered. Compared with Renoir's rich surfaces, Cézanne's work looks almost ascetic, renouncing the sensuous effects of color and light.

74. GEORGES PIERRE SEURAT: UNE BAIGNADE. 1883–84. *National Gallery, Milbank, London*

Seurat brings the variety of nature's organic forms into a neoimpressionist "scientific" scheme, building up precisely outlined areas in parallel planes. In strict obedience to his theories, he reduced the chromatic profusion of the visible world to a mosaic of minute dots of color—a technique called pointillism. The result is a balance between color and form, a tranquil composition with a uniformity of atmosphere that emphasizes the design. His bathers are remote from those of both Cézanne and Renoir—not nudes in nature but city dwellers with realistic indications of their daily lives.

75. PAUL GAUGUIN: BATHERS. 1893. *Collection of Mr. and Mrs. Sam A. Lewisohn, New York*

Gauguin sought in Tahiti that pristine purity of existence which the French symbolists celebrated in their poetry. He expressed this aim in compositions whose chief stylistic quality is a tapestrylike decorativeness that results from indifference to the third dimension. Descriptive details are translated into ornamental design. Large, solid color areas are illuminated by vivid smaller accents. Tropical and serene, his "Bathers" organizes all movement into flat, statuesque poses recalling Sienese and Florentine pictures of the early fifteenth century.

THE PICNIC

The theme of the Picnic bears a superficial resemblance to that of Bathers, even to the occasional presence of nude bodies, yet its artistic intent is exactly the opposite. Instead of assimilating human beings to nature, the Picnic theme draws nature into the sphere of man's social relations. Nature becomes background, almost a stage prop, and the real theme of the painting is the play and counterplay between society and nature, between the dressed and the nude, a typically romantic contrast, by turns idyllic, witty, and symbolic.

Through three centuries this scene with its contrived and sometimes artificial relation between setting and figures has had many interpretations, varying both in design and in emotional tone. The Renaissance approached the subject without coyness or prudery, humanism accepting the body in the natural spirit of ancient paganism, which did not associate mere nudity with libidinous indelicacy. Clearly, when Manet treated the same subject in the nineteenth century, age of the serge suit and cast-iron modesty, a much stronger pictorial discipline was needed to justify the theme as art for his city-bred self-conscious public. As for the eighteenth century, complete nudity was not in itself interesting to this sophisticated period; even in the work of such dissimilar painters as Watteau and Goya the dresses of the women intrigue the eye by leaving more to the imagination.

Regardless of the period in which it was painted, this scene always strikes us as simply transferred from the interior of a house to the outdoors, with the cultured and elegant participants fully aware of the change and apparently enjoying it thoroughly. The figures are surrounded by "nature" or landscapes that are sometimes as artificial as a stage setting. The Picnic theme always rests on the indirect inspiration of art, not on any immediate response to the real world. It is a cultural metaphor, derived from the artistic traditions and social habits of the artist's age, rather than an independent statement of an actual visual experience.

76. GIORGIONE: PASTORAL SYMPHONY. Between 1500 and 1510. *Louvre, Paris*

Although at one time the authorship of this painting was in doubt, it is now attributed to Giorgione and is considered one of his chief works. The picture space recedes in four distinct stages or planes, unified by the typical glowing Venetian atmosphere. The two women in the foreground define the first zone; then come the two elegantly dressed youths debating what music to play next; the shepherd with his flock occupies the middle ground or third plane; and the landscape with ruins draws our eye into the fourth plane. This arrangement influenced the composition of figures in landscape well into the nineteenth century, and with very good reason. It is the first canvas in which a single continuous space seems to envelop all figures and objects in an unforced way: the human figures occupy the same extended space as the trees, hills, clouds, and buildings, and the landscape is no longer a mere backdrop but the farther reach of a space that begins with the objects closest to the spectator. One need only observe how the turning body of the nude at the left pierces the space depth to realize the difference between this treatment and earlier compositions with more primitive front or profile views of the human figure. The members of the group seem unaware of being observed, as if the artist had drawn them without reference to the spectator; by contrast, the figures in similar *quattrocento* compositions always seem extremely "stage-conscious." In the Giorgione canvas, even nudity appears natural and matter-of-fact, one of the noble things to be enjoyed in life, as nature and music.

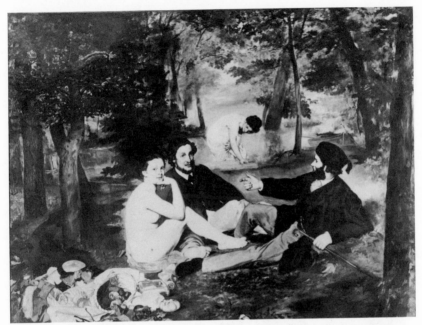

77. EDOUARD MANET: DEJEUNER SUR L'HERBE. 1863. *Louvre, Paris*

Manet's "Déjeuner sur l'herbe" was no doubt inspired in part by Giorgione's composition of nude and clothed figures in the open air, its scheme recalling an engraving after Raphael by Marcantonio. Yet this does not diminish the artistic importance of Manet's work. Dealing with the same problems as had Giorgione, Manet is original in his complete realism, which had not yet developed into full impressionism. Though it was pronounced vulgar by Napoleon III and art critics when it was first exhibited, the picture is no more immodest than Giorgione's, and what probably shocked Manet's contemporaries was not the theme but the freshness and immediacy of its realism. The pyramidal composition, including the half-dressed figure in the background, is almost classical, and the detailed still lifes in the foreground serve to enrich rather than restrain or counteract this effect. The colors are lucid and plain, based on contrasts between the warm flesh tones, the dark clothes of the men, and the silvery blue-green of the background.

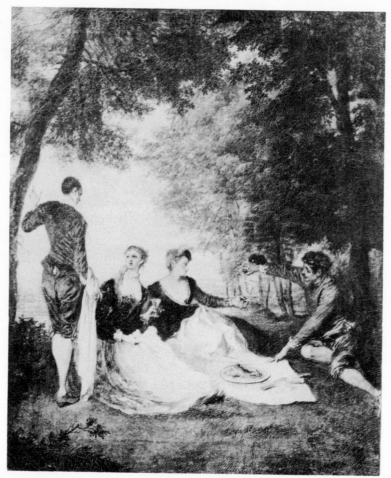

78. ANTOINE WATTEAU: BREAKFAST IN THE WOODS. 1710–16. *Kaiser-Friedrich Museum, Berlin*

Watteau's work mirrors clearly the style of the Regency, that first flowering of eighteenth-century art which was so unlike the accentuated dramatization of the preceding baroque. The free informality of this Breakfast would not have been dignified enough for French or Italian art of the seventeenth century. Even Rubens, the master to whom Watteau owed so much, would never have composed so light and casual a scene. Watteau's forms, though definite and fully stated, are rendered fluid by the lyrical atmosphere, and exhibit the same billowing agitation that enlivens the drapery of the ladies' garments. His subjects—*fêtes champêtres*, serenades, theatrical scenes and mythological episodes—are generally dictated by the prevailing taste of his time, but his distinctive musical colorism is essentially his own.

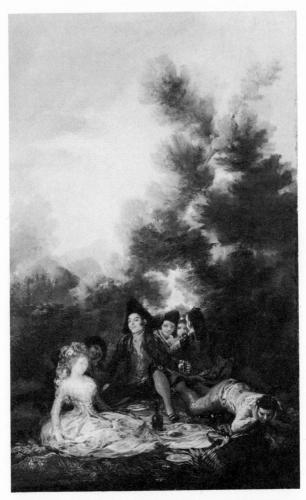

79. FRANCISCO JOSE DE GOYA Y LUCIENTES: THE PICNIC. 1790–99. *National Gallery, London*

Watteau's "Breakfast in the Woods" and Goya's "Picnic," respectively representing in a sense the beginning and the end of eighteenth-century painting, possess a superficial similarity in content and in costume. The differences are, however, far more profound. Watteau's figures are present in the scene simply because they are members of a certain social class, without any special personal relationship.

Goya's characters have conscious attitudes toward one another. Goya's psychological concern is so intense that unlike Watteau, he completely subordinates nature to the human group. Nature simply furnishes the background, vaguely indicated by the bold strokes of an impressionist brush. The same impressionism is evident in costumes, picnic cloth, and other accessories.

CARDPLAYERS

Whether a painting of contemporary life becomes a mere illustration, an anecdotal genre scene, a social message, or a self-sustained work of art depends entirely on the artist's creative powers and not at all on his conscious intentions. Very frequently it succeeds in spite of his intentions. Consider Daumier's oil paintings with their essentially psychological and sometimes satirical aim, the social manifestoes of Millet and Courbet, or the amatory scenes of such an eighteenth-century court painter as Fragonard: these are true works of art which can be enjoyed for their pictorial values apart from the associative interest of their content.

The card-playing scene, a favorite pictorial motif, affords many excellent opportunities to distinguish authentic artistic values from incidental "human interest" values. Here is a group of people gathered around a card table, an occurrence in itself trivial and commonplace. Since we all remember similar scenes, we may be amused if the artist has made one of the players an obvious cheat, or may sympathize with the reactions of the various players, or even feel from the painting "how the game will go," and thus derive the satisfaction that comes from seeing familiar scenes reproduced on canvas. Yet, if the picture is to be more than realistic reportage, we must be able to judge it by a criterion which would still be applicable if we were unfamiliar with card-playing and did not clearly understand what the characters were doing. The criterion is not the behavior of the players or the presence of recognizable details, but the direction of the light, the color mood, the organization of design, and the handling of masses. When these dramatize the scene, a work of art has come into existence. We then become aware that the artist has extracted from a genre scene, quite banal in itself, certain visual potentials that epitomize unforgettably a style of life, a social milieu, and a variety of human beings. Above and beyond any personal experiences or associations, an image of reality, far more intense than the reports we are usually given, has thus been crystallized through art.

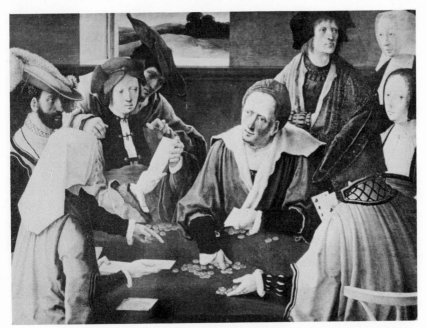

80. LUCAS VAN LEYDEN: THE CARD PARTY. Ca. 1514. *Earl of Pembroke Collection, Wilton House, Salisbury, England*

Lucas van Leyden was the leading exponent of the Renaissance attitude in the Netherlands, much as Dürer was in contemporary Germany. And like Dürer, van Leyden was creative in all the graphic arts. A few of his paintings, such as this "Card Party," mark him as one of the first Dutch artists to become interested in genre. A so-called Romanist, he shows Italian influence in the way he balances his figures; but his individualized cardplayers, varying even in their interest in the game, reveal his deeply rooted Northern realism. Human types are van Leyden's chief study here. Background, interior, and still-life elements—all so conspicuous in later treatments of this same theme—are secondary here.

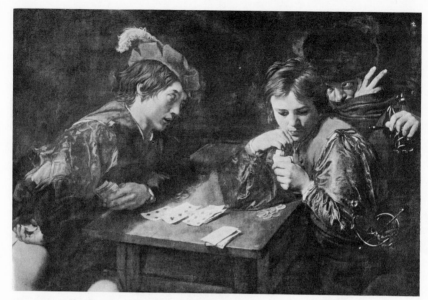

81. MICHELANGELO MERISI DA CARAVAGGIO (?): THE CARDSHARPER.
Ca. 1588. *Staatsgalerie, Dresden*

Genre was a natural theme for Caravaggio, to whom this painting is attributed, because of the baroque realism which he put to dramatic use in his religious scenes (fig. 38), and his telling use of light and shade in characterization. The difference between the art of Italy and that of the Netherlands and the passage of two generations after van Leyden's day show clearly in the treatment of light and space. Where van Leyden arranged his figures in flat, successive layers, Caravaggio knit his into a net of diagonal movements, thus creating a feeling for depth without the help of environmental guideposts. Again, where van Leyden distributed light rather evenly, Caravaggio used it psychologically, as, for example, in the way he cloaked the cardsharper in almost complete darkness.

82. ANTOINE LE NAIN: CARDPLAYERS. First half seventeenth century.
Louvre, Paris

Although the three brothers Le Nain were among the original members of the French Academy, founded in 1635, their style contrasted sharply with the official trend toward the heroic, mythological, and monumental. The naturalism of the brothers showed the influence of contemporaneous Dutch and Spanish art, but their simple peasant figures, scorned as ordinary by other French painters of the day, have a typical French dignity in their solemnly parallel, almost architectural posture, their sharp modeling in light and shade, neutral backgrounds, and absence of anecdotal detail. Even the large scale of the figures, so unlike the contemporaneous Dutch approach, gives a formality to this scene that almost contradicts the complete unpretentiousness of the subject matter.

83. ADRIAEN BROUWER: CARDPLAYERS. 1631–38. *Staatsgalerie, Dresden*

The juxtaposition of Dutch masters of the same period makes it clear that artists of the same nationality and almost the same generation are not necessarily alike in style. Their common style is baroque and Dutch, and their common theme is genre, but otherwise their pictorial approach differs.

The Dutch-born Brouwer first painted under the direct influence of Frans Hals, then moved to Antwerp and came under the influence of the great Flemish school. For Brouwer, a card party was primarily a group of people moving dramatically within a richly tonal atmosphere. A card game, soldiers throwing dice, a peasant brawl—these were occasions for depicting action, for creating people in terms of class rather than individual identity, and for scenes enlivened by high humor and by numberless transitions from luminosity to shade.

84. PIETER DE HOOCH: INTERIOR WITH CARDPLAYERS. 1658. *Her Majesty the Queen's Collection, London*

Pieter de Hooch's interest centers not on the game or the individuals, but on the interior. The card party is an excuse for a highly original visualization of a succession of light-space areas. In other paintings by de Hooch the motif, whether mother and child or mistress and servant, serves the same purpose. His interiors are conceived as sluices admitting floods of light from somewhere in the background or from some external source, and the three dimensions are visualized more convincingly by this streaming radiance than by any linear perspective. The cardplayers thus become mere props in the interpretation of space. Color, generated by the streaming light, is the decisive element in de Hooch's visual statements.

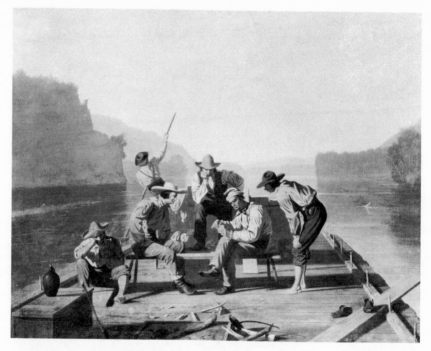

85. GEORGE CALEB BINGHAM: RAFTSMEN PLAYING CARDS. Ca. 1847.
City Art Museum, St. Louis, Mo.

Except for such giants as Géricault and Delacroix, painters of the romantic period were stimulated more by literary ideas and emotional associations than by direct visual experience. Because of their much shorter artistic tradition, American painters gave even greater attention to content than did their European contemporaries. George Caleb Bingham exemplifies this tendency. After brief study in Philadelphia he went to Düsseldorf, where he absorbed the German romantic outlook evident in his later work. In

"Raftsmen Playing Cards," the subject is naturally of primary importance, plainly recognizable as a typical native scene and enjoyed for its details and associations. But closer study reveals that Bingham had more to put down than a mere illustration of a folksy theme. The composition is a carefully balanced pyramidal design, and the converging river banks are used to suggest spatial depth, used, in other words, not merely for documentary background but for independent pictorial effects.

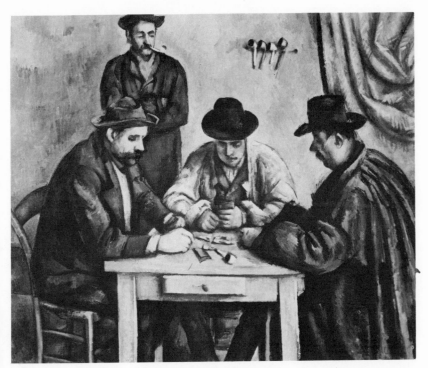

86. PAUL CEZANNE: THE CARDPLAYERS. 1890–92. *Collection Stephen C. Clark, courtesy The Museum of Modern Art, New York*

Cézanne truly wrestled with this theme, painting five versions of it between 1890 and 1892. Three of the versions have two players and another shows four players and an onlooker. In painting "The Bathers" (fig. 73), which he also studied in many versions, he explored the problem of figures in motion in the open air. The problem in "The Cardplayers" is that of relatively static figures within a closed space, though of course the interior itself is not part of the fundamental artistic aim. In treating both themes Cézanne pursued a vision of the human figure as a volume set within a limited space. The cardplayers are not seen as individual characters but as pure presences whose mass arrests the eye; they are made to seem real without the help of realistic descriptive detail. Where the impressionists had organized all the accidents of light and color into a rich surface tapestry, Cézanne organized both objects and human figures into simplified structures of planes and volumes, controlling them with a strict rhythmic design within the area of the canvas. From the strong verticals and horizontals of the table to the row of pipes on the rear wall, not a single element of the picture could be changed without disturbing its perfect formal balance. This impersonal geometry of recognizable objects and figures is the essence of Cézanne's special approach to the visual world.

FEASTS AND REPASTS

A festive repast gives the artist a fine pretext for handling groups of people within the frame of an organized action intensified by a relevant mood. There is no exact borderline between the festive banquet and the private meal. For it is not the simple act of eating that determines the scene, but rather the fact that a number of people have voluntarily gathered about a table in an accepted manner and with an overtone, however faint, of a "ritual." It is this context that relates the artistic problems of paintings as far apart as Chardin's "Saying Grace," the banquet scene on the Bayeux Tapestry, and Veronese's "Feast in the House of Levi."

While all versions of the Last Supper, for example, are necessarily shaped by its religious import, there are a great many Biblical festivals and repasts in which the sacred content merely provides a justification for painting a celebrational meal.

Compositional principles differ from age to age, but they are not the only factors modifying the appearance of this scene in art. Social customs and table arrangements play an equal part. It must be remembered, for example, that in ancient Rome the diners reclined on couches; that during the Middle Ages or at least until the late Gothic period chairs were scarcely used; that over the greater part of the earth today most people eat squatting; and that the common table is not even known in some cultures. Knives and forks are comparatively recent inventions, and a medieval manual of table manners found it necessary to suggest that the "gentle knight" must place the salt on his roast and not his roast in the salt dish. Table manners, quantity and quality of food, its preparation and style of service—all these are powerful elements determining the visual materials with which the artist must work to organize a communion of food-taking. As a theme, the feast or ritual meal reveals simultaneously a style in painting and a style in living.

Many artists use this topic as an excuse for arranging a still life on the table— sometimes so vividly that the diners themselves are overshadowed. Again it may be the accessories or interiors of dining rooms, banquet halls, or humble kitchens, or even little "sideshows" of servants and subordinate characters, that become the focus. But whatever the pictorial center of interest, this theme in all its variations is essentially life at one of its most simple but most truly human levels.

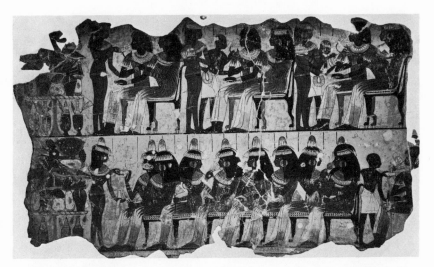

87. EGYPTIAN MURAL: FESTIVAL SCENE. *From the tomb of Amenemheb at Thebes.* Ca. 1500 B.C. *British Museum, London*

Since Egyptian painting is essentially narrative, with no attempt at space illusion, a story is unfolded in successive rows on a single plane. Exalted personages and their attendants are shown in the traditional Egyptian manner, in a combination of profile and frontal views. Such elements as the contours of vessels and the folds of dresses are handled with surprising freshness and realism. Aiming at clarity of narrative rather than illusion, such scenes as this, presented in continuous strips with rhythmically repeated motifs, satisfied the Egyptian love of order and sense of the static quality of existence.

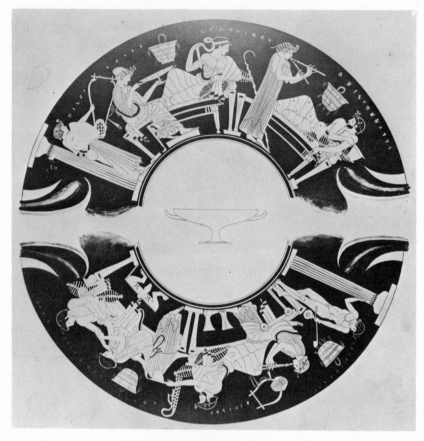

88. THE BRYGOS PAINTER: SYMPOSIUM. *From an Attic red-figured kylix.*
Ca. 480 B.C. *British Museum, London*

The theme of a festive gathering was a favorite in decorating this type of vase, for the vessel could be admired for its pictures even as it was being lifted during the feast. Body gestures, drapery and other accessories are vividly outlined, and a well-balanced pattern joins the figures of the guests, musicians, and handsome youths with the horizontals of the couches and verticals of the columns. In the late archaic style that characterizes the more than one hundred extant vases attributed to this master, highly realistic figures, moving freely in space, capture completely the animation of such a scene as this one.

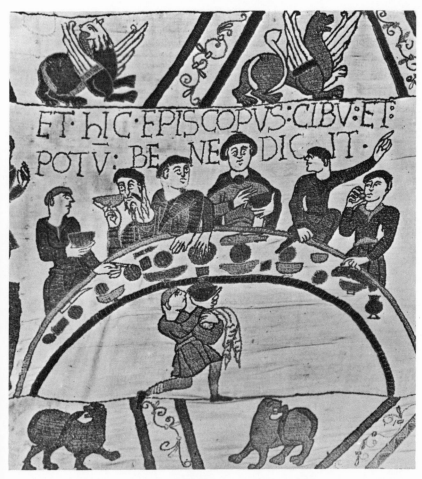

89. THE BAYEUX TAPESTRY: FEASTING OF THE BISHOP. End of eleventh century. *Library, Bayeux*

"And here the Bishop blessed the food and drink." The Bayeux Tapestry, a linen strip 231 feet long and 20 inches wide, and probably the most famous piece of embroidery in the world, presents the conquest of England in seventy-two scenes, almost in comic-strip manner. Eight colors are used in a style inspired by the Romanesque book illumination of the period. Despite the lack of perspective and anatomy, the aim here is real-istic. The horseshoe table setting follows ancient custom, the diners being served from the inner curve. Unlike the way the limited space of illuminated manuscripts brought different pictorial elements together, the large scale of the tapestry permits figures and background elements to remain isolated. Yet there is much freedom of movement and vivid expression here.

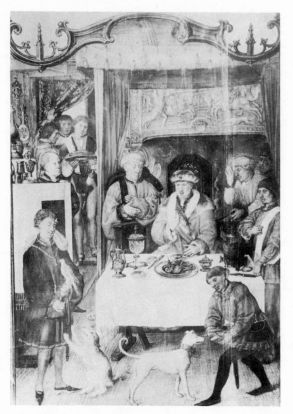

90. FLEMISH SCHOOL: FEASTING (MONTH OF JANUARY). *From the Grimani Breviary.* Ca. 1500. *Biblioteca Marciana, Venice*

The *Grimani Breviary,* a book containing the Divine Church Office for each day, is a very late masterpiece of Flemish illumination. Its illustrations for each month follow closely the famous Book of Hours, *Les Très Riches Heures du Duc de Berry* (see fig. 151). In both, the January scene is devoted to feasting, the prince sits at table with his courtiers, and even the dog hovering near by is duplicated. The composition reveals the freedom already achieved by fifteenth-century Flemish art, the anonymous artist combining Renaissance realism of characterization with the traditional atmosphere of illuminations. The carefully detailed accessories do not detract from the individuality of the figures; and the broadly festive mood emanates as effectively from this small page as from any larger painting or mural of the time.

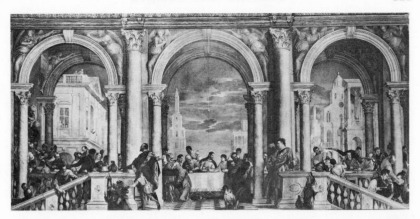

91. PAOLO VERONESE: FEAST IN THE HOUSE OF LEVI. 1573. *Accademia, Venice*

Last of the great Venetian Renaissance masters, Veronese became pre-eminently the painter of banquets and grand feasts. He delighted in showing men in their most self-indulgent and convivial moments. Biblical themes were simply pretexts for describing splendid repasts and moments of worldly epicureanism. This was true whether the painting was "The Marriage at Cana," "Feast·at the House of Simon," or "The Last Supper." This "Feast in the House of Levi," based on the story of the publican who was honored by the Lord's presence at his table, is an immense canvas, more than forty feet long, and was commissioned for the refectory of San Giovanni e Paolo in Venice. The figure of the Lord is almost centered within the rich architectural frame, but it seems deprived of its importance by other figures on the canvas. Rich color accents and varied grouping, spread over the whole canvas, keep the eye from fixing on the sacred presence. Servants in the foreground and pages on the grand staircases add to the feeling of brisk activity. This vast picture, coherent and well balanced despite its divergent centers of interest, is a perfect example of late Venetian Renaissance vision: space unified by an architectural frame, and a fine balancing of brilliant colors.

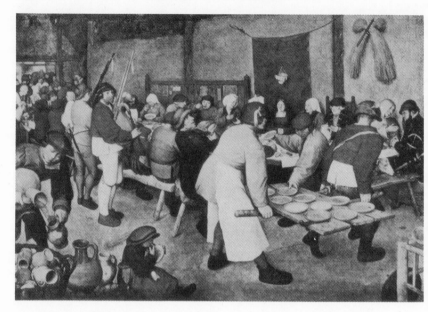

92. PIETER BREUGHEL THE ELDER: WEDDING FEAST. Ca. 1568. *Kunsthistorisches Museum, Vienna*

The Dutch-born Pieter Breughel studied and worked in Antwerp and Brussels, and his work belongs actually to Flemish art. Like all early baroque painting in the North, it shows the influence of Italian organization. But the really vital element is Breughel's unique personality, which lent original force to everything he painted, whether allegory, scenes from life, or Biblical episodes (fig. 68). The peasant types he made famous were more than mere representatives of a social group, for he saw and rendered them as the types of all humanity. In the painting reproduced here can be found the same kind of emotional forces that appear in more pretentious and elegant festival scenes painted in other times and places. The foreground figures are brought very close to the beholder's eye and the diagonally placed table sweeps back in an abrupt foreshortening that violently alters the scale of the carousing guests—an enlivening device characteristic of Breughel's mature period. The thronging motifs are unified by the emphatic perspective and the dramatic distribution of colors, especially the accentuated red.

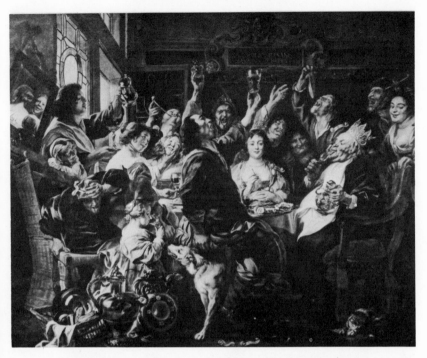

93. JACOB JORDAENS: THE KING DRINKS. 1654–56. *Kunsthistorisches Museum, Vienna*

Two influences modified the work of the Flemish painter Jacob Jordaens: first, that of Caravaggio, especially the latter's fondness for genre motifs, for dark shadows underscoring areas of light, and for overdramatized characterization; and second, that of his contemporary and fellow countryman, Rubens. Although his work is thematically more limited and less aristocratic than Rubens', he too epitomizes Northern baroque art. He never tired of describing the rich Flemish burghers at their holiday feasts. In this "Beanfeast" on Epiphany, the mock-king confers mock-rank on each guest. Though Jordaens packs into a cramped space the whole spirit of such a festival, from Dionysian revelry to the simple relieving of bodily needs, he finds room for the play of each guest's individuality. But the artistic impact of this picture depends less on the descriptive detail than on the general mood conveyed by vibrant contours against a clearly organized background, radiant color, and scintillating whirls of light.

94. FRANÇOIS BOUCHER: THE BREAKFAST. 1739. *Louvre, Paris*

Boucher devoted himself to pleasing the society of the French rococo period with amorous scenes, pastorales, allegories, and mythological episodes. Even when he condescended to do such a modest scene as this, his rococo spirit shone forth even more strongly by contrast with his unpretentious subject. There is scarcely a tranquil line in this group portrait. All the elements are transformed into dynamic events, projected in curves that rise and fall, whirling us into the depths of the chamber. The gestures of the adults cut diagonally across one another. The glances of one lady and the servant are countered by those of the child and mother in the foreground. Highlights and reflections pierce the unity of every area. Window frames and door are accented too strongly to be ignored, and their verticals and horizontals heighten the linear excitement of the scene. The result is that an informal breakfast becomes fashionably ceremonious. Here is the lavish rococo imagination restrained by charming and calculated composition.

95. JEAN BAPTISTE SIMEON CHARDIN: SAYING GRACE. 1740. *Louvre, Paris*

Chardin painted this picture only one year after Boucher executed "The Breakfast," yet there is no trace of rococo in its conception. Where Boucher indulged in curves and exciting patterns, Chardin simplified both design and individual forms so completely that he achieved monumentality even within the limits of a small canvas. Boucher's picture dances with separate spots of color; in Chardin's picture the colors are fused by a tonal harmony. Unlike the irregular sparkle of Boucher, the light here issues glowingly from one source and dwindles gradually as it permeates the room. Boucher cannot seem to describe enough ornamental details; Chardin is content with subtly unveiling a few elementary forms. His work is directly in the tradition of Dutch seventeenth-century interiors and genre, continuing the vision of a Pieter de Hooch (figs. 84 and 192) and a Vermeer van Delft (figs. 199 and 205). It is the choice of colors rather than the way they are handled which reminds us that Chardin belonged after all to the eighteenth century and to France. His distance from Boucher is, however, sociologically as well as visually great, for his art belongs to the *tiers état,* the world of the working people, rather than to the microcosm of court and château. Boucher's meal is a social function; Chardin's a scene of genuine unselfconscious home life. Stylistically Chardin was as much an isolated phenomenon in the eighteenth century as Rembrandt in the seventeenth or Breughel in the sixteenth.

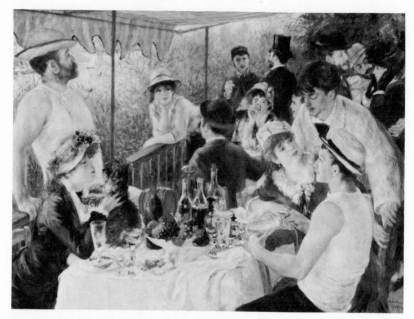

96. PIERRE AUGUSTE RENOIR: LE DEJEUNER DES CANOTIERS (LUNCH-EON OF THE BOATING PARTY). 1881. *The Phillips Gallery, Washington, D.C.*

This picture, like Manet's "Déjeuner sur l'herbe" (fig. 77), reveals the artist's delight in the beauty of women, in nature and the good things of life, as well as his intense interest in color and light, surface, texture, and atmosphere. What seems like a casual arrangement of a group is actually a very well-planned composition. The large figures in the left foreground are balanced by the group of three on the right, and the still life acts as a centering element, its function emphasized by the upright figure and the iron post beyond. The boundaries of the canvas cut through some of the figures, which prevents any feeling of a static frame and increases the impression that the scene is a passing moment captured as if by accident. The eye is carried backward by the curving rail, the awning, and the array of overlapping figures in the background. All structural elements are enveloped in a sun-mellowed atmosphere. Nature, the still life, the human figures—many of which are actual portraits, including the woman at the left, Renoir's future wife—all melt into a pictorial unit of triumphant vivacity.

Portraiture

THE INDIVIDUAL PORTRAIT

Among pictorial themes, the portrait reveals the trends of its time most intimately and explicitly. The period, after all, does not affect the subject matter of landscapes, nudes, still lifes, or religious paintings, and it is the artist primarily who adapts their appearance to the aesthetic standards of his own day.

But it is quite otherwise with portraiture. Here the theme is the sitter, necessarily a contemporary of the artist and like him a child of the age. The sitter's face and carriage, gestures, and taste in dress are dictated entirely by his milieu, and therefore express that milieu more explicitly than a landscape does and with more complexity than a figure composition or still life. This is true of all portraiture, whether it be the carefully amassed detail of a work by Hans Holbein or the swift, almost impressionistic strokes and striking presence of one by Frans Hals. Each sitter reflects the social style of his time, and that is the only style in which he can present himself to the artist. Clearly, then, a portrait is twice rooted in its time—through the artist and through the sitter who is its theme.

In considering some of the problems peculiar to portraiture, it should be remembered that the idea of resemblance is not always the same for the artist and for the layman. The layman frequently thinks of resemblance in a literal way, as signifying an exact reproduction of feature and outline. The artist thinks of it as the essential quality of the sitter: either a summation of his entire character in all its complexity, or an emphasis on one or more traits that dominate his personality. To convey this resemblance, this condensed biography, the artist may omit attractive but unimportant details or call attention to weaknesses which the sitter might prefer to have glossed over. Since most portraits are commissioned, the artist is always wrestling with the vanity, moods, and financial arrogance of the subject, striving to reduce these nonartistic influences to a minimum.

Though they differ in aesthetic means and the conventions of realism they use, the aims of the great portraits have been alike in three respects: descriptive resemblance to the sitter, psychological insight, and, as in all art works, pictorial and plastic coherence. The emphasis shifts with each style period from one to another of these concerns, and within the period there are always

127

as many solutions to a portrait as there are individual artists who possess a feeling for human beings.

Descriptive Resemblance. The question of photographic likeness does not apply to a work of art, even to the most realistic, and for very good reasons. For one thing, the camera does not "see"; it merely records or registers. The lens has no subjective or changing responses to what it sees, and the camera mechanism is not a living agent like the human hand.

The eye, however, both sees and perceives, and perception instantly brings about selection according to private associations, imaginativeness, and special sensibilities. A selective image results from these responses, and the image is transmitted to panel, canvas, stone, or marble by a hand that unconsciously uses a whole manual of graphic signatures and markings. Brushstrokes, lines, and chisel marks are peculiar to each artist, and are an essential quality in the finished work, quite apart from theme and treatment. The camera has no such quality, allowing only a limited exploration of color, line, and texture. The process of retouching is precisely an effort to impart some flexibility and artistic "life" to the record of the lens. Obviously a photograph, even a good one, can never be compared with a portrait for resemblance. A photograph may record an unlimited number of physical facts about its subject without necessarily producing a meaningful interpretation; a portrait can project a total personality by means of half a dozen selected traits. Because a portrait distills the essence of a man, we feel that such portraits must "resemble" the originals, that portraits by Titian, Holbein, and Rembrandt have so much character of their own that they must have had their source in real and unmistakable persons.

Psychological Insight. The novelist sets forth his characters in two ways, by direct comment upon them, or indirectly by reporting their actions and behavior and letting the report speak for itself. The portraitist uses the latter method only, translating everything into purely visual and self-sufficient terms. His problem is to fuse into a single unambiguous statement what he sees of a man and what he understands of him. The greater his selective faculty and power of communication the keener will be his portrait. Facial expressions and body gestures are a living language which we all have learned to read as a clue to, and use as a revelation of, character. A keen portraitist has a flair for this wordless language of the face, and simply by reporting the visible quantity of the body-soul equation he can give us insight into the hidden psychological quantity. Agreeing that the face talks, we tacitly accept a psychosomatic relationship between character and physiognomy. The portraitist may reanimate a facial structure partly broken down by age, revive colors that time has obliterated, or even add background or props to clarify his interpretation. By so doing he can point up qualities which the casual spectator has missed or

failed to appreciate. In this as in other things, most of us see stereotypes where a genuine artist perceives the individual. In fact, he may often have and transmit insights beyond his conscious intellectual powers, as children, without intellectual reflection at all, can often read the faces of adults.

Pictorial and Plastic Coherence. The primary organization of design, color, spatial clarity, and texture is as vital for the portrait as for any other theme. It must obviously use its medium in purely sensuous terms in order to create a picture at all, else it will fail to convey the descriptive and psychological content of its theme.

It need hardly be emphasized that ways of integrating art and information in portraiture change radically from age to age, following closely the development in all other fields of art. That is, style rules the evolution of portraiture as completely as that of landscape, group composition, or any conceivable aesthetic form. A quick comparison of portraits of different times makes it clear that each period, each generation in fact, evolves a new conception of portraiture. Each generation evolves its own image of a human being, literally creating its own "face," and this face is mirrored in masterpieces of portraiture, popular illustrations, posters, and advertisements—though on entirely different levels.

Modern portraiture first appeared unobtrusively in the form of the sponsor's and/or the *assistenza* portrait, where the sitter was introduced as a subordinate figure in religious scenes, a sort of "extra" in the group surrounding the main figures, or merely as a bystander looking at the action or kneeling near by. The bystander appeared in both Italian and Northern art. Not until near the middle of the fifteenth century were individuals painted by themselves, with no aim but that of recording a personality. These studies were realistic, since descriptive resemblance was an initial function of the portrait.

Once the portrait was established as an independent form, its development was subjected to general changes in style in two ways: in its visual conception as a work of art, and psychologically as a document of the ever-varying approach to the human personality.

97. EGYPTIAN MUMMY PORTRAIT.
From El Faiyum. Second century A.D.
The Metropolitan Museum of Art, New York

The Byzantine mosaics in their flat two-dimensionality excluded all illusions of space and reality; although faces could be individualized, bodies and gestures were rigid and conventionalized. In these San Vitale mosaics, the Emperor Justinian, sponsor of the church, his Empress Theodora, and their retinue are characterized with a psychological acuteness that is not diminished by the translation from three-dimensional reality into a two-dimensional design.

Egypt, in the final centuries of the pre-Christian era, was penetrated by foreign influences. After Egypt became a Roman province, the naturalism of Hellenistic art permeated all of Egyptian art. Thus this mummy portrait, used to cover the face of a mummy, is an example of Hellenistic Roman portraiture at its most naturalistic. Every device of modern portraiture, and especially an almost impressionistic immediacy of light and color, appears in this painting.

The illuminations in the Codex Manesse, a collection of poems by German minnesingers, have only a tenuous connection with the poetry. The miniatures are not really illustrations of the text, nor are the portraits of the kings, nobles, and minnesingers true likenesses. The portrait of Emperor Heinrich does not even attempt to reproduce an individual face, but represents merely the generic type of royalty. Dating from the end of the Middle Ages, it demonstrates the extent to which medieval unworldliness had rejected the Roman naturalistic conception of individuality.

98. BYZANTINE MOSAIC: EMPRESS THEODORA OFFERING GIFTS. 547 A.D.
San Vitale, Ravenna

99. SOUTH-GERMAN SCHOOL: EMPEROR HEINRICH. *From the Codex Manesse.* Ca. 1315–40. *University Library, Heidelberg*

100. MASACCIO: TRINITY. 1426–27. *Santa Maria Novella, Florence*

In this mural by Masaccio, the human figure, shown in life size, is integrated with the surrounding architecture for the first time in postmedieval painting. (It is still an open question whether the architecture was painted by Masaccio under the influence of his friend, the great architect Filippo Brunelleschi, or by

MASACCIO. Detail from TRINITY

the latter himself.) Masaccio attempts to atone for the presence of the sponsors in the sacred scene by showing them in somewhat smaller scale, and as kneeling outside the vault. The relationship between the figures is made still more explicit by the fact that the man gazes at St. John, the woman at the Virgin Mary.

Giotto had already introduced the so-called *assistenza* portrait, in which the artist depicted his contemporaries among the bystanders in religious paintings, but it was Masaccio's scheme for setting apart the figure of the sponsor that actually initiated portraiture as a legitimate and independent branch of painting.

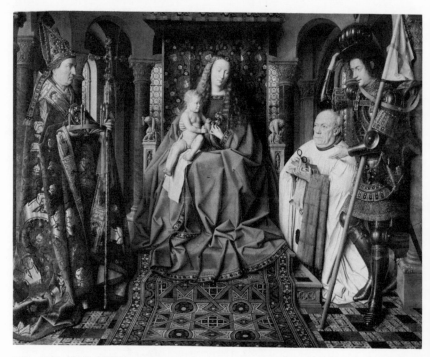

101. JAN VAN EYCK: MADONNA OF CANON GEORG VAN DER PAELE.
1436. *City Museum, Bruges*

A comparison of this work with a fresco of the same period, Masaccio's "Trinity," clarifies the difference in style between the Italian early Renaissance and the new epoch in the North. Masaccio aims at a clear spatial order within which the sacred and the profane figures are grouped on appropriate levels. Van Eyck attempts here, as in his "Madonna of the Chancellor Rolin," to achieve naturalism in every detail. He works with equal intensity on figures and inanimate objects, on the Virgin's face and the shining suit of armor, on the mortal sponsor and the sacred personages. This explains why there is no difference in scale between

JAN VAN EYCK: Detail from MADONNA

the human and the divine figures in the picture. Van Eyck places the sponsor, Canon Georg van der Paele, in the very middle of the sacred group; St. George, the canon's patron saint, stands beside him, and directly opposite stands the patron saint of the church for which the canon commissioned this painting. Since all the figures are thus on the same level, the portrait itself, in all its unmitigated realism, comes close to being the center of attention. The feeling that distance and subordination should separate the human from the divine, a medieval concept that still operated in such paintings as Masaccio's "Trinity," has here given way to an increasing respect for purely human existence.

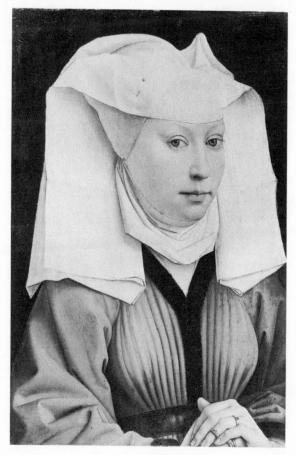

102. ROGIER VAN DER WEYDEN: PORTRAIT OF A YOUNG WOMAN.
Ca. 1435. *Kaiser-Friedrich Museum, Berlin*

Where an Italian painter might have felt free to subordinate some of the sitter's qualities for the sake of an over-all pattern or effect, the Flemish artist here assumes that his first pictorial obligation is to reality. He carefully builds up form upon form, attends meticulously to each detail, and faithfully develops individual characterization and the illusion of space.

Though the background is neutral, Rogier suggests space by turning the sitter slightly to one side, and adds further to the plastic effect by the subtle shading of colors. Though full freedom of gesture has not yet been achieved, the emotionally charged glance which the young woman turns toward the spectator more than makes up for her confined posture.

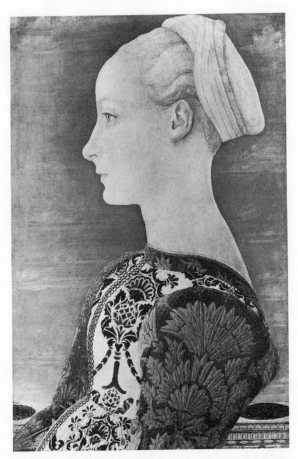

103. PIERO POLLAIUOLO: PORTRAIT OF A YOUNG LADY. Mid-fifteenth century. *Kaiser-Friedrich Museum, Berlin*

The first independent portraits, developing out of the *assistenza* or bystander portraits, appear early in the fifteenth century. Most of them show profile views. In this example (previously attributed to Domenico Veneziano), the artist uses a typically Florentine, precise linear description, both for the profile and for such ornamental details as cloth and jewelry. The empty areas of sky and ground throw the contours of the head into strong relief, and the pellucid colors of sky, hair, and face serve to accentuate the more vigorous colors of the young woman's garments. The artist treats the dress itself as a decorative pattern, without attempting to suggest the plastic form of the body beneath. Since the painter's primary aim is to design an ornamental panel composed of sky, face, and garment, it is not surprising that he seems to compress the whole figure within an invisible frame and makes no attempt to relate it to any particular environment.

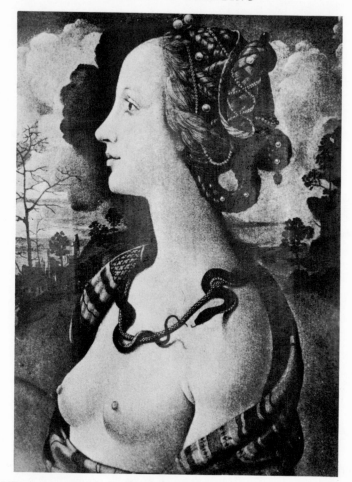

104. PIERO DI COSIMO: SIMONETTA VESPUCCI. 1500 to 1510. *Musée Condé, Chantilly*

In this portrait of Guiliano de Medici's mistress, whom Botticelli also painted, Piero di Cosimo reveals a wholly new approach—one in which the emphasis is on mood. Painted after Simonetta's death from consumption, its elegiac grief permeates the very landscape. The contour of the head is repeated in the darkening cloud, and the only touch of color in the somber scheme is the symbolic snake. In addition to having absorbed Venetian and Flemish influences, Piero di Cosimo was evidently influenced by Leonardo's handling of light.

105. LEONARDO DA VINCI: MONA LISA. Before 1505. *Louvre, Paris*

The Mona Lisa, supreme expression of Leonardo's psychological insight, shows a pyramidal design which is typical of the High Renaissance. It gives both freedom and weight to the figure's fluid contours. The landscape, more of a tapestry than an enveloping space, echoes the lines of the head. Leonardo's characteristic lighting with its mellow transitions—*sfumato*—integrates figure and background. Perfection of form, subtle characterization, and a uniform coloristic visual tonality here combine to create a painting unique in the history of portraiture.

106. LUCA SIGNORELLI: PORTRAIT OF AN ELDERLY MAN. Ca. 1500.
Kaiser-Friedrich Museum, Berlin

The Umbrian painter Signorelli is best known for large panels of mythological and religious themes and for such monumental murals as the ones in Orvieto and in the Sistine Chapel. Concern for structure and clear form is equally evident in both his portraits and his murals. Signorelli combines precise *quattrocento* drafts-manship with the freedom and breadth of design characteristic of the latter part of the century. The ancient architecture in the mythological background scene indicates the sitter's humanist interests. The face is done in a detailed naturalism that contrasts quaintly with the monumentally formal background.

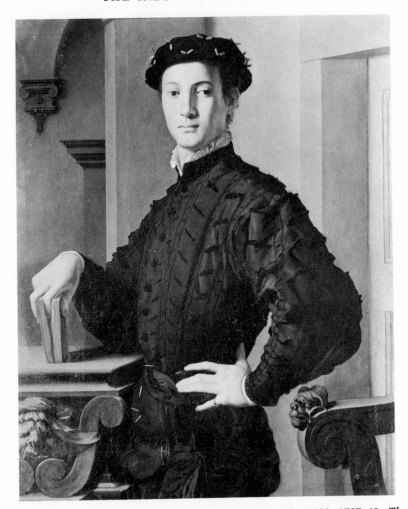

107. ANGELO BRONZINO: PORTRAIT OF A YOUNG MAN. 1535–40. *The Metropolitan Museum of Art, New York*

Bronzino, who was a poet and courtier as well as a painter, was as much at home in religious painting as in portraiture. The latter, with its emphasis on the social position of the sitters, best exemplifies his individual style and mannerist tendencies. As in this portrait, Bronzino favored the three-quarter length figure, which enabled him to give his subjects an imposing air and aristocratic bearing. The strong verticals help to create a firm background pattern. His fine gentlemen never betray emotion or indulge in casual movement, and only occasionally does a special attribute reveal some scholarly inclination or a devotion to the arts. Bronzino's elegant portraits are redeemed from superficiality only by the mannerist refinement of contour and detail.

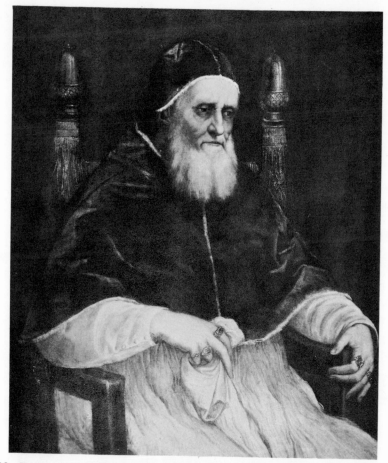

108 RAPHAEL SANZIO, ATTRIBUTED TO: POPE JULIUS II. 1510-12. *Uffizi, Florence*

Raphael, Titian, El Greco, and Velásquez are such superb masters of painting that a juxtaposing of their works on similar subjects should reveal their own individuality rather than the differences between their periods. Yet the four portraits actually do both, speaking as eloquently of the trends of various periods as of the special genius of each artist. The subjects, three popes and a cardinal, are all in similar poses, all seated on thronelike chairs. Raphael's portrait of Pope Julius II is dominated by the usual Renaissance scheme: the vertical of the head topping a basic triangle within the frame of the two posts. Lines are simplified, and all curves—as, for example, in the lower edge of the papal cape—are fluidly continuous. The pope sits in concentrated thought, his glance directed at nothing in particular, his closed mouth and fist expressing 'errific energy barely controlled. The simple forms give momentous scale to this vigorous personality.

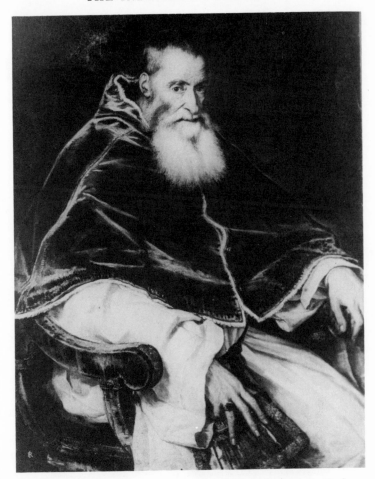

109. TITIAN: POPE PAUL III. 1543. *National Museum, Naples*

At first glance Titian's portrait of Pope Paul III appears to be almost identical in approach, but the differences that stem from time and place—more than thirty years later, and Venice instead of Rome—become evident in the greater tension of design, and especially in the richness of the color scheme. Titian has caught a momentary gesture: the pope is not relaxed and "sitting for a portrait," but has just turned to fix his penetrating stare on the beholder. The papal cape, which Raphael used as a simple base for the powerful head of his subject, interests Titian as an area for the exploration of light, color, and textural effects. Where Raphael's lines were tranquil and continuous, Titian's lines are active and broken, increasing the feeling of transiency. This portrait marks the end of the High Renaissance in Venice and already looks toward the baroque style.

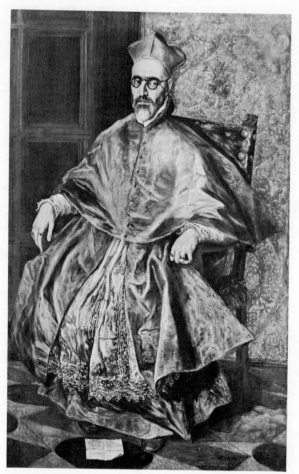

110. EL GRECO (DOMENICO THEOTOCOPULI): CARDINAL DON FERNANDO NINO DE GUEVARA. Ca. 1600. *The Metropolitan Museum of Art, New York*

El Greco's full-length portrait of the cardinal shows the changes in style that had taken place since Titian's day. The restlessness of line and surface which distinguished Titian's Renaissance scheme from Raphael's has here become an aesthetic language which a whole period has learned to speak. Though the cardinal's face looks calm, it suggests the pent-up force of a tightly coiled spring.

Tension molds every element in the picture, as, for example, in the contrast between both sides of the background or between the burnished fabrics and flaming brocades and the creamy white lace. Though Raphael's ideal triangular scheme still persists, it has changed considerably and now shares attention with other forms and relationships; and the whole darkly iridescent portrait is rich with a

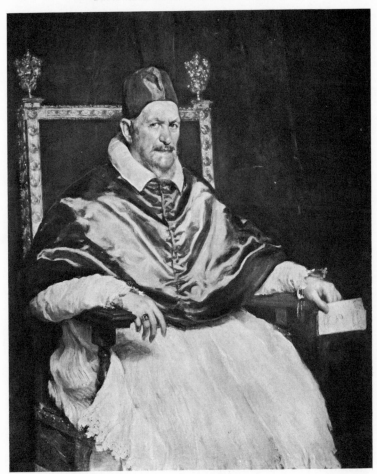

111. DIEGO RODRIGUEZ DE SILVA Y VELASQUEZ: POPE INNOCENT X.
1650. *Galleria Doria, Rome*

fusion of Venetian, Byzantine, and Spanish influences. Whether we call it mannerist or baroque, this El Greco canvas brings to painting a quality which makes even Titian's portrait appear calm by comparison.

Velásquez' picture of Pope Innocent X, often declared the greatest portrait in European art, conveys directly to the modern eye the impact of a great personality. It is the product of Velásquez' broadest and maturest manner. The whole picture is built up with numberless gradations of light, outlines are secondary, and cascades of color substitute for concretely defined forms. Unlike the other three, this portrait leaves no psychic or pictorial distance between the subject and the onlooker; least statuesque of them all, it uses every baroque device to convey a keen and living presence.

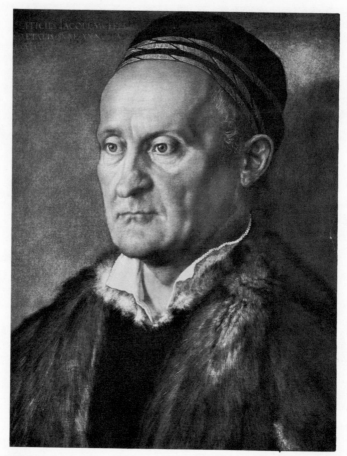

112. ALBRECHT DURER: PORTRAIT OF JAKOB MUFFEL. 1526. *Kaiser-Friedrich Museum, Berlin*

German portraiture came into its own rather late because German life, unlike that of the Italians and Flemish, did not push the individual personality into the limelight. Yet in the paintings by Dürer and Holbein, Germany contributed some of the greatest portraits of sixteenth-century art. In his last and most mature period, Dürer painted three outstanding male portraits which reveal his extraor-dinary flair for defining character through visual means. Without help from a quali-fying background, the head in this study of Jakob Muffel is modeled with the in-tensity of late Gothic sculpture. Unlike Holbein, who diffused light evenly over the face, Dürer molds features with strong contrasts of light and shadow, achieving the utmost firmness and clarity in detail and in encompassing form.

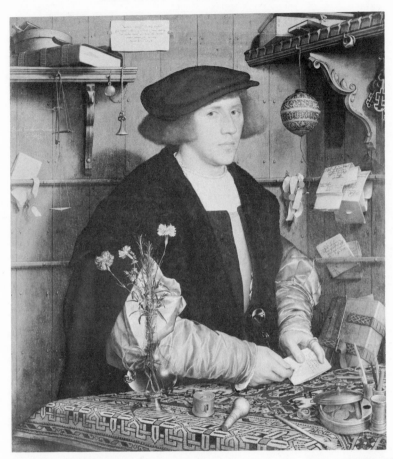

113. HANS HOLBEIN THE YOUNGER: PORTRAIT OF THE MERCHANT
GEORGE GISZE. 1532. *Kaiser-Friedrich Museum, Berlin*

Holbein's picture of the merchant Gisze is an outstanding example of the so-called professional portrait, which came into favor at about this time: the subject is set in his professional or commercial environment and surrounded by the implements of his occupation. All details, whether professional paraphernalia or such ordinary objects as flowers, rugs, and chairs, are here rendered with a fidelity and precision that goes back to the Flemish origins of Northern painting in the early fifteenth century. Yet the human qualities are no less important and give the panel a convincing unity of meaning and form. This portrait was painted during Holbein's second stay in London (1532–1543), where he later became court painter to Henry VIII. His earlier restraint and Gothic narrowness had by this time been modified by the broader concepts spread by the Renaissance. In this portrait Italian and Flemish influences combine with Holbein's inherited German approach, which is primarily that of the craftsman in line.

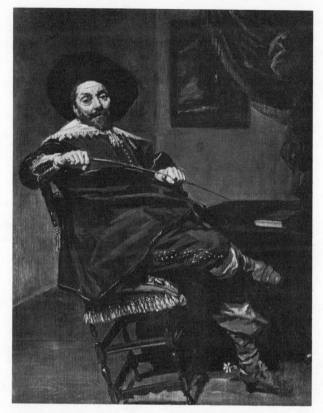

114. FRANS HALS: WILLEM VAN HUYTHUYSEN. Ca. 1637. *Royal Museum of Fine Arts, Brussels*

In many portraits by Hals the swiftness of the stroke and the transitory character of the gesture so overshadow the subject's individual quality that the pictures verge on genre. His broad, loose brush anticipates somewhat the technique of nineteenth-century impressionism. The fundamentally baroque organization is supported by the diagonal placing of the figure, the distribution of volumes, the interrupted outline, and the accents of light and shadow. The sparkling zest with which Hals invested this gentleman, whom he painted three times, makes the subject less an individual than a type.

115. SIR ANTHONY VAN DYCK: MARCHESA ELENA GRIMALDI, WIFE OF MARCHESE NICOLA CATTANEO. Ca. 1623. *Widener Collection, National Gallery of Art, Washington, D.C.*

Van Dyck, a disciple and later a companion of Rubens, brought to perfection the type of portrait which came into demand in European society in the seventeenth century and remained popular at least to the time of Sargent. Van Dyck became court painter to Charles I, and without his influence the great English portraits of the eighteenth century are unthinkable. During his six years of study in Italy, he assimilated the highly cultivated visual traditions of the Mediterranean, blending them with the more tempestuous tendencies of Rubens. Out of this fusion he created a portraiture that made his subjects appear both impressive and elegant, for he gave individual character and social position equal emphasis. "Marchesa Elena Grimaldi," painted about 1623 in the city of Genoa, naturally reflects the prevailing Italian ideas of *grandezza* and *noblezza*. The architectural verticals, the graceful gesture of the Negro page holding the protecting parasol—the red of which forms a kind of worldly halo—the landscape, and even the clouds, are all designed to impress upon us the exalted position of the subject. In the same way, the dominating black of her gown serves to underscore the patrician refinement of her face and hand.

116. SIR JOSHUA REYNOLDS: SARAH SIDDONS AS TRAGIC MUSE. 1784.
Henry E. Huntington Library and Art Gallery, San Marino, Calif.

Although English art in the eighteenth century was stylistically limited, its range, at least in portraiture, can be seen from these two paintings of Sarah Siddons, the famous British actress. Reynolds, first president of the Royal Academy of Arts and author of a treatise on painting, *Discourses*, portrayed Mrs. Siddons in the grand manner, as a heroic and somewhat theatrical Tragic Muse. In all his historical themes and portraits Reynolds eclectically combined qualities from the great Italian painters with those of Flemish and Dutch masters. The pose in this portrait is stimulated by that of Michelangelo's Isaiah in the Sistine Chapel ceiling.

117. THOMAS GAINSBOROUGH: MRS. SIDDONS. 1784. *National Gallery, London*

Gainsborough, painter of the famous "Blue Boy," gives us Mrs. Siddons as a fashionable lady of society, natural and wholly at ease, almost in the spirit of Van Dyck. The textures of fabrics, furs, and feathers are translated into colors and lusters that seem a fitting frame for the intelligence and nobility of the actress's countenance. This unassuming portrait with its still-life elements strikes the eye as far more eloquent than Reynolds' pretentious work, even considering the probable difference in the demands made upon the painters.

118. JOHN SINGLETON COPLEY: MRS. WINTHROP. 1773. *The Metropolitan Museum of Art, New York*

Portraits painted in America in the latter part of the eighteenth century tend to be straightforward and largely concerned with achieving the greatest possible likeness. They preserve a little of the fresh surprise and delight in the newly acquired technique of representation that marks European portraits of the fifteenth century.

Before going to England in 1774, Copley worked in Boston, where he turned out a great number of vigorous portraits, of which this one of the wife of the Har-

vard professor, John Winthrop, is perfectly representative. Despite passages of uncertain draftsmanship and rather brittle coloring, the canvas conveys a genuine personality. Copley's descriptive concerns lead him to give all details equal weight, but he nevertheless succeeds in recreating a face that arrests attention. Its very lack of aesthetic pretension lends the picture an air of sincerity and authenticity—qualities which disappeared from Copley's work when he tried to conform to fashionable English taste.

119. GILBERT STUART: MARTHA WASHINGTON. 1796. *Courtesy of the Boston Athenaeum, through The Museum of Fine Arts, Boston*

A single glance at Stuart's Athenaeum portrait of Martha Washington is enough to make one feel the artist's surprising force and his superiority over his American contemporaries. Stuart made the pilgrimage to England in 1775, and when he studied under Benjamin West he came into contact with the leading British painters and even exhibited at the Royal Academy; yet he held fast throughout to the substance of his own style. The anxiety over descriptive detail which absorbed his predecessors gives way in his work to a complete freedom of treatment. The modeling is achieved by means of light, and the broad, easy brushstrokes seize the moment and convey it with great immediacy. There is no attempt at formality: it is thus no accident that the famous Washington portrait to which this is the companion piece seems to be something of a sketch. On the level of his European contemporaries, Stuart created portraits combining reliable resemblance and genuine interpretation of character with the finest painterly qualities.

120. FRANÇOIS BOUCHER: MADAME DE POMPADOUR. 1757. *Adolphe de Rothschild Collection, Paris*

Every element in this canvas is dictated by the spirit of the period of Louis XV. The rococo curve affects the whole figure, from the leaning pose to the crossed feet and the bent fingers in the open book; it appears in the sweep of the quill, the legs of the writing desk, the folds of the curtain, and the casually strewn roses. In this period the interior and the sitter seem to have been of equal importance as objects of aesthetic interest. The furnishings, no longer mere background, have become an integral part of the picture, the sitter has become an element within a grand decorative scheme, and both co-operate to create an indivisible unity. The face itself tells more about the social position of Louis's famous mistress than about her character. The canvas glows with excitement and playful impulses as the light shimmers and bounces among the yards of precious satins, yet it has an order and a courtly discipline that make it the perfect embodiment of the Style Louis XV. Court painter Boucher (fig. 94) has tied together the various visual elements with great tact, and indirectly has caught, if not the character, at least the aura of a very distinct personality.

121. JACQUES LOUIS DAVID: MADAME RECAMIER. 1800. *Louvre, Paris*

David's portrait of Madame Récamier, painted forty-three years after Boucher's "Madame de Pompadour," epitomizes the neoclassicist reaction against rococo. The rococo had used every painterly device to pin down the passing moment, to let fluid curves mirror the elusive personality; by contrast, neoclassicism admitted only one device for visual statement, namely, line. Only line, creating cool, relieflike forms against a neutral background, was felt and enjoyed. The reaction from the "busyness" of rococo was complete in David. He develops his portrait of Madame Récamier by means of outlines whose calm perfection contrasts with the profusion of color that was central to Boucher's vibrating design. As in Boucher's portrait, environment and sitter are completely unified—in this instance by strict verticals and horizontals. Couch, lamp, dress, coiffure, and gesture reflect the austerity of the antique fashions favored by the Empire style. David, who was Boucher's nephew, looked down on portraiture, believing that great historical compositions were more worthy of his art. Sensitive because of criticism, he left unfinished this work which was later to become his most famous portrait. Yet his portraits represent the climax of his spectacular draftsmanship and today are admired far more than his pretentious historical canvases.

122. EUGENE DELACROIX: PAGANINI. 1831. *The Phillips Gallery, Washington, D.C.*

In 1831 Paganini gave his first concert in Paris, and Delacroix painted him. The prototype of romanticism in painting thus met the prototype of romanticism in musical interpretation. The virtuosity of the painter's brushstrokes corresponds exactly to the virtuosity of Paganini's bow strokes. Employing his unusual powers of empathy, Delacroix gives the whole figure of the violinist, with a sprung curve at the hips, for nothing less than such a full-length portrait could possibly have conveyed the demonic quality of this incredible musician. The mood of the romantic period is projected in almost abstract terms; the trinity of head, fiddle, and hand, based on the darker triangle of the movement of the body, interprets the subject in an almost Rembrandtesque simplification.

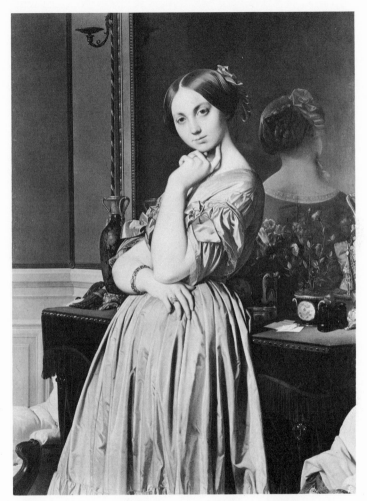

123. JEAN AUGUSTE DOMINIQUE INGRES: COMTESSE D'HAUSSON-
VILLE. 1845. *The Frick Collection, New York*

In his many theoretical pronouncements, Ingres, David's greatest disciple, said again and again that line and linear structure alone make the picture. In this portrait, however, he makes use of a richer coloring to achieve a stronger impression of three-dimensionality, especially in connecting the front view of his subject with a view of her back in the mirror. Like Boucher and David, Ingres integrated personality with cultural environment to achieve a "furnished portrait." Unlike his great contemporary Delacroix, he did not seek to capture a mood, but subordinated emotional ardor to objective and precise rendition. Despite the classicist scheme and the reticent color, there is no cool academicism about this picture, but the fullness of youth and life.

124. PIERRE AUGUSTE RENOIR: PORTRAIT OF MONSIEUR CHOQUET. Ca. 1875. *Courtesy Fogg Art Museum, Harvard University, Grenville Lindall Winthrop Collection, Cambridge, Mass.*

Monsieur Choquet, an art collector and the friend of many of the great impressionists, was painted twice by Renoir. Concentrating on Choquet's face, Renoir dissolves its forms and features into mere surface values. Apparently Choquet, who greatly admired Delacroix and collected his paintings, was able to perceive the qualities which Renoir had in common with the romantic painters. Certainly there was a resemblance in their approach to the use of color. But Delacroix would never have dared to let a chair cut so sharply across a picture or to limit the area of a portrait in so apparently arbitrary a manner. Renoir uses such abrupt devices to make clear the extreme informality and transiency of the sitter's pose.

125. THOMAS EAKINS: WALT WHITMAN. 1887. *The Pennsylvania Academy of the Fine Arts, Philadelphia, Pa.*

Eakins painted during the height of impressionism, and even studied in Paris, yet he made no attempt to create an American version of impressionism. His realism was that of Courbet's generation, fused with his native American feeling for the smallest details. Compared with the Renoir portrait, Eakins' study of the poet Walt Whitman gives one a sense of the subject's vigor and voluminousness, conveyed in solid three-dimensional terms and in colors very far from the contemporaneous impressionist palette. Dark and blackish tones prevail, reminding one that Eakins once studied Spanish painting. This portrait suggests an enduring quality in existence, which was certainly not one of the attitudes of contemporaneous impressionism.

126. HENRI ROUSSEAU:
PORTRAIT OF JOSEPH
BRUMMER. 1909. *Collection Dr. Franz Meyer, Zurich,
courtesy The Museum of
Modern Art, New York*

127. MARC CHAGALL: THE
RABBI OF VITEBSK. 1914.
*The Art Instiute of Chicago,
Chicago, Ill.*

128. GEORGE GROSZ: PORTRAIT OF HERMANN NEISSE. 1927. *Collection of the Museum of Modern Art, New York*

These three twentieth-century portraits illustrate the divergence in present-day artistic trends; whatever common denominator these have will become apparent only to a future age.

Rousseau's portrait of the art dealer Joseph Brummer illustrates his lucid, "primitive," untutored manner. With his unselfconscious style, molded by photographic images and by his technical limitations rather than by European painting traditions, Rousseau here creates a portrait so convincing that it forces us to accept the logic of its exotic decorations as well as its faults in description.

In Chagall's portrait of the Rabbi of Vitebsk three influences meet: the freshness of Russian peasant art, the brooding Jewish vision, and Parisian trends of the early twentieth century. The powerful design and the glowingly original color which it shares with Chagall's more fantastic compositions certainly give it more visual genuineness than can generally be found in works by Chagall's German contemporaries in the expressionistic idiom.

In Grosz' earlier work the verism of the German *Neue Sachlichkeit* movement is mingled with bitter social satire. This study of Hermann Neisse goes beyond its function as a portrait and becomes a social document condemning contemporary society. Poignantly and with the minuteness of the old German masters, Grosz draws out his lines and follows up forms until the brilliantly elaborated surface reveals depths of human feeling.

THE SELF-PORTRAIT

If the portrait is visual biography, the self-portrait represents autobiography. Like its counterpart in literature, the self-portrait involves a special problem in so far as its subject and its maker are identical. Psychological insight, so vital to the art of objective portraiture, is replaced by self-analysis. The capacity for self-analysis generally reaches its peak in later life, as we can see from the eloquent old-age self-portraits of Leonardo, Titian, Rembrandt, Chardin, and Goya. Sometimes, however, in self-portraits, vanity, social ambition, wishful escape, and other common failings are unintentionally disclosed—as, for instance, in the youthful self-studies of Dürer, Rembrandt, Van Dyck, Delacroix, and Angelica Kauffmann. Most self-portraits, though, strike a rough balance between truthfulness and flattering self-deception. If we are fortunate enough to have a whole sequence of self-portraits by the same man, as we have by Dürer and Rembrandt, we can, through their subjective testimonials, appraise quite objectively their growth both as human beings and as artists.

Inevitably each artist will assimilate his view of himself to the prevailing social image of his time. The ambition to look like a member of the best society is reflected strongly in the self-portraits of Dürer, Holbein, Velásquez, Rubens, Van Dyck, and most French and English painters of the eighteenth century. Others, including several seventeenth-century Dutch painters, Delacroix, and some nineteenth-century German romanticists, have cultivated the Bohemian look. In projecting themselves as "artists" they may indulge in a kind of posing or attitudinizing which they would not attempt in a commissioned portrait. The same license applies to portraits of themselves with wives or mistresses, and to self-portraits within the Artist in his Studio pattern which is discussed in the section on Interior.

The artistic effects of the use of the mirror, a necessity for self-portraiture, vary with changing styles and personalities. The Renaissance did not conceal the mirror-stare, but reproduced quite realistically the intensity peculiar to the self-studying look. In many baroque and in most romantic and impressionist self-portraits, which aimed at catching passing impressions, the mirror was more or less skillfully concealed, so that the subject appears not to be studying his own reflection, but simply to be seen from without.

Like other forms of portraiture, the self-portrait first appeared in the form of the *assistenza* figure. The artists rendered their own faces within group

compositions, disguising themselves as passive bystanders. Such self-portraits were less common in Northern painting.

After the self-portrait had outgrown the *assistenza* stage and become independent, its development paralleled that of general portraiture and became increasingly realistic. During the sixteenth century emphasis was centered on transient moods and emotions. With fully developed baroque, these passionate attempts to fix a passing moment in the artist's life were intensified by self-analysis and the self-awareness characteristic of artists. The resulting self-portraits were actually multiple documents reflecting the style of the period, a growing recognition of the complexity of human emotions, the social status of painters, and finally, the varying ability of individuals to recognize themselves and to reveal to the world what they recognize.

129. TITIAN: SELF-PORTRAIT. Ca. 1550. *Kaiser-Friedrich Museum, Berlin*

Though Titian created many master-pieces of portraiture, he did not paint his own features until his later years; the self-portrait shown here is one of the three he is known to have done in that last period. It is an unfinished canvas which in its balanced pyramidal High Renaissance design gives the painter an air of formality. The face lacks the wisdom of the self-portrait Leonardo da Vinci did in his old age, nor has it Rembrandt's tragic insight. It is the face of the distinguished prince of painters, the friend of the Emperor Charles V and other kings, the wealthy gentleman at ease in international court society. Yet Titian's rather cool self-appraisal is galvanized into life by the magnificent play of his rich palette. The color areas are carefully balanced and applied with the rich *impasto* of his late style. The light is intensified across the canvas from left to right, underscoring the implied alertness, almost impatience, of the figure.

130. REMBRANDT HARMENSZ VAN RIJN: SELF-PORTRAIT. 1660. *The Metropolitan Museum of Art, New York*

Among Rembrandt's more than one hundred painted, etched, and drawn self-portraits, those of his last period represent the climax of his portrait work. In these final canvases there are no longer any arrangements dictated by youthful pride, social ambition, or self-admiration. Rembrandt depicts unflinchingly the gradual decline and decay of his body, sometimes decking himself in splendid fabrics for ironic contrast, sometimes, as in this example, without any emphasis on dress at all. His real concern is with the flesh as a transparent medium for the soul, and in the painterly problems of reproducing that flesh on canvas. Eyes and mouth are the important messengers of what he has to say, and the light emphasizes those features which stand like ruins on the ravaged landscape of the face. All these late self-portraits are so full of human content that their glowing surfaces remain instruments, not ends, of expression. They constitute chapters in a private biography, tragic human documents, which at the same time show how the resources and devices of Northern baroque painting underwent progressive dematerialization.

131. WILLIAM HOGARTH: SELF-PORTRAIT. 1745. *National Gallery, London*

Social historian and storyteller, Hogarth used many playful literary allusions in his portraits as well as in his moralistic serials. Even this cool and obviously mirror-view self-portrait is symbolically modified: the pet bulldog connotes its master's alert watchfulness; two volumes by Swift imply the artist's satiric bent; the curve of the palette reveals the "line of beauty and grace" which in Hogarth's aesthetic treatise, *Analysis of Beauty,* is considered the secret basis of artistic organization. The symbols seem merely secondary to our present-day view, but Hogarth's masterly psychology and fresh rendering reveal the great painter behind the eighteenth-century intellectual.

132. SIR JOSHUA REYNOLDS: SELF-PORTRAIT. 1788. *The Toledo Museum of Art, Toledo, Ohio*

Unlike his rather pretentious allegorical and historical paintings and most of his fashionable and flattering portraits (see fig. 116), Reynolds' serious attempts at likenesses of mature men, unspoiled by flattery and fashion's dictates, achieve the status of great portraiture. Among the best is this straightforward self-portrait with its controlled light and fresh brushwork. The influences of past masters, too often unassimilated in Reynolds' pictures, are here absorbed and transformed into a style distinctly the painter's own.

133. JEAN BAPTISTE SIMEON CHARDIN: SELF-PORTRAIT. Pastel. 1775.
Louvre, Paris

This pastel shows Chardin's isolation within his period in much the same way that Rembrandt's self-portraits in old age show the Dutch master's isolation. Using reticent, subtly blended colors, and every effect possible in the medium of colored chalk, Chardin quietly states what he sees in the mirror, describing nose and scarf, mouth and visor, with equal objectivity. He employs no dramatic light or chromatic effects, no arresting play of forms. Here is a visual statement by an extraordinarily mature artist possessing the highest skill and a most acute artistic sensitivity.

134. FRANCISCO JOSE DE GOYA Y LUCIENTES: SELF-PORTRAIT. Between 1808 and 1813. *Smith College Museum of Art, Northampton, Mass.*

Chardin anticipated nineteenth-century realism with a calmly objective technique, Goya with a revolutionary subjectivism, interpreting life with the scepticism of nineteenth-century psychology (see also figs. 17 and 79). Even his self-portrait is not exempt from his biting sarcasm and merciless realism. Here is an old man, deaf and dirty, who has experienced "the vanity of vanities" and who records its mirage with cruel frankness, even in the treatment of himself. The abrupt nose, the harsh light and shade, and the dry colors round out a document of disillusion unlike both Chardin's tranquil summary of life and the heroic classicism of the early nineteenth century.

135. CHARLES WILLSON PEALE: THE ARTIST IN HIS MUSEUM. 1824.
The Pennsylvania Academy of the Fine Arts, Philadelphia, Pa.

Peale, a pupil of Benjamin West in London, returned to America in 1772. His native American pragmatism and his clear-sighted objectivity, evident in his paintings, also found expression in a lifelong interest in the natural sciences. This self-portrait, painted when he was eighty-three, shows the artist lifting, with a gesture of obvious pride, the curtain at the entrance to his museum. The perspective view of the background is somewhat conventional but the head and the hand are conceived with the same down-to-earth realism as characterized Peale's American predecessor, Copley (fig. 118).

136. JOZEF ISRAELS: SELF-PORTRAIT. 1908. *The Toledo Museum of Art, Toledo, Ohio*

A complete characterization is achieved in this fairly small, 21⅜- by 31-inch water-color. The aged artist shows himself before one of his large religious canvases, "David before Saul." As in most of his works, Israels combines the traditions of his native Holland with the late-nineteenth-century impressionist manner. Like the French realist, Millet, he deals mostly with the life of the poor; and his prevailingly melancholy mood suffuses this self-portrait. Broad areas of quiet tones build up figure and space, enlivened by sparse accents of brighter colors. An unpretentious work, it exemplifies the best European painting of the period, modern in its day and yet continuing the tradition of the seventeenth century.

137. VINCENT VAN GOGH: SELF-PORTRAIT. 1887. *V. W. Van Gogh Collection, Amsterdam*

Van Gogh's life has become a legend which continues to grow on the level both of serious interpretation and of popular sensationalism. The canvases that made this postimpressionist a pioneer of twentieth-century art were all painted during the last three years of his life. The revolutionary traits of that short creative period are present in his self-portraits: the wallowing in the pure medium of paint, the vehement stroke that shakes with continuous movement, and the discordant colors set audaciously side by side without mediating nuances. Out of this completely original and uncompromising approach a special form emerged which is completely identical with the content—as it is in every great work of art. The abrupt strokes and dots of strong red, green, and yellow against the blue background and jacket in this portrait bespeak the violence that Van Gogh read into everything he saw, never more appropriately than when he was painting his own portrait.

138. OSKAR KOKOSCHKA: SELF-PORTRAIT. 1913. *Collection of the Museum of Modern Art, New York*

Van Gogh's art exerted a strong influence on German expressionism and especially on the earlier works of the Austrian Oskar Kokoschka. For Kokoschka reality takes on an acutely subjective quality, without losing its recognizability. Kokoschka's self-portrait gives a minimum report on his external lineaments, expressing instead his emotional reactions to his self-scrutiny.

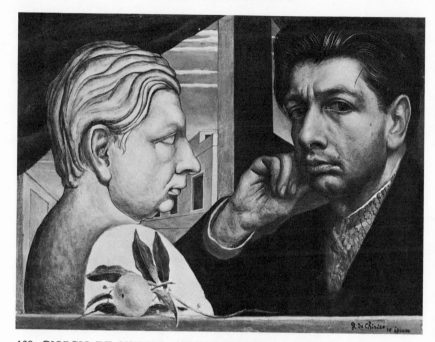

139. GIORGIO DE CHIRICO: SELF-PORTRAIT. Ca. 1923. *The Toledo Museum of Art, Toledo, Ohio*

The portrait double- or triple-viewed was painted as early as the sixteenth century in "Nobleman" by Lorenzo Lotto (1480–1556), or "Cardinal Richelieu" by Philippe de Champaigne (1602–1674). Typically surrealistic in de Chirico's schizoid self-analysis is the idea of confronting his self-portrait with his own portrait-bust. As so often with surrealist works, the imaginative visualization is delineated in classically precise forms.

DOUBLE AND GROUP PORTRAITS

Double and group portraits create an interesting and quite special problem. The single portrait involves but a single relationship, that which is set up between the subject and the spectator. The subject may appear to be looking out of the picture frame at the spectator, he may strike a self-conscious pose for the benefit of the beholder, or he may be depicted as apparently unaware of any external presence. When we analyze double and group portraits, the relationships grow far more complex. The sitters, in their relations first to one another and then to the artist or anticipated spectator, become enmeshed in a subtle interplay of emotional reactions, expressed through posture, glance, and facial expression. That such a complex network really exists in every double or group portrait becomes evident if we imagine the effect that would be created if the several subjects sat for the artist as though completely unaware of one another, like strangers in a library.

Furthermore the artist must arrange the figures on the painting so that they do not appear haphazard or too widely spaced. The painter's art consists in giving his arrangement a spiritual significance within an arbitrary spatial frame. This spatial frame generally takes the form of an interior, perhaps because interiors are obviously more explicitly related to men than is a background of nature. But whatever the spatial setting, it is never merely decorative, since it must also help account for the presence of the sitters as a group. Precisely because it provides the logic of the occasion, the setting has more importance as a common denominator in group portraits than in single ones. Sometimes a pair of golden scales or an art object may be enough pretext for explaining the coming together of the sitters. The more dramatic and lively the design of a double or group portrait the closer it approaches a genre scene, for our attention is shifted from faces and personalities to actions. And from action to story there is no very great step.

Dutch group portraits of the seventeenth century generally use the setting of a meal or feast, and sometimes a professional gathering or a parade, as a pretext for bringing the sitters together. The eighteenth century favored hunting scenes, military conferences of officers, or even promenades in a park. In these, of course, the sitters are generally shown as wholly absorbed in their interrelationships and seem unaware of the painter or spectator. In English "conversation pieces," all the sitters are consciously oriented toward the beholder, so that their awareness of being on display in itself helps to indicate

their social attitudes. These conversation pieces have their origin as compositions in the Venetian *sacra conversazione*, which presented Virgin and Child surrounded by saints, in much the same way as the scheme of meals as occasions for group portraits was influenced by the traditional organization of the Last Supper. The schemes of course have been assimilated to very different pictorial aims. The conversation piece remains understandable for us today, not through modern group portraiture, which is inconsequential, but through the group photograph, especially shots of family outings, weddings, testimonial dinners, graduation pictures, and the like.

In the countless variations on double and group portraits, the psychological problems are complicated by the demands of group composition. Sometimes these demands reinforce each other but quite frequently they overlap or come into outright conflict. Psychological unity might suggest, for example, that the several subjects be closely attentive to one another, while the mere sense of the action might require their heads turned more consciously toward the spectator.

It is not surprising that the peculiarly complex problems of double and group portraits have been solved only by very great masters.

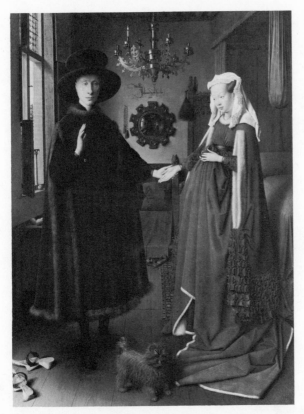

140. JAN VAN EYCK: GIOVANNI ARNOLFINI AND HIS WIFE. 1434. *National Gallery, London*

In van Eyck's time the marriage rite was a simple symbolic act, requiring only that groom and bride join right hands. In this portrait, Arnolfini, an Italian agent in the Netherlands, is shown extending his left hand instead of the right, a concession that allows both figures to face the picture plane logically and naturally and thus promotes representational clarity. Although van Eyck's visual approach here is as revolutionary as in his Ghent Altarpiece (fig. 4), the full-length figures are still presented with medieval solemnity. The chamber, which strikes our eyes simply as a fifteenth-century room, actually contained, for the painter's Flemish contemporaries, many symbolical objects referring to the wedding ceremony. An example of this is the lighted candle, representing the ever-present eye of God. Most important, however, is the location of the scene—reflected in the mirror on the rear wall—in a typical nuptial chamber, with the bed in plain view. Combining fifteenth-century naturalism and a feeling for light and perspective with a newly awakened psychological awareness of individuality, this is a landmark in portraiture, embodying an entirely new vision.

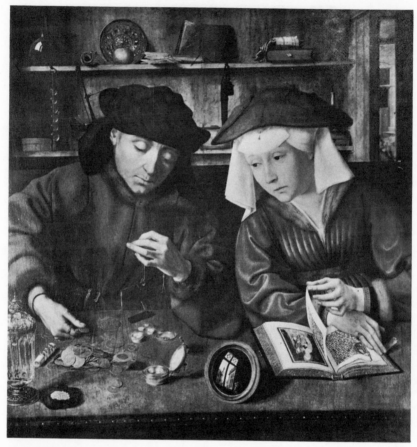

141. QUENTIN MASSYS: THE BANKER AND HIS WIFE. 1514. *Louvre, Paris*

During the sixteenth century both Northern and Southern artists learned to handle double and group portraits with the same freedom they had brought to the single portrait. Massys in this picture shows his sitters in their professional environment, which he depicts with painstaking concern for every last detail, even to the reflections in the mirror and the printed page of the book. Here is the traditional Flemish care for minute details, organized by repeated horizontals and without any Italianate overtones (see also fig. 67). The banker is weighing coins and his wife breaks off her reading to observe him; both are fully absorbed in their actions.

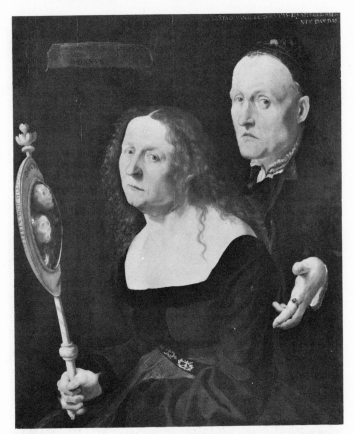

142. LUCAS FURTENAGEL: HANS BURGKMAIR AND HIS WIFE. (Formerly
attributed to Hans Burgkmair the Elder.) *Kunsthistorisches Museum, Vienna*

This double portrait is Renaissance in
organization, but its mood belongs in
the tradition of the medieval Dance of
Death. The consciousness of life's brevity
which permeates the picture gives a
harshness to forms and gestures: the
painter's wife holds a mirror in which
both faces are reflected as skulls, and the
same theme is stressed in the inscriptions
on the scroll. Yet for all its gloomy
atmosphere the panel is organized with-
out discords in design, and with that
harmonious balance that the influence of
Renaissance style had by this time
brought to the visual concepts of the
North.

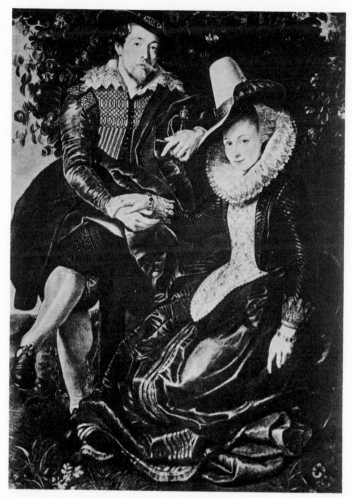

143. PETER PAUL RUBENS: RUBENS WITH HIS FIRST WIFE, ISABELLA BRANT. 1610. *Alte Pinakothek, Munich*

In this double portrait there is a perfect balance between genuine marital affection and the complacence of the gentleman-painter who appreciates his position in society. The central motif is the loose handclasp; the eye is led toward it by the crossing diagonals of limbs and bodies—a typically baroque composition. Both sitters face the spectator, making the portrait obviously formal and representational.

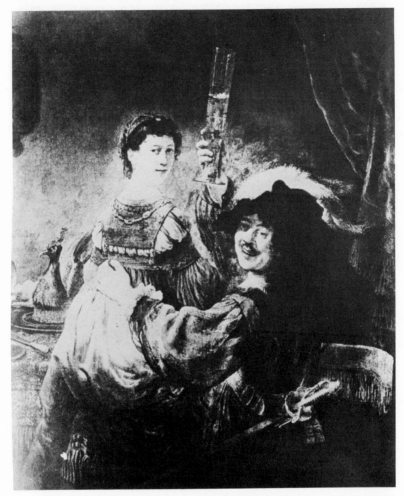

144. REMBRANDT HARMENSZ VAN RIJN: SELF-PORTRAIT WITH SASKIA.
Ca. 1635. *Staatsgalerie, Dresden*

Rubens' double portrait achieves its ends through its baroque structure; Rembrandt's "Self-Portrait with Saskia" is realized through the medium of light. Light dramatizes the features of the painter while it mellows those of Saskia; light evokes the gleam of surfaces, the feather in the hat, the lifted wineglass, the saber; and light tempers a certain overhearty familiarity in the scene. Baroque tendencies, manifest in the emphasis on the third dimension, in the richness of each form, and especially in the handling of light, are still stronger in this early work than are the unique qualities that characterize Rembrandt's later portraits (fig. 130).

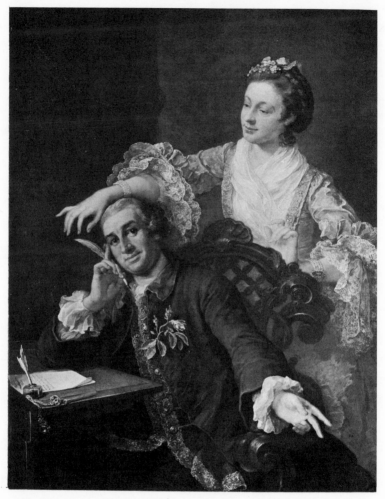

145. WILLIAM HOGARTH: DAVID GARRICK AND HIS WIFE. 1757. *His Majesty the King, Windsor Castle*

Hogarth's extraordinary gift for sharp characterization, made familiar by his pictorial satires on the social scene, is evident in this portrait of his friend, "the Great Garrick," and of Garrick's wife. The famous actor's "Muse" is trying to interrupt his work by taking away his pen. Despite descriptive minutiae and a profusion of playful forms—the vi-brating outline, the gestures, carvings, lace frills—the two portrayals are direct and pungent. More reserved than contemporaneous French portraits (fig. 120), less severe than his own self-portrait (fig. 131), this canvas is a spirited document on eighteenth-century England.

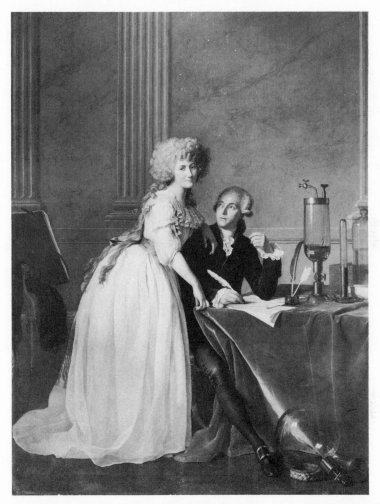

146. JACQUES LOUIS DAVID: MONSIEUR AND MADAME LAVOISIER. 1788. *Reproduced by permission of the Rockefeller Institute for Medical Research, New York*

Portraits always reflect the social attitudes of their period, and so we find portraits, especially the professional type (figs. 113, 141), becoming more and more "bourgeois." This study of the great French chemist Antoine Lavoisier and his wife, set in the scientist's laboratory, has all of David's characteristic linear clarity. Yet there is enough of the passing eighteenth-century spirit to give the picture a certain genre warmth and charm, traits which David later suppressed in favor of a cool classicist dignity.

147. REMBRANDT HARMENSZ VAN RIJN: THE SORTIE OF THE COM-
PANY OF FRANCIS BANNING COCQ, CALLED THE NIGHTWATCH. 1642.
Rijksmuseum, Amsterdam

The basic problem of portraying a larger group had already arisen for Dutch painters before Rembrandt's time. Honorable citizens were generally posed around a table, eating, drinking, and conversing; sometimes they were shown simply standing together. Rembrandt first dealt with the problem of the group portrait in his "Anatomy Lesson of Dr. Tulp" in 1632 and again in the "Nightwatch"—actually a daytime parade, as the recent restoration clearly proves. Twenty-nine full-length figures—sharpshooters led by their captain—move out of the depths of the picture toward the beholder. Movement and gesture flow together and disperse again as the figures, some iso-lated by the concentration of light, others still half hidden in the gloom, begin to emerge. Local colors, blues, yellows, and darkish reds, concentrate on a few fig-ures, and in particular on the young girl, who has apparently been intro-duced only to provide a color foil for the captain and his lieutenant. The good burghers of Amsterdam certainly did not get good likenesses in this portrait, but they did get an enchanted vision, and through it an immortality their own features could never have earned them. Here space and forms, movements and colors, are integrated by the magic of light, now flaring up, now withdrawn, eddying and surging across the canvas.

148. FRANS HALS: THE WOMEN-GOVERNORS OF THE OLD MEN'S ALMSHOUSE. 1664. *Frans Hals Museum, Haarlem*

In his old age Hals mastered—much as had the aged Rembrandt in the "Syndics of the Cloth Guild," 1662—the problem of the group portrait. Hals here exercises the firmest discipline over form and color. Gone is the spontaneity that distinguished his earlier single and group portraits (fig. 114), and gone too are the flowing diagonals, the broken textures, the sketchy contours. This picture is a pattern of rigid horizontals and verticals and of large geometrical forms that isolate each personality and yet permit the artistic unification of the canvas. With one exception, no genial human warmth lights these faces, nothing but bitterness, distrust, and parsimony, expressed in the hands no less than in the features. Even the palette range is severely limited to heavy blacks and stern grays. The bitterness with which Hals experienced the remorseless advance of old age found here the perfect subjects through which to express itself.

Landscape

Landscape as an independent theme did not come into its own before the end of the sixteenth or the beginning of the seventeenth century. We are familiar with Roman landscapes, and even with Egyptian and some late medieval landscapes, but these functioned within the picture only as props, as narrative signposts, or, in Roman murals, as background décor. They were never aesthetic aims in themselves. Even the Renaissance, despite its enthusiasm for nature and its interest in perspective, long subordinated landscape to the human figure, the portrait, or the narrative sequence. The mental evolution and the liberation of the human soul which took place during the first two centuries after the close of the Middle Ages were necessary before men could acquire a feeling for landscape as such and consider it worth presenting for its own sake. The human body was aesthetically rediscovered before the human environment, and for a long while everything was secondary to its glorification.

Even in literature there are very few individualized descriptions of nature before the latter part of the sixteenth century—nothing that compares, for example, with Michel de Montaigne's *Travel Diaries,* which appeared in 1580. In earlier European literature the comment on and description of landscape are largely conventional and formal, inspired more often by Greek and Roman literature and the Psalms than by the writer's own visual impressions.

The history of man's conscious feeling for nature has often been studied as an aspect of poetic literature or as a theme of private correspondence, travel reports, diaries, and other documents that reveal an age. The clichés of visual interest change from time to time in the same way as conventions in dress, feminine beauty, or social behavior. Today we no longer rhapsodize like the Victorians over romantic waterfalls, picturesque crags, and breath-taking views, though these still pervade travel guides and real-estate advertising.

The ancient Romans, as we may see in their poetry, favored only the *amoena,* that is, agreeable stretches of flowering meadows, cultivated trees, gradual slopes. Forests were considered savage and formless, the towering Alps altogether forbidding. This attitude toward nature's abundance was so deeply ingrained in the general European mind that, as late as the eighteenth century, writers continued to call the Alps Gothic, by which they meant barbarous.

During the Middle Ages, religious concepts led to the rejection of landscape along with other earthly manifestations, all of which were supposed to distract

man's thoughts from salvation and the hereafter. Landscapes were avenues leading back into this world: if they were grandiose and elemental, like sea, forest, or mountain, they were literally dangerous and therefore to be shunned. If charming and seductive to the eye, they were thought to be fraught with even greater perils for the soul, since their beauty might be the devil's bait of sensuous distraction.

It was St. Francis of Assisi (1182–1226) who rediscovered nature's meaning for Christianity. St. Francis's feeling for nature was the very opposite of that recorded by antiquity. The Greeks and Romans looked at nature from a realistic and rather matter-of-fact point of view; it was something to be enjoyed. But St. Francis was the first to feel and express a humble acknowledgment that man and all "lower creation" are linked by a common destiny. This new outlook encouraged an all-embracing visual sympathy which eventually led men's eyes to dwell with understanding upon their surroundings, upon inanimate things as well as plant life and the world of animals. Thus the idea of Landscape was born, though it did not immediately emerge as an independent aesthetic interest, remaining for a while subordinate to background requirements and decorative aims.

Leonardo da Vinci and Albrecht Dürer, for example, in their nature studies explored landscape with a scientific rather than a purely artistic interest. And if these artists discovered beauty there, they saw it as an accessory, background, secondary beauty, for to them and their age human beings were still the only worthy subjects of art. The evidence of Dürer's water-color landscapes may seem to contradict this assertion; these, however, were not meant as independent works of art but as studies.

The interpretation of Landscape has been subject to many changes and variations. Five different approaches can be clearly distinguished, though two or more are often combined in one picture.

Landscape as a Descriptive Element. In early narrative scenes, landscape consisted entirely of a few symbols or descriptive shorthand marks sufficient to set the scene and identify the story for the beholder. In Egyptian wall paintings, in Byzantine mosaics, and in medieval manuscripts, the artist placed several trees, a rock, a few waves, or the mouth of a cave, not behind the human figures but beside them, obviously for the purpose of description. They were guideposts, sometimes merely symbols, introduced not for spatial clarification, beauty, or interest in nature but to help identify the story.

This descriptive use of landscape was given additional impetus by the trend toward realism which triumphed by the middle of the fifteenth century and at last became the decisive factor in European painting. When the laws of perspective were systematized, the artist had the means by which to set his scene naturally and unmistakably. In place of the old object-symbols, land-

scapes were now painted in their familiar continuity and fullness. Miniatures by Jean Fouquet, the enchanting calendar pages from the Duc de Berry's Book of Hours, an Adoration by Fra Angelico or Fra Filippo Lippi are all marked by a single conception of the presentation of landscape: the clearest possible description, but description only. These landscapes are not moods visualized, nor do they offer any counterpoint for the character of the human figures. Such conceptions do not appear until the end of the fifteenth century, turning up in the Venetian school, and especially in the work of Giovanni Bellini, and among such Northern painters as Gerard David, Joachim Patinir, and above all Pieter Breughel. With these artists the landscape goes beyond mere description. It receives attention for its own sake and intensifies the psychological and social presentation. But even in this stage, the land-scape remains descriptive, still a part of a story, and still subordinated to a group of human figures.

Landscape as Decorative Background. The decorative landscape can be defined as an accompaniment to the human figure or figures, comparable to the obbligato in music. It is not yet present in the panoramic views of Konrad Witz, for example, or Mantegna, for though these artists strive for a certain decorative effect, they do not integrate figures and background. They paint their protagonists in front of a factually described scene.

The decorative function emerges in the last decades of the fifteenth century in such works as Ghirlandaio's murals and altarpieces or Botticelli's mytho-logical scenes. Later on the decorative purpose in Italian painting is always integrated with structural, descriptive, and emotional tendencies, though it does not vanish entirely. In Flemish, German, and Dutch art, landscape back-ground is never used merely as decoration. The ingrained Northern love of objective truth could not countenance such merely decorative treatment.

After the emphasis on mood in the landscapes of the late sixteenth and the seventeenth centuries, a reaction took place, and the eighteenth century saw a revival of the decorative landscape in French and English figure com-positions and portraits. From Watteau to Fragonard, and from Reynolds to Lawrence, backgrounds were simply background, entirely subordinate to the human figure and sometimes reduced to visual clichés and stock nature images designed to set off portraits or groups.

Landscape as a Structural Aid to Composition. No pedantically sharp line can be drawn between decorative and purely structural functions of landscape. Yet Gozzoli's murals or Botticelli's paintings clearly use the landscape back-ground for decorative completeness alone. Details of the countryside are se-lected and assembled for their appropriateness to the central human figures. However, in the works of Perugino, Raphael, and Titian, landscape contours, the verticals of trees, the horizon line, and the curves of hills are closely

related to the main figures through parallel and contrast and may serve to frame the human body, blend it with other elements, or emphasize the direction of body movements; the structural and the decorative functions of the landscape are here completely balanced. A century later, landscapes by Poussin and Claude Lorrain are structures in themselves, with the human beings as "staffage" or accessory figures. Observe that if these figures were removed, the picture might lose a little of its completeness, but not its essential effect, which is a view of the outdoor world, a scene large or small, distant or near, magnificent or quietly rural, but first and last a scene. The figures might be replaced by other elements of the same size, shape, and value without changing the structural design of the picture. As figures, whether human or animal, they merely illustrate the mood of the picture, and are therefore the exact opposite of figures in early Renaissance paintings.

Northern artists did not tend to organize the forms of nature into such structural schemes, any more than they could regard them as mere decorative accents for human figures. Through every change of style down to the present, Flemish, Dutch, and German artists have retained an intense feeling that nature is too meaningful to be manipulated merely as a structural aid.

A certain feeling for the structural approach of the High Renaissance came back with the classicist revival at the end of the eighteenth century. But this was temporary and vanished completely during the nineteenth century, when impressionism rejected all structural schemes. For impressionists the landscape was another occasion for seizing and interpreting the prismatic breakdown of light on textures and forms. With Cézanne and his followers the structural idea returned in full force; in fact, these postimpressionists went still further. They built up the structure of the landscape almost in terms of architecture, an architecture realized through mountains, rock formations, trees, water surfaces, building masses, and varying levels of terrain. Retrospectively, Poussin's landscapes may be seen as steps leading to this fugal vision of space expressed through the structural modulation of landscape.

Landscape as a Central Theme. Landscape as an independent theme became possible only when the human figure was dispossessed from its central place and could be treated as a secondary element. Pure landscape appeared in the work of the sixteenth-century Italian painter Annibale Carracci, whose hunting and fishing scenes showed the human figure typically subordinate to the main theme. During the seventeenth century, landscape as the central theme gained major status through the works of a galaxy of masters: from Nicolaes Berchem to Rembrandt in Holland, Rubens in Flanders, Salvator Rosa in Italy, and, in France, Nicolas Poussin and Claude Lorrain, in whose structural compositions landscape is incorporated as an organic whole. With these artists, landscape became a full-fledged division of painting, taking its place beside

religious, historical, and portrait painting. The seventeenth century witnessed the climax of the absolute landscape idea, of nature painted purely for its own sake. It might embody an unambiguous mood or remain emotionally neutral, it might define a well-balanced structure, but in any case it was the central theme, self-explanatory and chosen for reasons beyond the need to provide descriptive, decorative, or structural background. A similar feeling for pure landscape unmodified by pictorial functions dominated the outdoor scenes of the great impressionists in the nineteenth century. In such landscape painting we find a real documentation of the visual conquest of nature. Natural objects and mass formations which have no relevant human meaning or anecdotal charm are presented as radiating their own significant light. The true landscape painter composes colors and forms out of his visual experience, without preconceptions, and so describes the earth we tread as molded by the same primary force that shaped the spirit of man.

Landscape as an Expression of Mood. Again no hard and fast distinction can be drawn between landscape as a central theme and landscape as expression of mood. A "pure" landscape may look emotionally neutral to one man, who will find its meaning in the artist's handling of the aesthetic problems; while to the next man the same landscape may appear to express a specific mood, unambiguously serene or unquestionably melancholic. It is impossible to say just how much of a mood is read into a picture by the spectator and how much emotional value was intentionally placed on the canvas by the artist's organization of paint and composition. A painting or any work of art can give us only a few explicit clues to its intentions, but it is so constituted that even its limited hints permit us to divine many truths which would be incommunicable in the language of literal fact.

Today we are inclined to see in every landscape painting an expression of mood; we actually ask for emotional identification between artist and subject. A modern landscape painting without these associations would seem to us to be without artistic value. This attitude is obviously peculiar to our time and we should be wary of using it in evaluating works of the past. El Greco's "Toledo," the landscapes of Rubens and Rembrandt with their intense moods are not greater than Vermeer's "neutral and objective" paintings of Delft. They are only different. The mere fact that the landscapes expressing pronounced moods seem more accessible to our contemporary feeling should not be permitted to mislead our judgment.

A word should be added at this point concerning the difference between the five landscape classifications used here—descriptive, decorative, structural, central theme, and mood-expressing types—and the conventional academic classifications of heroic, picturesque, romantic, *paysage intime,* and so forth. The categories developed in this text refer to the picture conceived as a

totality, to the way it works through the artist's visual orientation and through the way he actually organizes his material on the canvas. The academic classifications, however, refer not to the functioning of the landscape elements in painting, but to certain subjects or contents which landscape painters have depicted in different times. These are largely verbal conventions which may or may not coincide with the aesthetic aim of any particular picture.

Precisely because landscapes seem to be so obviously simple and natural a task for the painter, it has been important to point out the variety of possible pictorial approaches and to suggest further that in any particular canvas two or more of these approaches are likely to overlap and fuse.

149. POMPEIIAN MURAL: DECORATION IN THE HOUSE OF MARCUS LUCRETIUS FRONTO. Third Style. First century A.D.

Landscape as a topic did not engage Greek or Roman painters until late Hellenist times. Even then they used it mainly for background in decorative wall paintings depicting favorite myths or the pleasures of contemporary life. Best known are the landscapes illustrating the Odyssey, which were found in a villa on the Esquiline hill in Rome. Like the Pompeiian example here, the Esquiline landscapes are mere backgrounds for figure groups and carefully projected architecture. The perspective is surprisingly correct, with buildings, trees, and hills receding in proper order. Light and color occupied the anonymous landscape artists of this period more than did the kind of sharp linear definition that had been employed in earlier Greek vase painting (figs. 31 and 88).

150. STEFANO DI GIOVANNI SASSETTA: MEETING OF ST. ANTHONY AND
ST. PAUL. 1432–36. *National Gallery of Art, Kress Collection, Washington, D.C.*

Unlike the Florentine pioneers of the *quattrocento*, the Sienese painters gave up with great reluctance the golden backgrounds they inherited from fourteenth-century painting. In this charming legend as told by the Sienese artist Sassetta, all the landscape elements are clearly stated: cave, trees, hills, and road are as distinct as the props of a medieval mystery play. Yet these elements do more than place events and provide background; a poetic atmosphere unites them in an aesthetic relationship that goes beyond their function as symbols. Although he still feels bound to the traditional forms of the preceding period, Sassetta recounts the various episodes of the saint's journey quite realistically, using even a certain amount of foreshortening.

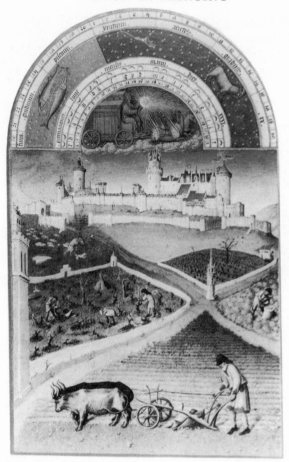

151. POL DE LIMBOURG AND HIS BROTHERS: MONTH OF MARCH. *From Les Très Riches Heures du Duc de Berry. 1411–16. Musée Condé, Chantilly*

In one of the most treasured examples of Books of Hours—liturgical books for the use of laymen—the brothers de Limbourg identified each month according to characteristic occupations and seasonal changes and under appropriate signs of the zodiac. Completed in 1486 by a later miniaturist, the book became the generally accepted model for calendar illustration until the early sixteenth century (fig. 90). The month of March is here shown as dedicated to plowing, pruning, and planting. The rather regularly patterned landscape, seen from a great height in almost correct perspective, is crowned by the castle of Lusignan, one of the many strongholds of the Duc de Berry. The scene is a miracle of delicate and minute description. It reflects the attitude of the Franco-Flemish miniaturists toward nature, being at once an enchanting expression of the waning Gothic age and a precursor of the new vision of the van Eycks.

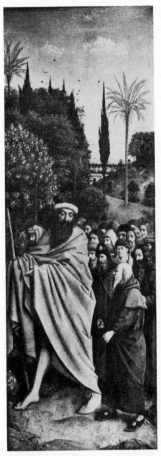

(Detail)

152. HUBERT AND JAN VAN EYCK: WING FROM THE GHENT ALTAR-
PIECE. 1427–32. *St. Bavo, Ghent*

This panel from the famous Ghent Altar-
piece (see also fig. 4) represents the
beginning of modern landscape painting.
It is the first painting in which the space
of the picture and the landscape are
seen as a pictorial unit. The landscape, no
longer a backdrop, actually exists in
space which envelops the composition
and shares attention with the human
figures. The extraordinary freshness of
the van Eyck vision becomes clear if we
compare the buildings in the background

here with those in the calendar page
from the Duc de Berry's Book of Hours,
and again if we compare the very differ-
ent role of the foreground details in the
two landscapes. The new medium of oil
with its deeply glowing hues provides a
sharp contrast between the work of the
van Eycks and the tempera paintings of
their Italian contemporaries; the latter,
more formal and intellectual, relied
rather on linear perspective for project-
ing space.

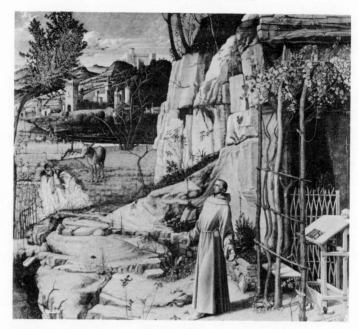

153. GIOVANNI BELLINI: ST. FRANCIS IN ECSTASY. Ca. 1480. *The Frick Collection, New York*

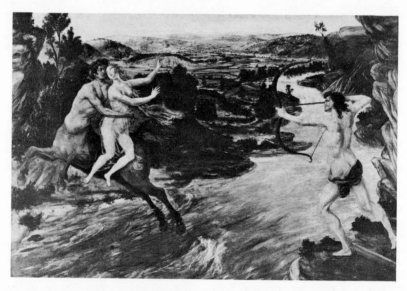

154. ANTONIO POLLAIUOLO: THE RAPE OF DEIANIRA. 1480. *Yale University Art Gallery, New Haven, Conn.*

155. PIERO DI COSIMO: THE DEATH OF PROCRIS. Ca. 1510. *National Gallery, London*

In the first half of the *quattrocento,* such Florentine painters as Masaccio, Fra Filippo Lippi, and Benozzo Gozzoli began to set their pictorial narratives in front of a landscape background, gradually developing the illusion of depth through linear perspective. After the middle of the century many North Italian artists, including Bellini and Carpaccio in Venice, and Mantegna in Padua, moved in the same direction, perfecting perspective techniques and enriching the general store of pictorial motifs. The last generation of the fifteenth century finally achieved complete freedom in the handling of landscape.

Bellini's "St. Francis in Ecstasy" discovers matter of equal interest in the foreground, middleground, and background. There is a natural transition from plane to plane, all integrated by the artist's intense Venetian colors. Although clearly drawn, rocks and plants, animals, the distant town, and even the saint himself are really subordinate, or supporting, elements of the landscape theme.

Pollaiuolo has already moved far beyond Bellini's approach in the mythical episode of Hercules shooting the centaur Nessus, who is attempting to abduct Deianira. The artist is no longer absorbed in detail, and the composition rests on broad areas of color. Both landscape and figures are treated in the same swift and almost dappled manner. In the receding landscape stretching toward the horizon, the play of light becomes a vital element.

For Piero di Cosimo (see also fig. 104), who was influenced by Leonardo da Vinci, by the Venetians, and even by the Flemish painters, landscape has become the immediate vehicle of a mood. In this scene of the death of Procris, the nymph who was accidentally shot by her lover, the low horizon, bare plain, and cool dry light express the tragic mood as explicitly as the mourning satyr and the melancholy dog. A new significance has been given to landscape: its elements are manipulated to reflect human feeling beyond nature's silent indifference.

156. JOACHIM PATINIR: THE REST ON THE FLIGHT INTO EGYPT. Early
sixteenth century. *Kaiser-Friedrich Museum, Berlin*

In the work of the Flemish painter
Patinir, whom Albrecht Dürer praised
highly, religious details and figures play
a greatly reduced role in relation to sur-
rounding landscape. In fact, Patinir treats
his figures as "staffage," human figures
subordinate to their surroundings and
therefore drawn in small scale. Patinir
was among the first painters to introduce
this altered scale. His paintings teem
with varied and often heterogeneous
motifs—rivers and fantastic rocks, tidy
villages and turreted castles, isolated
trees and dense forests; each picture, in
short, a world in itself. He organized this
superabundance by means of a device

widely used in his time, namely, a very
high horizon line that leaves a large area
of the panel free to accommodate many
motifs. The larger figures in the fore-
ground—which may be the work of a
fellow artist, such collaborations being
common practice at the time—help push
back the middleground and background,
and the color scheme contributes to
the illusion by moving from the heavy
browns of the foreground through the
greens of the middleground and into the
airy blue of the distance. Patinir painted
another version of this topic, about 1520,
now in the Minneapolis Institute of Arts.

157. ALBRECHT ALTDORFER: THE REST ON THE FLIGHT INTO EGYPT.
1510. *Kaiser-Friedrich Museum, Berlin*

Altdorfer's "Flight into Egypt" was painted almost at the same time as Patinir's, and the two pictures clearly illustrate the difference between German and Flemish art in the sixteenth century. The German is poetic and has imaginative vision; the Flemish is realistic, warm, and of this world. Altdorfer's landscape is frankly a background for the sacred episode and not merely a painter's experiment in space. The Holy Family—Mary resting on an elegant chair, the Christ Child playing with cherubs beside a richly carved Renaissance fountain, Joseph bringing food— is the central theme and everything else is subordinate. The vista is seen from a high angle: ruins, crumbling towers, and a small town with a gate and bridge, and mountains and forests in the background bordering on a quiet lake. The delicate, iridescent colors avoid strong contrasts and their fairy-tale atmosphere is quite unlike the concrete reality of Patinir's scene. A crowding richness of motifs is the only quality common to the two paintings.

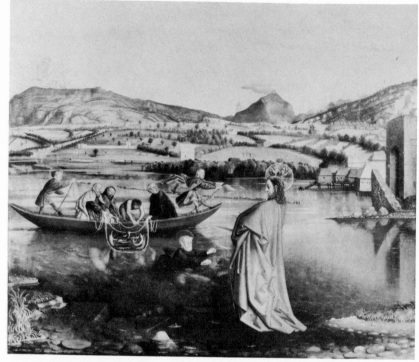

158. KONRAD WITZ: THE MIRACULOUS DRAUGHT OF FISHES. *From the Geneva Altar. 1444. Museum of Art and History, Geneva*

Throughout the fifteenth century, German painting in general still clung to medieval traditions. Two South German painters, Konrad Witz and Lukas Moser (active about 1430), however, began, in their approach to nature and landscape, to anticipate the new vision which was to find supreme expression in the watercolors of Dürer and the landscapes of Altdorfer. Perhaps Witz' experience of the broad vistas of the Swiss lakes opened his eyes to the artistic problem of light and atmosphere while his contemporaries were still struggling with the perspective of small objects in cramped surroundings. This "Miraculous Draught of Fishes" attempts for the first time to depict a broad area of water within an impressive landscape—an actual spot on Lake Geneva. Christ and the disciples in the boat dominate the foreground but are related to the landscape by a fine sequence of elements. The eye is led from the level foreground toward the opposite bank, thence upward in a gradual slope culminating in the distant mass of Mont Blanc, which serves to accentuate the head of Christ. This broad structural sweep is the more astonishing when we realize that most Northern landscape painters for the next two generations employed no gradual transition between figures and landscape. They were content with an abrupt backdrop of bizarre mountains in contrast to the true breathing space in Witz' painting.

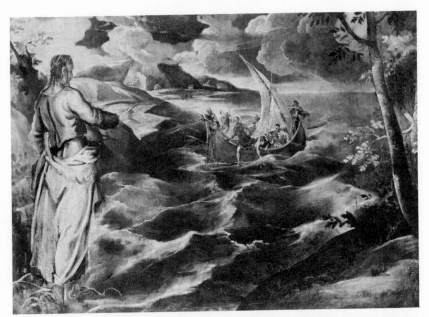

159. TINTORETTO (JACOPO ROBUSTI): CHRIST AT THE SEA OF GALILEE.
Ca. 1562. *National Gallery of Art, Kress Collection, Washington, D.C.*

More than a century after Witz, Tintoretto conceived of the miraculous draught of fishes in typically Venetian mannerist style. The content naturally follows the Scriptural narrative, but the surrounding landscape, its motif, mood, and lighting, and the figures of Christ and His disciples with their dramatic gestures are somewhat removed from Witz' serene vision. The mild equable light of Witz' Lake Geneva has given way to Tintoretto's sharp and spotty light breaking through menacing clouds. The figure of the Lord is accented by the same rush of light that touches the storm crests of the waves. The elements that make for a silent miracle in Witz' picture are transposed into tempestuous drama by Tintoretto's mannerist brush.

160. EL GRECO (DOMENICO THEOTOCOPULI): TOLEDO. Ca. 1600. *The Metropolitan Museum of Art, New York*

Genius can hardly be fitted into exact classifications, and none less than El Greco, man of many countries and influences. In this view of Toledo (another, more maplike view hangs in the Museum of Toledo in Spain), the dramatic influence of Italian mannerism, and especially of Tintoretto, is obvious. Yet the intensity of this picture goes far beyond even this era's pronounced tendency to dramatize. In El Greco's work, nature is a menacing presence in itself; beneath the wild surface lurks an ominous solitude. The bathers in the foreground, so small they are scarcely recognizable as human beings, make clear in their diminutive size the oppressive immensity of the landscape. Light and darkness alone evoke the forms of nature, and even the forms seem unstable—subject to dissolution at any moment. The foreground is almost impressionistic, but the farther distances fall more and more into patterns of contrasting forms.

161. ANNIBALE CARRACCI: LANDSCAPE. Ca. 1604–1609. *Kaiser-Friedrich Museum, Berlin*

Annibale Carracci's landscapes reflect the late sixteenth-century Italian trend toward the baroque. His style is a mannerism that arranges naturalistic motifs, ancient ruins, and fantastic landscape elements in a careful balance, striving to revive the structural principles of the High Renaissance, stimulated especially by Raphael's compositions. Figures and story content are subordinate to the kind of heroic landscape that was to remain a pictorial type for more than two centuries. The fact that this type became more and more conventional and that Carracci's scheme of composition, taught by all European academies, became, in the hands of feeble imitators, a mere pattern should not blind us to the expressive and intense feeling which emanates from his genuine landscapes.

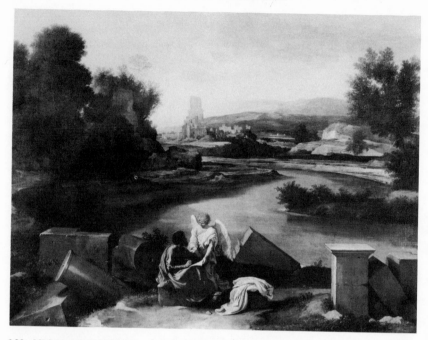

162. NICOLAS POUSSIN: LANDSCAPE WITH ST. MATTHEW AND THE ANGEL. After 1643. *Kaiser-Friedrich Museum, Berlin*

Poussin's greatness does not declare itself to our eyes at first glance. In translating emotion into reason, and intuition into ordered laws, Poussin was only expressing the artistic approach of seventeenth-century French classicist spirit. With baroque everywhere triumphant, the classicism that looked back to Raphael and antiquity was carried forward only by Italian eclectics (fig. 161) and by French painters in Italy. It was therefore not by chance that Poussin lived in Rome and was the disciple of Domenichino (fig. 22). In his landscapes, with their subordination of the human figure to the organization of space, religious and myth-ological episodes are used merely as points of departure. Layer by layer and plane by plane Poussin builds up the objects of nature into firmly stated units. His structural approach is not at all unlike that which was to characterize Cézanne's reaction to the looseness of impressionism. Like Cézanne, too, Poussin introduced strong architectural forms—towers, bridges, and ruins—using their unequivocal shapes for the bones or scaffolding of his compositions. The crystal-like clarity of these low-keyed landscapes creates a restrained and yet deeply moving world.

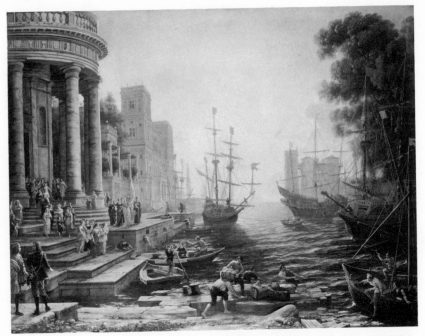

163. CLAUDE LORRAIN: SEAPORT: EMBARKATION OF ST. URSULA. 1646. *National Gallery, London*

From the great freshness and immediacy of Lorrain's many drawings it is plain that the strict balance of his landscape paintings was not an expression of a temperamental attitude, but rather a discipline consciously self-imposed. His compositions are as classicist as those of Poussin, but light, color, and atmosphere play a more important role, almost as great a one as in the landscapes of his Dutch contemporaries. Architecture, too, dominates even more than in Poussin's work. Lorrain's harbor scenes are always filled with the same kind of monumental Roman structures that suggest the same kind of historic setting whether they frame the "Arrival of the Queen of Sheba," the "Landing of Cleopatra," or the "Embarkation of St. Ursula." In the St. Ursula scene, the sunlight, dropping through tranquil air, gilds each little wave crest, models the columned porticoes, and illuminates trees, masts, and human figures with a calm unchanging radiance that softens the rigidity of the underlying linear composition.

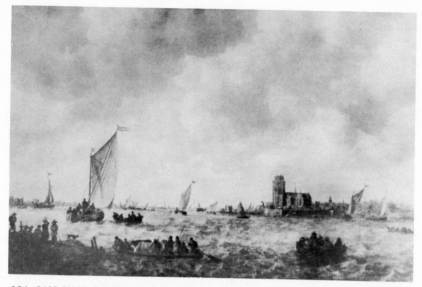

164. JAN VAN GOYEN: VIEW OF THE MEUSE AT DORDRECHT. 1653(?).
Royal Museum of Fine Arts, Brussels

By the seventeenth century the Dutch landscapists had abandoned Patinir's conception of landscape as a panorama of various elements accumulated below a high horizon line. The new approach called for the unifying effect of a lower horizon, a pervasive atmosphere and mood. No story-content was required, no dominating human figures; landscape had become an independent kind of nature portraiture. Foreground, middleground, and background were no longer separate elements of composition but only aspects of a single visual unit. Most important, it is not the solid forms of things that determine the artist's reaction, but harmonies of light and texture. Within this general trend in style, the Dutch landscapists developed an incredible range of individual interpretations.

Van Goyen's view of the river Meuse is a representative example of Dutch painting about the middle of the century: here are the low horizon, foreground figures that push the background into farthest distance, atmosphere that is lambent, soft, and misty and yet permits us to distinguish the forms of objects. This was one of van Goyen's favorite schemes; characteristic, too, is the dominance of brown and gray tones and the almost complete suppression of actual local colors.

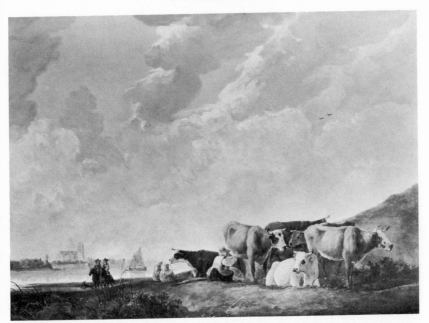

165. AELBERT CUYP: PASTURAGE NEAR DORDRECHT. 1660–70. *Ringling Art Museum, Sarasota, Fla.*

Cuyp painted both animals and landscapes, in combination as well as independently. He was more interested than van Goyen in the volume and mass of individual objects; and his forms show greater variety and movement, their frankly baroque organization suggesting a Dutch version of Claude Lorrain's work. The foreground objects in this picture are more important to the composition than the barges in van Goyen's "View of the Meuse at Dordrecht." Cuyp's palette, too, is in a warmer key, the local colors being sufficiently strong and rich to allow human beings and animals to maintain their importance in relation to the enveloping atmosphere.

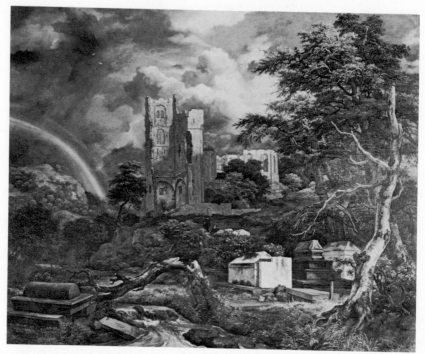

166. JACOB VAN RUISDAEL: THE JEWISH CEMETERY AT OUDEKERK.
1655–60. *Detroit Institute of Arts, Detroit, Mich.*

With Ruisdael, Dutch landscape loses a little of its particularly national character. If the term "heroic" were not inconsistent with the Dutch outlook, one might apply it to his landscapes. In any event they are certainly romantic, with their ruins, rainbows, waterfalls, and great masses of trees. In his work a poetic feeling for quiet streams, forests, or isolated trees begins finally to play a sig-nificant role, though he did have a few timid predecessors, such as his uncle Salomon van Ruisdael, in this approach. Clouds and trees are clearly drawn, and architectural motifs and colors are firm and full bodied. The interaction of light with extraordinarily voluminous forms is entirely baroque and creates an atmosphere that is new to the seventeenth-century Dutch landscape.

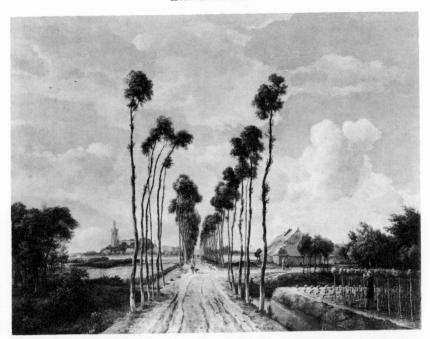

167. MEINDERT HOBBEMA: MIDDLEHARNIS AVENUE. 1689. *National Gallery, London*

Jacob van Ruisdael had built up his canvases with strong contrasts and massed forms, but Hobbema, his friend and probably his pupil, painted with a loose and mellowing brush. The avenue here is carried straight to the horizon by means of sharp foreshortening. Trees, fields, huts, and the village in the background are all subordinated to this central movement, contributing the impression of receding depth. The subdued, entirely undramatic light and the permeating atmosphere are almost palpable.

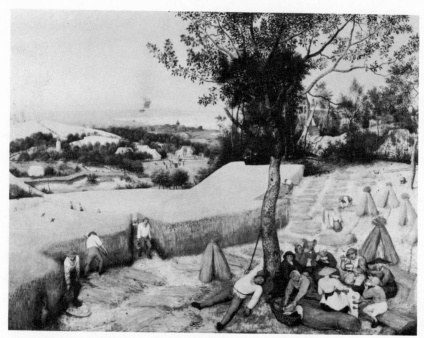

168. PIETER BREUGHEL THE ELDER: THE HARVESTERS. 1565. *The Metropolitan Museum of Art, New York*

"Peasant Breughel" combined scenes of peasant life with landscape themes, just as he integrates landscape with his allegorical, mythological, or Scriptural themes (fig. 68). As he made the life of a peasant into a symbol of man's existence, so he made landscapes a symbol of the cosmos. "The Harvesters," clearly inspired by old calendar illuminations, belongs to a series representing the months of the year, and is one of five that have been preserved. The human figures—peasants reaping or eating, a boy fetching water, women binding the sheaves—are as much a part of nature as the trees or the wheat. Though the firmly designed composition shows Italian influence, the mood belongs to the Netherlands, which alone could have produced the combination of misty horizon and wide prospect with minute background detail. This is a landscape both finite and infinite, both of boundless vistas and close, painstaking description.

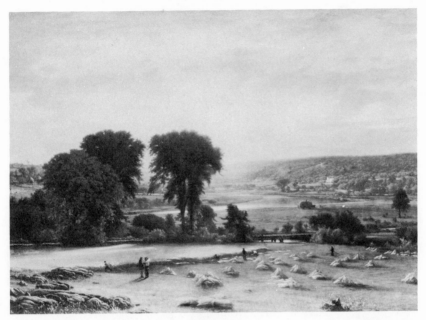

169. GEORGE INNESS: PEACE AND PLENTY. 1865. *The Metropolitan Museum of Art, New York*

The harvest theme has been treated many times, but probably nowhere in a manner so different from Breughel's as in this canvas by the American artist George Inness. Painted shortly after the Civil War, it is a vision of life as secure and peaceful rather than as full of toil and human activity. The hidden violence of nature that menaces the apparent calm of Breughel's harvest scene is entirely suppressed here. In this early Inness painting, romanticism shapes an idyllic normalcy. Still following the early nineteenth-century traditions of Europe, the artist in his almost classicist scheme achieves a careful balance of individual elements in successive planes. It is the union of this classicist discipline with a romantic vision which gives true poetic charm to the coloristic understatement of this canvas.

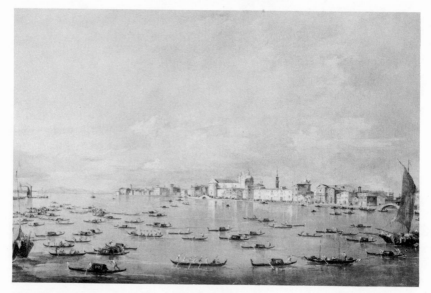

170. FRANCESCO GUARDI: VIEW OF VENICE. Ca. 1780. *Courtesy Fogg Art Museum, Harvard University, Cambridge, Mass.*

Venetian painters had always been more interested in color and light than were those of other Italian schools. Three facts may explain this: the Byzantine tradition of glowing colors, which was part of Venice's heritage; the position of Venice as gateway for imports of richly colored Oriental carpets, fabrics, tiles, and other products; and not least important, the peculiar quality of the Venetian atmosphere, in which mists and exhalations broke all light into brilliant prismatic refractions. The Bellinis, Giorgione, Titian, and Tintoretto had already blended colors more luminously than their Roman and Florentine contemporaries. And in

the eighteenth century, when the Venetian predilection for color was reinforced by the sparkling play of the rococo style, Venetian painting reached a second climax. Guardi's vistas of Venice are somewhat impressionistic in their interpretation of palaces, bridges, gondolas, and colorful inhabitants. His fleet brush blurs all forms till they seem a part of the very iridescence of the atmosphere. Apparently the brilliance of his light sometimes led him to ignore the topographical accuracy prized by his master, Antonio Canale, called Canaletto (1697–1768), and by his nephew, Bernardo Bellotto (1720–1780), also called Canaletto.

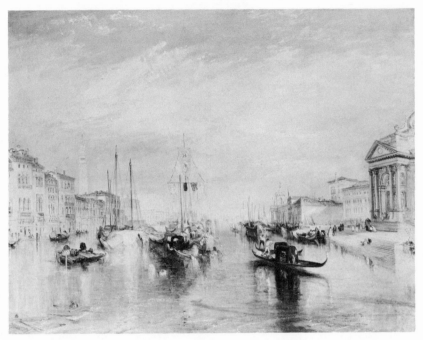

171. JOSEPH M. W. TURNER: GRAND CANAL, VENICE. Ca. 1834. *The Metropolitan Museum of Art, New York*

It was primarily Venice's wealth of literary and historical associations which, in Lord Byron's time, attracted British travelers seeking fulfillment of romantic dreams. It was her watery lanes, glittering façades, and luminous golden-colored air which drew Joseph Turner, obsessed colorist, in search of inspiration. Though Turner certainly blurred his forms with veils of light, he cannot be considered a true forerunner of impressionism. Actually he looked backward, attempting to combine the color effects of a Claude Lorrain with the seventeenth-century Dutch landscapists' delight in broad expanses of water. By intensifying the painterly effects of his Venetian predecessors, Turner did create atmosphere, but it is rather the atmosphere of the stage. The reticence of Guardi's picture obviously contains more impressionist indications than Turner's dramatized interpretations. The meticulous details of the gondola and of the architecture in the foreground and middle distance are not at all consistent with his boisterous applications of color. Yet Turner's typically romantic overdramatization and his desire for more and more color represent a strong impulse toward the liberation of color which took place in the latter part of the nineteenth century.

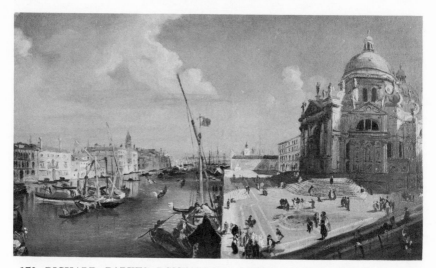

172. RICHARD PARKES BONINGTON: SANTA MARIA DELLA SALUTE.
After 1826. *Worcester Art Museum, Worcester, Mass.*

This vision of Venice by the English painter Bonington (actually a free variation of a painting by Canaletto now in the Louvre) stands midway between the interpretations of Guardi and Turner. More solidly built than Turner's, it shows firm, swift brushwork. Stark contrasts of light and shadow, broken by sparkling accents, almost anticipate the manner of early canvases by Manet.

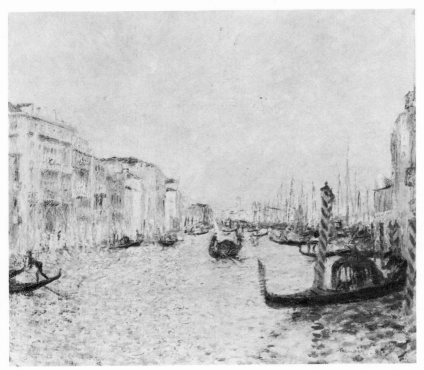

173. PIERRE AUGUSTE RENOIR: ON THE GRAND CANAL, VENICE. 1881.
Museum of Fine Arts, Boston

Renoir's view of Venice epitomizes the handling of color and light in impressionism. Volumes, forms, and lines have lost all their traditional weight. There is nothing tangible or solid here, nothing but air and surface—those elements which are decisive for the unique visual phenomenon of that city.

174. JOHN CONSTABLE: WEYMOUTH BAY. Sketch. Ca. 1816. *National Gallery, London*

The comparison of styles, which is the primary aim of this book, refers essentially to the art of different periods, countries, or schools. Changes in an *individual* artist's style may, however, occasionally point to developments which later become general. Thus both the Englishman Constable and the Frenchman Corot exhibit evolutions in their personal styles which are significant for later trends in nineteenth-century painting. For example, Constable's sketch of Weymouth Bay shows an interest in light and a directness almost unheard of in his time; note the dramatically luminous clouds and the abrupt contrast of large

175. JOHN CONSTABLE: WEYMOUTH BAY. Ca. 1819. *Museum of Fine Arts, Boston*

color areas flecked with impressionist touches. Constable owed much to the seventeenth-century Dutch landscapists, especially Hobbema, and the influence is clear in both of the works reproduced here. In the sketch the traditional vision is modified by the artist's own new way of seeing. But the style of the later finished painting is well adapted to the smooth conventions of the period, halfway between classicism and romanticism. In the painting Constable has subordinated his original vision to the one approved by his age. The stylistic differences between sketch and final painting here go far beyond the changes usual between these two stages.

176. JEAN BAPTISTE COROT: TOWN ON A CLIFF. Ca. 1827. *Smith College Museum of Art, Northampton, Mass.*

There is scarcely any other nineteenth-century painter whose work shows two such strongly contrasting trends as does Corot's art. His fame rests on landscapes that seem to evaporate into mist and silvery atmosphere, in which objects lose their contours in muted light. This was the style of his later period when he, together with Theodore Rousseau, Jules Dupré, Charles François Daubigny, and others, was one of the masters of the so-called Barbizon School (School of Fontainebleau). Then he turned the atmospheric values of the seventeenth-century Dutch landscapists and of the eighteenth-century Venetians into a romantic vision of nature. This vision, however, contained in its interpretation of atmospheric effects so much realistic observation that Corot was called a realist as often as a romantic. In an earlier period of his life, after he had first come to Rome in 1825, he began his

177. JEAN BAPTISTE COROT: BOATSMAN AMONG THE REEDS. 1860–
1865. *The Metropolitan Museum of Art, New York*

work with translucent landscapes built solidly of firmly contrasted lights and shadows and using a palette limited for the most part to clays, browns, and ochers. These landscapes differed decidedly from the then fashionable work of the popular leader of the French academic school, Claude Joseph Vernet. It was Corot's almost architectural structure, the clear-cut juxtaposition of firmly outlined planes, the complete lack of so-called lyrical qualities, that distinguished his work from that of his contemporaries. In brief: he anticipated a concept of visual organization which was later to become characteristic Cézanne and which had appeared earlier in Poussin's work. On the other hand, in those later paintings which caused his world-wide fame, Corot emphasized tonal and coloristic values which made him in certain respects almost a forerunner of impressionism.

178. CLAUDE MONET: POPLARS. 1891. *From the Chester Dale Collection,
on loan to Philadelphia Museum of Art, Philadelphia, Pa.*

It was the showing of Monet's "Impression: Rising Sun," along with works by Pissarro, Renoir, Sisley, and Cézanne, in 1874, that gave the name "impressionist" to the entire group. Monet actually was, and remained, the most vigorous exponent of pure impressionism, for Renoir and Degas to a certain degree, and Cézanne most decidedly, rediscovered structural volume in their later works. Monet, too, was the most insistent plein-airist, that is, advocate of the practice of painting entire pictures outdoors. He often studied and painted the same subject or view under different atmospheric conditions, each as a new visual experience. Landscape naturally offered the widest opportunity for exploring surface impressions and for communicating atmospheric effects that were almost independent of three-dimensional reality.

179. VINCENT VAN GOGH: THE OLIVE PLUCKING. 1889. *Wildenstein &
Co., Inc., New York*

Van Gogh found his most personal means of expression in vehement color, which he explored apart from the qualities of light and atmosphere that absorbed his contemporaries the impressionists. Van Gogh's landscapes, like his interiors and portraits (fig. 137), are governed by violent, unrelieved colors, made even more exclamatory by the extremely subjective dramatization of his themes. His interpretations invested objects existing quietly side by side with a savage antagonism of form, conveyed by thick dark outlines around each object. Every tree swirls; branches and even leaves transmit a sense of turbulence; and the soil undulates and heaves like a stormy sea. There is no static spot in the picture; everything is resistlessly driven. Although such a picture as this is inconceivable before the work of the impressionists, Van Gogh's view of reality is an entirely subjective one, differing from both the objective approach of impressionism and the "scientific" aims of the neoimpressionists (fig. 74).

180. PAUL CEZANNE: MONT ST. VICTOIRE. 1885–87. *The Metropolitan Museum of Art, New York*

Slowly and painfully Cézanne freed himself from impressionism, re-establishing the three-dimensionality of objects, their density and plastic impact. And he required, further, that while conveying the solid structure of things, a canvas be also a meaningful pattern in itself. Volumes are set against one another in successive planes, much as they are in the landscapes of Poussin and of the young Corot. The tree dominating the foreground of this picture, for example, serves both to create distance and structurally to oppose a vertical element to the horizontal viaduct in the farther plane. The geometric forms are created with short shifting brushstrokes that weave a closely knit pattern. The color is cool and reserved; it does not compete, as in the work of the impressionists, with the plastic aspects of reality, but is employed primarily to fortify forms through low-keyed tonal sequences.

181. ANDRE DUNOYER DE SEGONZAC: HARBOR SCENE. Between 1925 and 1930. *Collection of Mr. and Mrs. Sam A. Lewisohn, New York*

Although Segonzac was under the spell of Cézanne and Van Gogh, he nonetheless succeeded in developing a certain stylistic independence. A classicist by temperament, he held the ideal of the *tenue,* an utterly simple balance which he built up with fat dabs of pigment. His palette is extraordinarily rich and dense, where Cézanne's is restrained and is used only to clarify forms and volumes. There is a sensuous enjoyment of color which is equally distant from Cézanne's locally confined colors and Van Gogh's outbursts of turbulent paint.

182. LYONEL FEININGER: THE BLUE CLOUD. 1925. *Buchholz Gallery,*
New York

Feininger adapts the cubism of Picasso and Braque (figs. 228, 229) to a highly individual style of his own. He dissolves the visual world into transparent patterns of sharply defined angular areas, differentiated essentially by light, thin colors. Naturally he stresses the immense continuous planes of sky and water as well as those architectural elements whose natural forms already correspond to his ideas of design.

Interior

As an independent subject for painting, Interior came into its own with the Dutch masters of the seventeenth century. Before that time, interiors had been painted for their intrinsic interest, although the ostensible purpose was to provide background in religious and historical scenes. Actually, whenever the artist gave his fullest descriptive energy to the setting, the religious or mythological content became secondary.

During the first centuries of the Christian era, Roman artists were familiar with the laws of perspective but did not use them to construct actual interiors. The Roman muralist suggested his setting with "props"—a door, a window, a couch, a few columns supporting an architrave. Roman murals rarely show the solid structure of floor, walls, and ceilings, the artist usually being content with a frame that resembled a stage set.

The paintings, mosaics, and illuminated manuscripts of Early Christian and Byzantine art reveal no true interiors, since such art rejected perspective and three-dimensional space along with its rejection of the material world. Instead it developed architectural symbols which could be used to indicate a palace, a stable, and even the "heavenly Jerusalem." Sometimes a solitary piece of furniture, such as a throne, a table, or a bench, signified an entire room. The same simplification occurs throughout the Middle Ages. In the later Gothic period, there were hesitant efforts to describe interiors, but with very imperfect perspective.

The Renaissance brought a rediscovery of perspective and certain optical effects, and painters began to map and chart the "geography" of interiors as adventures in bounded space. From this time onward four different trends developed. In the first, the artist reproduced a definite physical or socially typical environment in order to clarify and set his story. In the second, he used the interior as a compositional aid for the design of his picture. In the third, he employed interiors to convey a certain mood or atmosphere. In the last, he was interested only in the plastic and painterly values found in the shapes of rooms and their equipment; his attention was on the room itself, the texture brought into being by colors, lights, and shadows, and out of these he created a picture as he might create a still life out of the fruits and vases on a table. Of course two or more of these intentions might be fused in one painting.

Interior as a Descriptive Element. To identify a scene, the artist introduces characteristic objects: barrels and drinking vessels for a tavern; anvils and

bellows for a forge; certain types of furniture for a drawing room. Like a stage director, he fills the scene with recognizable "props," and we identify the background even before we take note of the action. Excellent examples of interior as descriptive background can be found in seventeenth-century Dutch paintings, in the "conversation pieces" of Hogarth, and also in paintings of a very different order, namely, the works of social significance which began at the end of the nineteenth century.

Interior as a Structural Aid to Composition. Here the interior functions almost as architecture. When the Virgin and the announcing angel, for instance, are framed by impressive arcades, when the figure of Christ is clearly silhouetted by light radiating from a window behind Him, and when the spectators in a religious episode lean against symmetrically placed doors, then the artist is employing architectural elements and ornaments not for their own sake but to give dramatic underscoring to the figures of his drama. Such were the interiors in medieval paintings and illuminated manuscripts, and in most Italian Renaissance art. Raphael's murals, and of course Leonardo da Vinci's "Last Supper," are typical of this approach.

Interior as an Element of Mood. In this type of interior painting, the walls, windows and doors, furniture and decorations of a chamber are used primarily to evoke a mood and sustain a subjectively felt atmosphere. The artist floods these inanimate objects with light or casts them into shadow, fusing their colors into a single feeling of gloom, or mystery, or serenity. This was the intent of some seventeenth-century Dutch masters, and particularly of Rembrandt; a similar use of interior as mood is evident in the eighteenth century in some of the works of Chardin and in the nineteenth-century German romanticists.

Interior as Still Life. The glow of a lighted stucco wall, draped curtains, the intricate elegance of certain furniture, exuberant colorings in rug and carpet, golden or nacreous reflections on copper bowls and crystal candelabra—all such elements may be combined to form a large still life. When human figures appear in the room, they are bathed in the quality of this *nature morte.* Their personalities and their actions are of less interest than their existence as mere òbjects among all the other objects that fill and give form to the space. In this context, there is really no background. The inanimate things do not serve to clarify a story; they are themselves the story. Such was the creative intent of many seventeenth-century Dutch masters, especially Vermeer van Delft, and sometimes of the French impressionists.

THE BIRTH OF THE VIRGIN, AND THE NURSERY

A great many secular scenes from daily life received no pictorial attention until the advent of genre painting in the seventeenth century, since they were not considered worthy of being depicted as independent events. The theme that later became the nursery theme of mother and child with attendants was first localized, before and during the Renaissance, in the Birth of the Virgin theme, just as the first use of the theme of the Artist in His Studio showed the artist's surroundings projected into a version of St. Luke painting the Virgin. Naturally this rather democratic identification of sacred episodes with ordinary human events was possible only with episodes of minor religious importance. The Annunciation, Nativity, or Crucifixion, for example, partook too distinctly of the divine or miraculous to be viewed as common human experience. Such scenes as the Resurrection or Pentecost were of necessity entirely supernatural. In scenes of revelation and miracle, all analogy with ordinary temporal experiences would have been impossible both emotionally and artistically.

However, the abundance of homely episodes in the Old and New Testament and in the legends of the saints challenged the artistic imagination to visualize quite realistically certain scenes comparable to common experiences of the artist and his contemporaries. The way each artist depicted these sacred scenes— in not always too reverent a manner—depended essentially on two factors: first, his own social environment and the compass of his worldly experiences and, second, his degree of respect for the holiness of the episode.

The New Testament makes no statements about the birth and childhood of the Virgin. On the other hand, scarcely any figure in the New Testament has been the center of so much Christian homage and mythmaking. Stories and legends from her life have inspired countless artists and poets. The favorite *Marienleben* (life of Mary) themes in medieval and Renaissance art were her birth, her presentation in the Temple as a very young girl, and her death.

When dealing with birth and nursery life, the artist, guided by first-hand knowledge or by imagination, took pains to depict typical accessories, domestic arrangements, the costumes of attendants, swaddling and nursing procedure, and details of the bedroom interior. Social milieu and relationships play an important part in this scene, and we see countless friends and relatives bringing gifts, women neighbors helping the mother or lending a hand with household

chores, and all the commotion and responses that attend the coming of a new life. The reflected social level is sometimes very high, but more often it is middle class or humble. There was no attempt to reconstruct the actual historical background of the Virgin's birth in ancient Palestine. Therefore the transition from describing the birth of the Virgin to recording birth scenes in contemporary homes came about naturally.

In all these birth and nursery scenes, as in the rendering of any other topic, composition, color scheme, and light map developments in style. This is evident from early times, when the interior was merely descriptive background, to the seventeenth century and later periods, when it became the pictorial focus of the painting. Beyond these general stylistic differences, however, rendering of nursery scenes involves still another factor affecting style. This is the important role played by the interior as such, and by the individual furnishings and utensils, which are more prominent here than in the rendition of most topics. The forms of these objects naturally reveal changes of style in the applied arts. As part of a painting, they provide an additional characterization of the period, beyond that created by the concept of the work as a whole. Thus these domestic scenes reflect the style of a period in two ways: directly, as any work of art of a particular period does; and indirectly, by the changing elements of their subject matter.

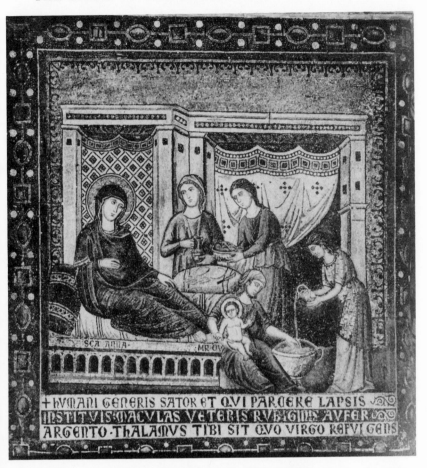

183. PIETRO CAVALLINI: THE BIRTH OF THE VIRGIN. Mosaic. Ca. 1291–1300. *Santa Maria in Trastevere, Rome*

By 1300 such leading Roman mosaicists and fresco painters as Pietro Cavallini and Jacobus Torriti (fig. 60) had begun to throw off the rigidity of the Byzantine style and to suggest a certain illusion of space. In Cavallini's mosaic cycle devoted to the life of Mary, St. Anne is depicted lying on a bed and attended by two maidservants, while two other servants are bathing the newborn child—all in strictly frontal representation. The background of curtains hanging between pillars is deployed like a flat screen, but the architectural elements themselves, and the table and bed, are meant to suggest three dimensions, despite the faulty perspective and lack of relation between the objects. Compared to the symbolic settings of earlier Byzantine mosaics, this scene is recognizably an interior, though the indications of space are not as effective as those achieved by Giotto in the same period (fig. 47).

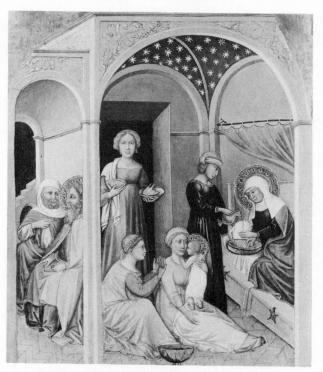

184. ANDREA DI BARTOLO: THE NATIVITY OF THE VIRGIN. First quarter fifteenth century. *National Gallery of Art, Kress Collection, Washington, D.C.*

The late Sienese masters, including Bartolo di Fredi, Sano di Pietro, and Sassetta (fig. 150), generally clung to the medieval tradition of the Sienese school and turned toward the naturalism of the Renaissance with much hesitation. Yet we find such a Sienese artist as Andrea di Bartolo, the son and pupil of Bartolo di Fredi, depicting the Birth of the Virgin with an evident delight in amusing naturalistic details: note St. Anne washing her hands, an attendant dandling the newborn babe, and another attendant bringing fried chicken! Probably influenced by Giotto, the artist has unmistakably defined the scene as an interior. The bedroom with its painted ceiling vault and its curtained alcove is separated from an antechamber where St. Joachim converses with a visitor. We are shown both rooms from the exterior, the house being represented as a stagelike shell. It is true that the perspective is faulty and that the figures are out of scale—as is only to be expected in a painting of about the year 1400—but that the artist attempted to suggest space and depth is beyond question.

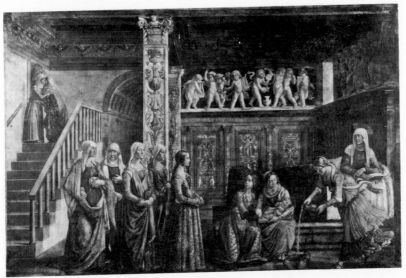

185. DOMENICO GHIRLANDAIO: THE BIRTH OF MARY. Ca. 1490. *Santa Maria Novella, Florence. Photo ENIT*

In the Santa Maria Novella murals, Ghirlandaio painted two birth-chamber scenes, one depicting the birth of St. John the Baptist and the other the birth of the Virgin. The central theme of mother and holy infant is almost overshadowed in both scenes by subsidiary motifs: visiting relatives and friends, servants, furniture, and décor. The birth of the Virgin is set in the more elegant interior, a room typical of a lavishly appointed Florentine Renaissance palace. Hall and staircase lead into other rooms, the walls inlaid with precious woods and topped by a marble frieze of gamboling *putti*, and the ancient motifs on the columns reflect Ghirlandaio's keen interest in antiquity. The various events depicted in this fresco are no more important to the artist than the interior, flawless in perspective, which reflects the climax of splendor in décor at the end of the fifteenth century.

186. FRA CARNEVALE(?): THE BIRTH OF THE VIRGIN. 1467. *The Metro-politan Museum of Art, New York*

Though painted earlier than Ghirlandaio's fresco, this panel with its spacious halls and architectural details anticipates the spirit of the High Renaissance. This feeling for monumental architecture obviously prevailed at the ducal court of Urbino, where Fra Carnevale worked and where Raphael and Bramante, the masters of High Renaissance architecture, were soon to make their appearance. The panel is not limited to a single interior but depicts the entire palace from the outside as well as a room inside. The structure is conceived in full, as against di Bartolo's shell-like representation of the same scene, and is, in its ornamental reliefs of mythological figures, definitely "antique" in mood. The event of Mary's birth is somewhat subordinated to this dominating structure: mother, child, attendants, and visitors are reduced to secondary importance. Arranged in successive planes, they chiefly serve, along with the sequences of columns and arches, to increase the sense of depth and space. Where Ghirlandaio composes his interior by the accumulation of decorative details, Fra Carnevale makes use of monumental perspective to construct house and interior. A sacred episode has become scarcely more than a pretext for indulging in grand architectural fantasies.

187. ANDREA DEL SARTO: BIRTH OF MARY. 1514. *Santissima Annunziata,*
Florence

A fully matured High Renaissance spirit stamps this fresco by the Florentine Andrea del Sarto. Neither perspective nor details are overstressed, figures and furniture are well distributed about the room, and the room itself is harmoniously proportioned. The story is clear, and the interior is neither overelaborate nor reduced to mere background. The little *putti* take part in the event without detracting from the dignified solemnity of the visitors or from the realistic domesticity of the servants. Space is conveyed by light radiating from a window at the right and from an undefined source in the foreground. The colors are unusually brilliant for a fresco. A genuine atmosphere, revealing the influence of Leonardo da Vinci's chiaroscuro and of Venetian colorism, unites all elements.

188. BARTOLOME ESTEBAN MURILLO: THE BIRTH OF THE VIRGIN.
1655. *Louvre, Paris*

Fusing exalted vision with realistic details, the Spaniard Murillo reduces the interior, so often an essential part of this theme, to mere background. St. Anne in her bed and the servants at the fire are barely visible in the depths of shadow. The mild, unearthly light, characteristic of Murillo's work, is concentrated on the holy infant and her angelic visitors, softening the baroque animation of intersecting and counterthrusting diagonals.

189. MATIAS ARTEAGA Y ALFARO: THE BIRTH OF THE VIRGIN. Last half seventeenth century. *Provincial Museum, Seville*

For the Spanish artist Arteaga y Alfaro, space and architecture all but overshadow story. He enlivens many of his vast perspective constructions, recalling stage designs, with scenes from the life of the Virgin. Gestures, the grouping of figures, the interior, and the palace architecture, all are fused in and united by chiaroscuro —a chiaroscuro which in this case also helps to create space.

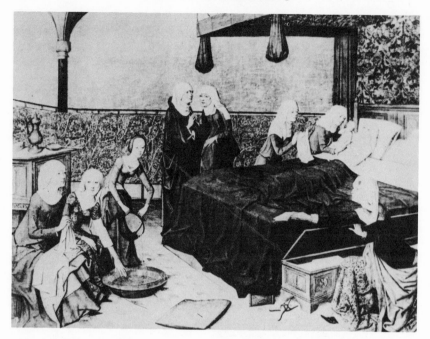

190. MASTER OF THE LIFE OF MARY: THE BIRTH OF THE VIRGIN.
Ca. 1470–80. *Alte Pinakothek, Munich*

In the late fifteenth century, German painters of the Cologne school sought anxiously to achieve that visual conquest of reality which they found in Flemish art. Unlike Stefan Lochner (fig. 69), his townsman of an earlier era, the unknown master of this panel attempted to follow the Flemish Rogier van der Weyden and Dirk Bouts (figs. 49, 65), but his grasp of perspective was not up to the task of conveying an interior convincingly. The figure groups are undoubtedly touching and the responses of the middle-class townsfolk to the happy event are faithfully observed; yet the room with its double bed—the height of luxury to the good burghers of Cologne—is not at all clearly defined. We cannot even tell whether the little column with the cross-vault springing from it indicates a rectangular corner. The composition fails to organize the figures, each of which acts out its part before an isolated piece of descriptive background. In the absence of structural clarity a certain poetic naïveté takes the place of naturalism.

191. ALBRECHT ALTDORFER: THE BIRTH OF MARY. Ca. 1520. *Alte Pinakothek, Munich*

Displaying a certain poetic imagination, Altdorfer sets the birth of Mary in the aisle of a late Gothic cathedral—a cathedral which already shows some Renaissance ornamentation. A maidservant is caring for St. Anne on the bed, another fondles the newborn baby, a third maid is leaving the scene, and St. Joachim is entering with a loaf of bread. Apart from this interior within an interior, devotions continue in the church as usual. The holy episode is tied to the reality of the church by a splendid vision of angels flying in a round-dance from the dark vault of the aisle up to the light-flooded nave. It is this celestial dance which brings all parts of the church into convincing relationship. The masterly directing of the light makes us forget the incongruity of this place as a birth chamber. By its glow we perceive a unity of space enveloping the sacred family scene.

192. PIETER DE HOOCH: THE MOTHER. Ca. 1659–60. *Kaiser-Friedrich Museum, Berlin*

The transformation of the sacred episode into a scene from contemporary family life took place in the North. This was particularly true of the Dutch seventeenth-century painters, whose major interest, along with landscape and still life, was the interior. De Hooch and Metsu share a preoccupation with light, color, and texture. For them, an interior is above all a unifying space, one that can bind together various separate still-life effects.

In de Hooch's canvas light pours in through the window and rear door and actually builds up the interior, and every object has clear form and texture. There

193. GABRIEL METSU: VISIT IN THE NURSERY. 1661. *The Metropolitan Museum of Art, New York*

is no "story," no dynamic sequence of events—only a peaceful and secure existence as seen by seventeenth-century Dutch eyes.

Metsu, like the Italian and German fifteenth-century masters, actually tells the story of a visit to the newborn child.

The interior of the opulent bourgeois home that he reproduces is toned down to mere background, permitting only the carpet and table to retain some still-life interest. Metsu relies more on the sensuous effects of his color scheme than on the direction and modulation of light.

194. JEAN HONORE FRAGONARD: THE VISIT TO THE NURSERY. Ca. 1767. *National Gallery of Art, Kress Collection, Washington, D.C.*

In France, a similar secularization of this Scriptural subject took place in the eighteenth century as in seventeenth-century Holland. Fragonard's characteristic sense of the special qualities of colors (figs. 16 and 71) is evident in this "Visit to the Nursery." But the anecdotal interest, couched in terms of French eighteenth-century sentimentality, is so insistent that one must study the canvas to discover the structural function of the room. Such study shows that the light caught by the curtain or the door edge serves to balance the lighted figure in the middle and that the curving canopy, the hats, and the hood of the cradle are clearly framed by the horizontal of the rear cupboard and the lower edge of the cradle. Although the interior has relatively few elements, it plays an important part in the composition.

THE ARTIST IN HIS STUDIO

The artist naturally sees his occupation and his workshop as interesting and likes to describe both. The first attempts in this direction may be seen in numerous pictures showing St. Luke painting the Madonna. St. Luke had become patron saint of the artists' guilds when medieval legends spread the story that he had painted the Virgin. Artists of the fifteenth century used the St. Luke theme as pretext for scenes from their own lives, in contemporary settings. After the Reformation, artists found the courage to paint themselves and their environment without the pretext of legend: in the secularized handling of the theme the Virgin became a living model and the room described was the artist's own studio. Under such auspices reality was evidently felt to be truly worth depicting.

Throughout the centuries, the theme of the Artist in His Studio has been the occasion for many interpretations of Interior as an aesthetic experience, and only occasionally as mere background for a self-portrait.

195. ROGIER VAN DER WEYDEN: ST. LUKE PAINTING THE VIRGIN.
Ca. 1435–40. *Museum of Fine Arts, Boston*

Still not daring to portray himself in his own surroundings, the artist here depicts St. Luke, patron saint of painters, drawing the Virgin. The room, with its view of a late medieval town, is not a typical artist's studio, nor is the Virgin drawn from an actual model nursing an infant. Yet the rendering of all the details shows clearly the artist's familiarity with scenes from everyday life. Influenced by his travels in Italy, van der Weyden added typical Italian columns and a marble floor, combining with a native Flemish interior certain atmospheric and imaginative elements apparently deemed more appropriate to the dwelling of divinity.

196. SO-CALLED MASTER OF THE PERINGSDOERFER ALTAR: ST. LUKE
PAINTING THE VIRGIN. 1487–90. *Germanisches Nationalmuseum, Nuremberg*

Many German treatments of the St. Luke theme in the late fifteenth century are closer to earth and depict more of the artist's actual studio world than does Rogier van der Weyden's work. This panel, which is better known than similar paintings by such North Germans as Herman Rode and Victor Dünnwege, was once thought to be the work of Dürer's teacher, Michael Wohlgemuth, but is now ascribed to Wohlgemuth's workshop.

Here St. Luke is shown as a contemporary painter surrounded by the materials of his craft. Virgin and Child are posed as actual models, and the picture on the easel shows the connection between reality and art. Although carefully calculated, the perspective is still incorrect, having two vanishing points, but the effect is nevertheless that of a real interior, detailed and intimately known.

197. MABUSE (JAN GOSSAERT): ST. LUKE PAINTING THE VIRGIN. Ca. 1515. *State Gallery, Prague*

The Flemish painter Mabuse, who painted the St. Luke theme twice, executed this version for the Guild of St. Luke in Malines, probably in order to display to his colleagues his skill in perspective and Renaissance forms. Intimacy is gone, the architectural frame being less a home or interior than the porch or loggia of a palace. St. Luke is separated from Mary by a perspective view down a street. The over-rich colonnades, inspired by Mabuse's trip to Italy, do not make up for the lack of warmth. Tricks of perspective and an erudite use of antique forms clash with the broken Gothic lines of the figures. The Flemish atmosphere is incompatible with Renaissance motifs introduced for reasons of scholarship rather than visual conviction. The artificial result, lacking completely the emotional sincerity of earlier St. Luke treatments, is typical of this period in Flemish art.

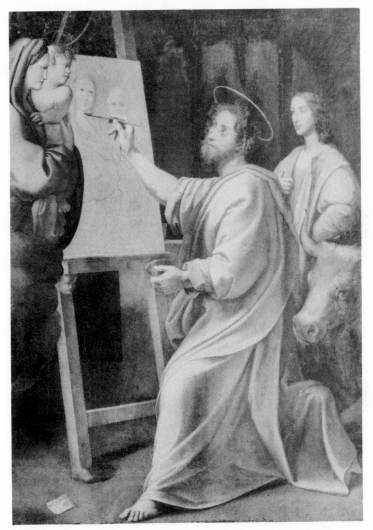

198. ITALIAN SCHOOL: ST. LUKE PAINTING THE MADONNA. Second half sixteenth century. *Accademia di San Luca, Rome*

Basically unlike Northern conceptions of St. Luke, this canvas concentrates on the story itself. Emphasizing the act of painting, it disregards the interior as an element in the scene. The unknown Italian mannerist, perhaps Taddeo or Federigo Zuccari, thought in broad architectural terms, ignoring environmental details. The influence of Raphael is reflected unmistakably in the organization of the picture as well as in the individual figures.

199. JAN VERMEER VAN DELFT: THE ARTIST IN HIS STUDIO. Ca. 1665–70.
Kunsthistorisches Museum, Vienna

The quiet monumentality of this serene work, done at the same time as "Las Meniñas" by Velásquez (fig. 201), is astonishing. Compared to Vermeer, all other artists dealing with the same topic seem to be mere storytellers. If the slogan *l'art pour l'art* could ever be applied purely, it could be to this canvas, in which the figures have no more narrative or thematic import than apples in a still life. This lack of interest in story-telling goes so far that the artist gives a rear view of himself. As in a still life, the aesthetic interest is in the orchestration of pure, cool colors—blue-green, orange,

brownish-red—and the texture of surfaces. The model is posed as a "Fama," an allegorical figure of "fame." The light tones in which she is painted grade into the sensitively described wall, and the dark cap and clothes of the seated painter relate to the draped foreground curtain. The ceiling beams, curtain, chair, and tiled floor frame the interior as a stage is framed by a proscenium. The room is enlarged by the sharp contrast of foreground and background. The picture is a perfect example of interior conceived as still life, enchanting visually, and evoking a mood of serene harmony.

200. ADRIAEN VAN OSTADE: THE ARTIST IN HIS STUDIO. 1663. *Staats-galerie, Dresden*

Vermeer's contemporary, Ostade, though influenced by Frans Hals, Adriaen Brouwer, and Rembrandt, was a more folksy artist than they were. While striving to paint interiors through subtlest light nuances in Rembrandt's manner, Ostade unconsciously focused on story elements. This interior, background for a self-portrait, overemphasizes "artistic disor-der," materials of the painter's craft being strewn about in order to convey the romantic carelessness and independence of an artist's life. Since the result is almost a stage set for an "interesting" Bohemian scene, the values are anecdotal rather than visual. The painting is typical of the contemporary Dutch interest in genre.

201. DIEGO RODRIGUEZ DE SILVA Y VELASQUEZ: LAS MENINAS (MAIDS OF HONOR). 1656–57. *Prado, Madrid*

In contrast to Dutch interiors of the same century, this canvas by Velásquez is very large. The artist depicts himself painting the Infanta Marguerita with her ladies-in-waiting, dog, and court dwarf. The mirror at the rear reflects the king and queen at the studio door. Velásquez, diplomat and court painter, working almost exclusively for the king of Spain, created this picture ostensibly as a portrait of the Infanta but actually as a self-portrait, with the royal group serving to enhance his own position. Yet we feel his fundamental artistic aim was to build up an interior through light effects. Light comes from a source outside the picture and streams from the open door at the rear, helping to place each figure in relationship to the total interior. The lighted left-hand edge of the huge canvas functions like the curtain in Vermeer's interior, and the glittering brocades of the dresses make the dark rear wall seem to recede still more. Although they are exactly and profoundly projected, persons and objects are still secondary to the harmonies of light, in contrast with the genre trend of Dutch interiors.

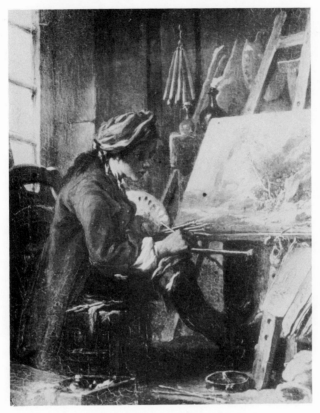

202. FRANÇOIS BOUCHER: ARTIST IN HIS STUDIO. Ca. 1715. *Louvre, Paris*

Boucher's art is pure rococo, an integral part of the period which substituted the pretty for the beautiful. Boucher's coquettish academicism, decorativeness, and striving for effect are as evident in this studio-set self-portrait as in his mythological and pastoral scenes. Though cupids and shepherdesses are absent here, the light skips from brush to palette, from window frame to wall, from the artist's neck to the tip of his nose. The simplicity of the scene is carefully staged, everything being arranged to produce a romantic, picturesque atmosphere. Yet, compared with Boucher's other paintings (figs. 35 and 94), the intimacy of the environment here gives the effect of a fresh and casual study. The Bohemianism of the artist's workroom is emphasized to sharpen the contrast with the courtly atmosphere of most of Boucher's work.

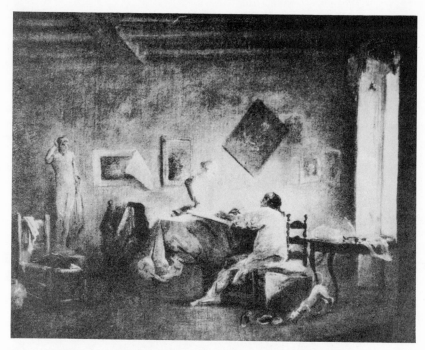

203. HUBERT ROBERT: THE ARTIST IN HIS STUDIO. Last quarter eighteenth century. *Louvre, Paris*

Robert, famous for his paintings of Roman architecture and landscapes studded with ruins, presents a much more honest studio interior than Boucher. The intimacy is genuine: the disorder, the pictures askew on the wall, the spottiness of the light, and particularly the casual posture of the artist—as though he were a subordinate figure and not the subject of a self-portrait. The atmosphere of the room, charged with the nervous tension generated by the working occupant, is apparently not arranged for effect. The playfulness and artificial romanticism of rococo is giving way to a quiet recognition of the life of the rising middle class, and the artistic interpretation of interiors has undergone a parallel development.

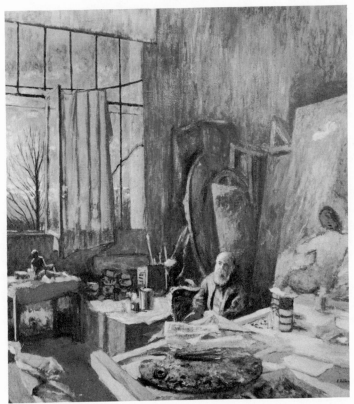

204. JEAN EDOUARD VUILLARD: INTERIOR. 1925, retouched 1935. *Petit Palais, Paris*

From their very nature, impressionism and plein-airism were unlikely to encourage an interest in the presentation of interiors; and even when impressionists painted human beings indoors they paid little attention to the room itself. Vuillard, however, did adapt a modified, somewhat decorative impressionist manner to the handling of interiors. He belonged, along with Pierre Bonnard and Odilon Redon, to a group which, although no longer fully satisfied with the visual means of impressionism, had not found such distinctly new means as were later to be found by the *fauves*. In this canvas Vuillard admits a cool wintry light from out-of-doors into the high-ceilinged studio and causes it to be reflected by furnishings, instruments, and the artist. The human figure, Vuillard's brother-in-law, is handled, like any other object, as a way station for color and light, but at the same time as a symbol of aged wisdom.

THE GIRL BY THE WINDOW

The real theme in every version of this motif is the contrast between the indoor and outdoor world, with all its visual and psychological implications. There are also many other topics whose representations allow the artists an outlook into the outer world through a frame created by the foreground. However, we are not made conscious of this contrast, for instance, in the panoramic views appearing behind the figure of an Italian Renaissance Venus (figs. 12 and 13), in the vistas behind the figure of St. Luke painting the Virgin (fig. 195), or in Flemish and Italian Annunciations and legends of the saints. In these, the opening through the rear wall and the view beyond, which are actually the historical beginnings of landscape art (see Landscape), are meant only as decorative additions, that is, as part of the background. The painters neither felt nor stressed the contrast between the interior as a manifestation of human order, in which the human hand has organized the forms of shelter and furnishings, and the unorganized outdoor world in which countless diverse objects exist side by side.

The window in earlier paintings was an opening to admit light and sometimes to afford a partial view of the outside world. Gradually the window begins to assume the function of a selective frame. This frame creates a picture within a picture and becomes a visual device for stating the contrast between interior and exterior, so that the framed-in view is separated from the interior and yet remains a part of it.

The motif of the frame within a frame is familiar to us from many seventeenth-century Dutch genre scenes: a child blowing bubbles out of a window, a cavalier smoking his pipe or lounging against the sill, a young girl beckoning, and so forth. In these, the window frame is still used chiefly to play up the character of the figure. The view is from the outside looking in, and our interest is centered on the individual as a subject for genre description or portrait study. Goya's "Majas on the Balcony" and Manet's "On the Balcony" also belong in this category. In all these pictures, the interior, if recognizable at all, creates only a more or less distinct darker background for the figures.

The window as the main motif of an interior viewed from within has a very different meaning. Since we are looking at the window over the shoulder, as it were, of the depicted figure, we are led to identify ourselves with him and to share his mood. Here, too, the means of visualization changes from age to age; and the interest also shifts, resting now on the human figure, now on the atmosphere of the room, but seldom on the prospect through the open window.

Different as the various solutions may be, they have one factor in common: the light streaming in through the window always serves to bind the figure more closely to the interior, to connect the human being with its surrounding walls, furniture, and utensils. Thus it emphasizes the fusing of the individual with its organized environment. Light becomes merely the messenger from the outside world, which in itself is not an object of interest.

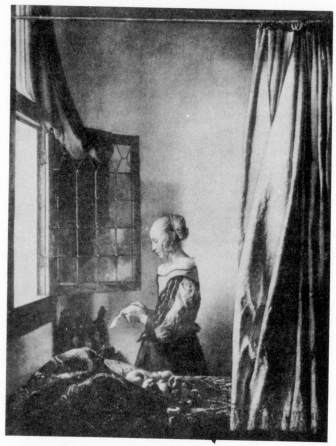

205. JAN VERMEER VAN DELFT: GIRL READING A LETTER BY A WINDOW. Third quarter seventeenth century. *Staatsgalerie, Dresden*

This picture and Vermeer's "Artist in His Studio" (fig. 199), are constructed in much the same way, using successive layers or stages parallel with the picture plane, and even employing the curtain as a structural element. The primary difference between the two is in the lighting: in this canvas the window, radiating light, increases the contrast between the interior and the outer world and intensifies the aura of privacy surrounding the figure of the young girl in her chamber. The girl and the objects about her have almost the silent character of a still life. In this canvas Vermeer reduces story content to a minimum and concentrates on the relation of color values as his central problem.

206. JACQUES LOUIS DAVID: MADEMOISELLE CHARLOTTE DU VAL
D'OGNES. 1799–1800. *The Metropolitan Museum of Art, New York*

Both David and Vermeer arrange the suc-
cessive planes of their paintings parallel
with the picture plane, but there all re-
semblance ceases. Where the seventeenth-
century Dutch master wraps figure and
interior in one flowing chromatic se-
quence, the French neoclassicist is
scarcely interested in the room as an
interior. He employs wall, window, and
even the entering light merely as de-
scriptive details to form a screenlike back-

ground for the figure. The same approach
is evident in his famous portrait of Ma-
dame Récamier (fig. 121). Note how in
this interior the strong verticals and hori-
zontals merely serve to outline the figure
more precisely, and how the cool light
illuminates the girl but does not fill the
room. The interior serves as an appro-
priate frame for a portrait without receiv-
ing attention as a subject in its own right.

207. MORITZ VON SCHWIND: MORNING-HOUR. 1858. *Schack-Galerie, Munich*

German romanticism looked upon painting as an occasion for literary rather than visual experiences. Spectator and artist alike approached the object less as a problem in form, color, and composition than as a starting point for poetic associations. In this it differed from French romanticism, wherein a Géricault or a Delacroix (fig. 43) was able to embody literary associations in genuinely visual terms. Von Schwind here reproduces the light-flooded morning atmosphere of his daughter's room with a humbly faithful attention to every kind of detail. But form, color, and design remain items in a narrative rather than a visual sequence. So von Schwind here creates a specific mood, reflecting a typically romantic blending of subjective and objective attitudes. The unity between the interior and the figure of the young girl is arrived at less by a painterly vision than by a careful inventory of middle-class furnishings.

208. HENRI MATISSE: GIRL IN GREEN. 1921. *Collection Mr. and Mrs. Ralph F. Colin, New York*

Matisse's vibrant colors and brilliantly decorative patterns—frankly Byzantine-Moorish in inspiration—together with lighting dappled and filtered by half-open shutters, bring about a new marriage between the indoor and the outdoor world. The result is that this room seems a part of the open space beyond. Where his predecessors emphasized the contrast between the enclosed area and the out-door world, Matisse feels the continuity of the two. His characteristic procedure becomes markedly clear in this picture: by means of large, unmodeled areas of color, and an all-embracing, unlocalized illumination, he produces space relations without any definite perspective depth and without vital distinction between living figures and inanimate objects.

Still Life

Still life bears much the same relation to other forms of painting that chamber music does to other forms of musical composition. Its enjoyment requires a keen response to the pure qualities of the medium, a faculty for contemplating the patterns of linear statements, composition, light and shade, textures and color combination, and perhaps most important, the infinite range of tonal values. Dürer's claim that all painting is as enigmatic as a foreign language to anyone but artists is certainly an extreme statement, yet it is almost true of still life. The still life lacks any overt story, religious or mythic meaning; it is indifferent to those literary and historical associations which seduce many into enjoying genre, portraiture, and figure painting, and it is certainly without that aura of vague emotionalism which Victorians mistook for art and beauty because it gave a rosy glow to the harsh stuff of reality. In other words, still life is independent of all nonvisual associations. The plastic values are of decisive importance, and must be appreciated almost as abstractions in themselves. Still life offers no "human interest," but simply a collection of fruits, flowers, cabbages, glasses, pots, pans, dishes with dead fish, oysters, dead rabbits, pieces of fabric, and other equally unpredictable objects. Translation from reality into picture is the sole aim. The artist approaches his subject without preconceived ideas or notions based on nonvisual experience. Still life is food for the eye, never for the mind. Yet it is possible to be profoundly moved by an arrangement of glowing goblets, voluted shells, or merely apples on a tablecloth.

It is a misconception to look upon still life as a kind of decoration in which appropriate things are arranged for the dining room. It is a pure concentration on the world of the eye, drawing on no storehouse of content or verbal ideas. Its variety as an art form lies in the fresh view that each artist takes of reality and in the fresh idiom he develops for translating inanimate objects—*nature morte* is the apt French term—into forms and colors, light and shadow. Thus if the flowers in a particular still life happen to have come from a wedding bouquet or a funeral wreath, the artist presents them without involving us in the emotional associations of either situation. Still life may be defined as the art of organizing the visual aspects of things without regard for their associations and meanings.

It is easy to see that the still lifes of ancient art, Cretan, Greek, and Roman, were not still lifes in our present sense, though they, too, depict flowers, shells, fish, animals, and accessory objects like pitchers and vases. Minoan murals,

Pompeiian murals, and Roman mosaics were intended to create a descriptive illusion or to decorate a chamber, and nothing more. The antique still lifes were decorative motifs, suitable to the rooms they enriched and often wonderfully skillful, but without atmosphere in the painterly and psychological senses. That emotional experience by which the eye is made aware of a higher order and intensification of reality as compared with the blurred generalities of our daily surroundings is absent from all ancient still lifes.

After the medieval negation of nature was finally overcome and the Renaissance had literally rediscovered this earth, garlands of fruits and flowers and vases filled with blossoms began to make their appearance in pictures. Yet Crivelli's profuse, carefully drawn garlands and festoons of bright fruits, or the floral foreground in van der Goes' "Adoration of the Shepherds," were not true still lifes but rather decorative elements to which the painter gave prominence so that he might indulge in the newly developed techniques of realism. Certain fruits and flowers were still sometimes derived from Christian symbols originally introduced for hieratic rather than decorative or evocative reasons. Grapes signified the Blood of the Lord, the lily was Innocence, the peacock denoted Immortality, the fish stood for Christ, and so forth. Again, comparatively early versions of the Last Supper begin to show plates, drinking vessels, and even food on the table, but these descriptive elements were added only to fill out the sacred episode and make its visualization more intimately memorable for the faithful who could not read. These dining accessories acquired independent artistic importance only after the middle of the sixteenth century. In such paintings as the "Last Supper" by Tintoretto (fig. 54) and the "Feast in the House of Levi" by Paolo Veronese (fig. 91), for example, the purely artistic treatment of the table furnishings became more forthright as the distinction between symbolic and aesthetic values disappeared.

Not only religious paintings but also portraits, especially in the North, began to show still-life elements as secondary focuses of interest. From van Eyck's Arnolfini portrait (fig. 140) to Quentin Massys' portrait of the "Banker and His Wife" (fig. 141), nearly a century later, there is a noticeable gain in the importance of small objects. But the process was slow, and the accessory motifs, though no longer hieratic, continued to be selected for their relation to the story theme or their social appropriateness to the portrait. Their appearance in the picture was still governed by other considerations than the artist's desire to paint them for themselves, which is to say that they were given aesthetic interpretation but not as independent still lifes.

At the very end of the sixteenth and the beginning of the seventeenth century, the true still life finally appears, entirely free of ulterior motifs. The story scaffolding has been removed, the objects are enjoyed without support or benefit of latent meanings. It should be noted that this extended extension of

visual attention to all things was further stimulated by the enormous physical expansion of Western civilization. Through geographic discoveries, extended trade routes, and imperial growth the number of paintable objects multiplied beyond count. Exotic fruits and flowers, Chinese porcelains and Oriental art works and other importations increased the store of new forms. Holland contributed many new organic forms of which the products of her charming tulip mania were only one example. Whether the seventeenth-century painter chose floral arrangements, plants and pendent fruits, dead game dramatically posed, bright-scaled fish, tropical shells, intricate bronzes or homely kitchen utensils, musical instruments playfully assorted—all his views of *nature morte* were painted to delight the eye alone, for purely visual enchantment. Even the so-called "vanities," favored so much during the seventeenth century, which aimed to remind men of life's brevity by means of gloomy arrangements of heaped-up skulls, books, coffins, helmets, swords, and skeletons, gradually lost their solemn impact in a welter of painterly effects, spectacular draftsmanship, and startling optical illusions. Their sensuous appeal soon outweighed their mournful message.

The eighteenth century was less absorbed in exploring the individual objects within a still life than in creating an ensemble, an integrated impression. The result was that even kitchen pots were lent an atmosphere of transcendent significance. It is difficult to look at a still life by Chardin without becoming aware of the same kind of presence one feels in a Rembrandt portrait, a van Goyen landscape, or an interior by Vermeer. And what does it matter if this impression is conveyed to us by things as insignificant and inert as lemons and glasses, shells and dead game? With the exception of Vermeer in the preceding century, no artist had approached Chardin in the faculty for distinguishing the accidental and transitory from the essential and immutable in the appearance of things. The special kind of realism which Chardin anticipated in his still lifes was to culminate in the nineteenth century in impressionism.

At the turn of the century, there was a quite natural reaction against the impressionist passion for purely visual, light-borne qualities. Where the impressionist interpreted all things as tone poems in light and reflection, Cézanne in his still lifes interpreted the world through its geometric qualities (see Part III). Apples and oranges were primarily hard, massive, spherical, or oblate, challenging space in their dimensional, shaped immediacy, while the same apples and oranges arrested the eye of the impressionist primarily by their ruddy or yellow glow, their glistening surfaces, radiance, opacity, and so forth. For the postimpressionists, including Cézanne and Matisse, light was something that served mainly to illuminate or reveal the structure of objects and their relationships in space; while for the impressionists, objects and spatial arrangements had served chiefly as way stations for light and its prismatic possibilities. And

this reversed approach becomes most conspicuous in the category of still life, which is by definition concerned with visual immediacy.

So it is not surprising that still life became a favorite theme of postimpressionist painters; it left them free to elucidate nature in all her shapes and densities, without fortuitous literary overtones and emotional undertones. And again, when the cubists, led by Braque and Picasso, renounced all imitative intent and boldly dismembered objects in order to reorganize them more freely within a fresh pictorial scheme, they too showed a preference for this form which sanctioned a concentration on purely aesthetic effects. Their subjects were the now familiar assortment of playing cards, violins, tobacco pipes, printed pages, corners of furniture, and so forth; these were objects which nature or man had already endowed with distinctive forms, so that even when disrupted they seemed to have a form and an objective order of their own. Through all their distortions the objects remain recognizable, and thus connect the cubist canvas with external reality, if only as a point of departure. To this degree, cubist design may be considered a further phase of still life.

By contrast, abstract or nonobjective art (see Part III) borrows nothing recognizable from the world about us, and consequently has no more formal connection with still life than with figure, portrait, landscape, or any other category of painting. Nevertheless, its appearance and the logic of its design were anticipated by developments from postimpressionism to cubism, developments which were most clearly realized in still life.

209. POMPEIIAN MURAL: PEACHES WITH WATER JAR. Fourth style, probably 63–79 A.D. *National Museum, Naples.*

Roman still lifes generally appeared in murals or mosaics, and only rarely as independent paintings. Unlike later still lifes, they strove not for emotional overtones or poetic associations. Decorative or naturalistic according to the trend of the time, the Roman still life aimed at realistic illusion through the use of line and color, means identical with those of post-Renaissance painting. The render-ing of the glass jar in this still life, for example, is not excelled in creation of pure illusion by anything in later oil painting. The handling of perspective and of light and shade was certainly as competent in later Hellenist as in seventeenth-century still life. The difference lies in the visual intention, for Roman still life remained content to use the achievements of illusion for pure decoration.

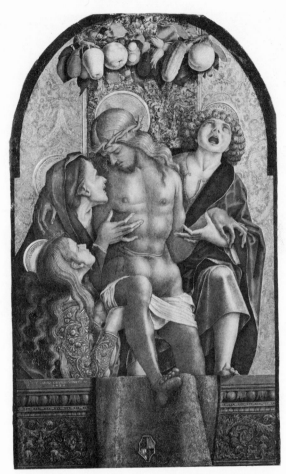

210. CARLO CRIVELLI: PIETA WITH ST. JOHN AND ST. MAGDALEN.
1485. *Museum of Fine Arts, Boston*

Still life made a shy and hesitant appearance in Italian Renaissance painting, entering, like the portrait, as a subsidiary motif. The Venetian artist Carlo Crivelli liked to decorate his pictures, as in this Pietà, with garlands and festoons of fruits that had no inherent relation to the subject of the painting. Inspired perhaps by the passion of his Northern contemporaries, Crivelli introduces all these carefully rendered materials and architectural ornaments merely to satisfy his love of perfect illusion. The motifs can be called still lifes with reference to content, not purpose.

211. MICHELANGELO MERISI DA CARAVAGGIO: STILL LIFE. About 1595.
National Gallery of Art, Kress Collection, Washington, D.C.

Caravaggio's naturalism (fig. 38) led him quite logically to the concept of the pure still life, a kind of painting that would have no topical implications whatever. He was the first Italian to envision such a painting, for the still lifes of Jacopo de' Barbari, executed about 1500, cannot be considered genuine Italian. Caravaggio presents even minute details in a clear cool light and with a precision almost suggesting surrealist tendencies. Here is a world of exact forms without softening atmosphere, a world unrelentingly harsh and intensely real. Caravaggio's approach

212. BATTISTA BETTERA: MUSICAL INSTRUMENTS. First half seventeenth
century. *The Wadsworth Atheneum, Hartford, Conn.*

was taken up by seventeenth-century still-life painters of northern Italy, especially those from Bergamo, of whom Battista Bettera is typical. These artists favored the distinctive shapes of musical instruments as the subject of studies in three-dimensionality. As a result the "musical" still life became a separate category that kept reappearing in every stylistic idiom, and finally almost monopolized cubist and surrealist still lifes.

213. ANTONIO PEREDA: THE PASSING OF THE EARTHLY. 1640–50.
Kunsthistorisches Museum, Vienna

The so-called "vanities," those lugubrious reminders of the vanity of human life, were arrangements of skulls, hourglasses, skeletons, coffins, books, and similar symbols of mortality. Popular in seventeenth-century Flanders, Holland, and other countries, they were nowhere painted more often than in fanatically religious Spain. Such artists as Antonio Pereda and Juan de Valdés Leal (1622–90) produced in their "vanities" religious opposites to the earthy vitality found in the Spanish *bodegones* or table still lifes created by Francisco Pacheco (1571–1654), Alonzo Vásquez (1600?–49) and, later, Don Luiz Menéndez (1716–1780). In Pereda's canvas, "The Passing of the Earthly," the presence of too many symbolic objects interferes with the immediate visual effect. Baroque profusion charges the design with competing details which are included only because they multiply the associations of mortality.

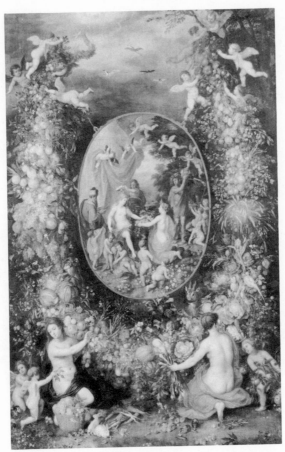

214. JAN BREUGHEL and HENDRIK VAN BALEN: SACRIFICE TO CYBELE. Early seventeenth century. *Royal Picture Gallery, The Hague*

Pieter Breughel's son Jan, called Velvet-Breughel, was a virtuoso of the craft of painting. He frequently collaborated with other painters, among them his friend Rubens, embellishing their canvases with fruit and flower garlands. Here the mythological rite of the sacrifice to Cybele is represented in a small medallionlike oval, surrounded by demigods, cupids, and harvest offerings of fruit and grain. The eye must shift constantly from one scale to the other with the result that it is almost impossible to concentrate on the beauty and perfection of the details. With this lack of a coherent scale and with the focus concentrated on a picture within a picture, the painting becomes merely a huge ornament based on typically baroque contrasts, movements, and countermovements.

215. JAN FYT: STILL LIFE. Mid-seventeenth century. *The Metropolitan Museum of Art, New York*

Jan Breughei, Frans Snyders (1579–1657), and the latter's pupil, Jan Fyt, all took exuberant and typically Flemish delight in cramming their still lifes with objects of every kind. Much as their fellow countryman Rubens (figs. 28 and 34) liked women and costumes ample and rich, they liked fruits and foods abundant and full textured. Both Fyt's "dining-room piece" and Snyders' less pretentious "kitchen pieces" combine dramatic composition with carefully rendered textures. In Fyt's painting, note the feathers of the bird, the shimmering grape skins, the richness of the fur, the bloom on the peaches. Drapery and architectural elements are used to increase the effect of pomp and grandeur, performing the same function in the still life as in the portrait and figure composition of the period.

216. PIETER CLAESZ: BREAKFAST TABLE. 1656. *Frederick M. Stern Collection, New York*

Dutch seventeenth-century still lifes were distinguished by an extraordinary visual selectivity most unlike the riotous abundance of their Flemish counterparts. Within the frame of this selectivity there was room for the individuality of Willem Claesz Heda, Pieter Claesz, Jan Davidsz de Heem, Abraham van Beijeren, Willem Kalf, Jan Weenix, and many others.

Claesz' "Breakfast Table" is built upon the contrasts between the masses of food, the glinting glassware, the metallic containers, and the soft fabrics, all swimming in a rich. warm tonality.

217. ISAAC VAN DUYNEN: STUDY OF FISH. Last half seventeenth century.
The Metropolitan Museum of Art, New York

Van Duynen's still lifes of fish—and
those of Abraham van Beijeren as well—
are subtle arrangements in transitions of
color and luminous reflections. Taking
the not too appealing motif of dead fish,
van Duynen and van Beijeren burnish it
with prismatic splendor, approximating
the many-hued effects of flower arrange-
ments, a triumph indeed of the magic of
color.

218. WILLEM KALF: STILL LIFE WITH NAUTILUS CUP. After 1655.
H. E. Ten Cate Collection, Almelo, Holland

Kalf's still lifes are pretentious in every respect, but because of his extraordinary ability to convey the texture of a few selected objects through nuances of tonal values, they appeal both to the sense of touch and to the eye. Porcelain bowls, silverware, Persian rugs, the nautilus cup, and the ever-present peeled lemon combine in a lovely, low-keyed harmony, a kind of chamber music for the eye.

219. JAN VAN HUYSUM: VASE OF FLOWERS. First half eighteenth century.
Museum of Fine Arts, Boston

Van Huysum's still lifes have long been held in the highest esteem by connoisseurs and public alike, chiefly for what has been described by contemporaries as their "precision and close imitation of nature." In actual fact, however, this painter, like his compatriot Rachel Ruysch, simply adapted the tradition of Northern flower painting to the idiom of the eighteenth century, whose so-called "return to nature" strikes us today as another form of artificiality. Van Huysum's art shows two distinct trends: he shares with painters like Jan Breughel a passion for flowers in all their dazzling variety of colors and textures; and he inherits from the great seventeenth-century Dutch tradition of Heda, Pieter Claesz, Kalf, and others a feeling for delicacy in detail and for the sensitive rendering of texture. The stylistic attitude of his own period appears in the looser flower arrangement, the more natural movement, and a decorativeness belonging to the world of rococo.

220. JEAN BAPTISTE SIMEON CHARDIN: THE WHITE TEAPOT. 1764.
Wildenstein & Co., Inc., New York

Chardin's reserved figure compositions are characterized by an objectivity which scarcely distinguishes between animate and still objects (figs. 95 and 133). It is not surprising, then, to find him in his later years turning more and more toward still life. In Chardin's still lifes the last vestiges of story have vanished and full scope is given to his wizardry with colors. Using oils, as in this picture, or pastels, he combines in ever-varying forms a few pots and jars, some dishes and fruits, copper and porcelain—mostly in front of neutral backgrounds. Thus on the smallest scale he creates art works of such subtlety and richness of color that his placid microcosms seem to embrace all the visual forms of nature.

221. CHARLES BIRD KING: VANITY OF AN ARTIST'S DREAM. 1830. *Courtesy Fogg Art Museum, Harvard University, Cambridge, Mass.*

American still life in the nineteenth century tended toward a prim but charming interest in precision and illusion, stressing primarily descriptive skill.

Charles B. King, a pupil of Benjamin West, carries off a true *trompe l'oeil* in this bitter description of an artist's earthly possessions: a broken Greek bust, palette and brushes, dry bread, a picture ironically showing coins flowing from a cornucopia, and as a final wry comment, books

bearing such titles as *The Pleasures of Imagination* and *The Pleasures of Hope.* Dutch and French painters in the seventeenth and eighteenth centuries had already excelled in the pictorial trick of *trompe l'oeil,* by which objects appeared as actually tangible. King modifies the usual frontal view of a *trompe l'oeil* with a chiaroscuro treatment of highlights and shades, thereby adding a romantic overtone to his straight visual report.

222. WILLIAM M. HARNETT: OLD CREMONA. 1885. *The Metropolitan Museum of Art, New York*

Among American artists of the nineteenth century, William M. Harnett certainly achieved the greatest mastery of the *trompe l'oeil*. The same themes appear in most of his canvases, whether he follows the tradition of the music still life of seventeenth-century Europe, concentrating on a musical instrument or two, or whether he paints newspapers, dollar bills, and so forth. These articles are arranged in front of a door, a cabinet, or some other surface that would logically be parallel with the beholder; the forms are modeled by shades and shadows and drawn according to the strictest rules of perspective, applied to even the most minute parts of the design. The result is almost invariably a perfect optical illusion; thus a sort of super-realism is made to perform the most "unreal" function in art, almost anticipating the surrealism of today.

223. CLAUDE MONET: SUNFLOWERS. 1881. *The Metropolitan Museum of Art, New York*

Still lifes by Monet and Van Gogh are as unlike as their landscapes (figs. 178 and 179). Perhaps the difference between the still lifes is even greater, for the absence of the problems of space, atmosphere, and open air reduces the aim to one that reveals clearly each artist's approach to form, color, and light. For Monet, color

224. VINCENT VAN GOGH: SUNFLOWERS. 1888. *Reproduced by courtesy of the Trustees, The National Gallery, London*

and light are the essence of identity and make up the very substance of the picture; his forms are barely indicated and serve only as carriers for tinctured flames and flakes of light. Van Gogh sees forms as almost alarmingly definite, and employs intense colors to reproduce these definite forms as vividly as possible.

225. PAUL CEZANNE: APPLES AND PRIMROSES. 1890–94. *Collection of Mr. and Mrs. Sam A. Lewisohn, New York*

To Cézanne spatial order was the central problem even in a still life, and the solution of space organization absorbed all his energies once he abandoned his earlier impressionist efforts. In limited successive planes of color, with small strokes of the brush, he models the shapes of apples, the primrose plant, and the tablecloth.

Matisse's still lifes show the same vigorous color, brilliant light, and tendency to all-over patterns that characterize his figure compositions and interiors (fig. 208). The earlier still lifes are rather austere; the later ones, like the one reproduced here, sparkle with the influence of Mediterranean light and color; but all share the discipline of Matisse's strong and civilized sense of design, and in all of them distinct forms emerge from intense colors placed close against one another.

Dufy's painting, although clearly based on Matisse's art, is less severely governed by an all-inclusive design and in its casual gaiety is closer to reality.

226. HENRI MATISSE: PINEAPPLES AND ANEMONES. 1940. *Collection of Mr. and Mrs. Albert D. Lasker, New York; photo courtesy Philadelphia Museum of Art*

227. RAOUL DUFY: THE BASKET. 1926. *From the Chester Dale Collection, on loan to Philadelphia Museum of Art, Philadelphia, Pa.*

228. PABLO PICASSO: STILL LIFE WITH A GUITAR. Oil and Collage. 1913. *Sidney Janis Collection, New York. Photo courtesy The Museum of Modern Art, New York*

Cubism progressed on the aesthetic assumption that the visual world must be restated in two-dimensional terms. Eventually the cubists experimented with the creation of surface effects through the use of such items as fragments of newspaper, chicken wire, and mortar, all assembled in the form of a collage. Textures were played up and given as important a role as light and color. Curiously enough those collage still lifes by Braque and Picasso, which almost completely renounce the representation of real objects, came closest to the *trompe l'oeil* effects of earlier still lifes (figs. 221 and 222). For in their roundabout way they reintroduced the tactile, that is, the verifiably real, aspects which impressionism had rejected altogether. Appealing to the sense of touch as well as to the eye, these cubist still lifes came back to reality but by wholly new aesthetic paths.

229. GEORGES BRAQUE: STILL LIFE. 1928. *From the Chester Dale Collection*

Braque and Picasso followed almost parallel courses during the first years after their pioneering in cubism and their experiments with collages. But thereafter they diverged markedly. As Picasso rushes from experiment to experiment with unrestrained inventiveness, Braque, in the great tradition of French painting, cultivated with increasing maturity a somberly lyrical style, always emphasizing texture. He refines an expressive design outlining simple flattened forms. Based on a subtle palette of rare sensitivity, Braque's still lifes are visual understatements that unfold their riches only gradually and only to the discerning eye.

230. JUAN GRIS: BOWL AND PACKAGE OF CIGARETTES. 1923. *The Phillips Gallery, Washington, D.C.*

After some youthful experimenting, the Spanish artist Juan Gris extended the cubist palette with more intense and varied colors. The elements of his still lifes are typically cubist: jars, tobacco pipes, mandolins, newspapers, and so on. The still lifes of Gris, Picasso, Joan Miro, Fernand Léger, and Albert Gleizes clearly demonstrate that cubism is by no means a uniform style but rather, as Gris put it, "a state of mind" with a wide margin for individuality. All the cubists have sooner or later relinquished the rigid formulations of the movement's early years, each following his own artistic inclinations.

231. MAX BECKMANN: STILL LIFE WITH SKULLS. 1945. *Buchholz Gallery, New York*

Trends in style seem to move in a spiral of recurrences. The recurrence is sometimes quite striking, as when the collages of Braque and Picasso repeat certain effects of the seventeenth- and eighteenth-century *trompe l'oeil*, and again when the German expressionist Max Beckmann virtually revives the "vanity" form of still life. The three skulls on the table are cruelly and powerfully contrasted with trivial items of daily use: the candle, the bottle, the cards. Dark, burning colors tied together by sable shadows delineate the intentionally crude forms. Here is a frowning *danse macabre* comparable to medieval stained-glass windows.

232. WASSILY KANDINSKY: COMPOSITION. 1923. *Buchholz Gallery, New York*

Lacking content, story, or other intentional associations, the nonobjective or abstract picture is certainly not any closer to still life than to any other category of painting; yet in a sense still life, by reason of its comparatively neutral content or subject matter, prepares the way for the abstraction. From its inception about 1910, nonobjective painting followed two main lines: on the one hand the subjective musical abstractions, called "Improvisations" or "Compositions," of Kandinsky and his followers; and on the other the calculated rectangular designs of the Dutch *Stijl* group and, later, the neoplasticists led by Piet Mondrian.

Kandinsky interrelates graphic forms and splashes of sudden color, whorls of light rays floating like radiant eyes in areas of purest transparency. In his many theoretical writings he repeatedly emphasizes the fact that his painting aims at purely emotional and spiritual pleasure without thematic connections, and that his canvases are to be experienced like music, without the detour of "recognizing" real objects. Kandinsky succeeds in compelling a strong visual response in the beholder, even though the emotions he arouses may vary in different spectators.

233. PIET CORNELIS MONDRIAN: TRAFALGAR SQUARE. 1939–43. *Collection of John L. Senior, Jr., New York*

This Dutch artist bases his compositions on a very definite aesthetic theory. He condenses the abundance and variety of forms in the visual world into rigid geometric schemes, and arranges these in statically balanced rectangular areas; some of these areas he sets in bright primary colors against a whitish ground, implying if not actually evoking a feeling of space. These color areas and the neutral ground on which they are dispersed, all divided by dark vertical and horizontal lines of varying width, apparently represent for Mondrian the essence of the perceivable world. His crystal-perfect schemes, calculated in year-long labor, and executed with mathematical precision and scrupulous taste, were certainly more real to him than reality. The intellectualized balance between color and abstract forms has come to be considered an absolute artistic aim in itself, beyond its suggestive value for architectural and applied design.

III. *A History of Styles in Painting*

A general history of styles so severely condensed as the one presented here must naturally be reduced to the barest outlines. Yet such a survey of styles is needed if individual art works and artists are to be seen in their cultural environment and as part of the all-embracing trends of history.

Any attempt to define and delimit the style of a historical period must be made with caution. Each so-called style has a background of growth through many generations. No trend develops in a perfectly straight line, and even when a movement seems, as we look back on it, to have been inevitable and overwhelming, its actual growth will have included fluctuations, setbacks, foreign influences, and of course, regional peculiarities.

The following outlines will be justified if they manage to provide the reader with a historical vantage point for analyzing individual works of art.

EARLY CIVILIZATIONS AND PAINTING

The unfolding of styles in painting and the underlying process of seeing owes but little to the creations of the three major cultures preceding that of Greece. Although the three great civilizations, the Mesopotamian, Egyptian, and Cretan-Minoan, are profoundly different in their basic artistic tendencies, they are alike in one important respect: their grandest works were realized in three-dimensional forms; architecture and sculpture were dominant and painting only secondary. The art of those early cultures may justly be called tectonic and glyptic. Since style must always be understood as comprising all the diverse creations of a period, it would be misleading to characterize the styles of such civilizations on the basis of a form of art that was not of primary importance to them. We must wait upon the rise of Greece before we meet signs of those artistic trends that were ultimately to be fundamental to European painting. And even in Greece and Rome, painting was subordinated to architecture and sculpture,

though it was of much greater importance than it had been in Mesopotamia, Egypt, and Crete. The very names Greece and Rome at once suggest temples and theaters, arenas and triumphal arches, statues and sculptured reliefs, and only as an afterthought Greek vase painting and Roman murals.

The archaeological remains of Sumer, Akkad, Babylonia, and Assyria, dating roughly from 4000 to 800 B.C., yield only a few fragments of painting, these being mostly colored reliefs on glazed tile and an occasional segment of a mural on stucco. They depict chiefly cattle processions, conquered peoples, and royal offerings, all in a very limited number of colors. We find in them no attempts at perspective, no hints of spatial sense, no use of light and shade. Conceived as a kind of low relief heightened by colors, these friezes on glazed brick must be regarded primarily as architectural decoration and not as independent pictorial expression.

In Egyptian art too, throughout its long conservative development from about 3300 to about 800 B.C., painting was the handmaiden of architecture. It was used in countless colored flat reliefs narrating sacred and dynastic events, and in horizontal mural bands made up of figures that were outlined and colored but did not project beyond the plane of the background. There is never any hint of spatial illusion (fig. 87): the painted surface always remains part of the wall. Egypt's anonymous artists made their figures speak solely through the use of line. The outline had to reveal all the facts clearly and simultaneously, and therefore each figure was presented according to certain rigid conventions of legibility: the head and limbs in profile, the eyes and trunk in a frontal view. Scale too was not realistic, but served a symbolic purpose: gods, kings, and queens were tallest, officers and nobles of the court next in size, commoners and slaves shortest. Such objects as rivers, lakes, gardens, and other indications of place or location were always given in horizontal projection, almost in the form of a layout. All such drawings were interspersed with hieroglyphic writing in unbroken continuity, which supports our feeling that no illusional effect was intended and that the difference between the hieroglyphs and the figures is only one of degree and not of kind. Within these set limits, however, the details show a surprising realism; the movements of animals and the gestures of human beings are observed with a subtle feeling for nature and individual traits, though the details never coalesce into an illusion-creating picture. The colors, at first limited but in later centuries varied, were also symbolical: men are brown, women creamy white, and so forth. There are no color nuances or use of light. All these characteristics are equally true of the water-color pictures executed on papyri. The immediate motive behind Egyptian art was not the disinterested aesthetic activity we now think of as art, but the recording of sacred truths for religious and state purposes. Nevertheless, everywhere in these records made for primarily practical purposes a very great aesthetic sensibility appears. The

stylistic unity of Egyptian art is so strong that no detail of painting ever violates the flat surface of a wall, the pictorial narrative always remaining subordinate to the mural plane or the surface of the papyrus sheet.

The Minoan or Aegean culture, which centered on Crete and the islands and coasts of the eastern Mediterranean from approximately 2500 to 1200 B.C., reveals a naturalism that contrasts with the formalized quality of Mesopotamian and Egyptian works. Yet we know from the typical Cretan vases depicted on Egyptian reliefs that Minoan culture maintained considerable contact with the older civilizations. In sculpture this naturalism produced perfect figurines in painted clay and ivory. In painting, the projection of three-dimensional objects in terms of two dimensions created a remarkable style: objects are presented in profile, simplified, yet so vividly projected that they seem almost realistic. No greater contrast can be imagined than appears in the use of profile in Egyptian wall painting and in Cretan murals. Egyptian reliefs outlined each figure clearly, but most positions were formalized and only the emphasis on certain details gave them variety. The Cretan mural presented each figure in a free and freshly observed gesture, so that despite the imperfect handling of the third dimension the entire picture has the immediate vitality of a quick sketch from life. There are in these figures none of the conventional formulas or symbolic notations that mark Egyptian figures, and therefore none of the fixed monumentality of Egyptian art. Cretans delighted in the rich unexpectedness of men, beasts, and flowers as they constantly surprise the eye. They described living things; the Egyptians recorded the mere facts of life. Unlike Egyptian murals, Cretan murals became independent of the wall—no longer structural and subordinate to mass but almost like windows opening on a gay and festive world, the world of their delightful island home. In addition to murals, they developed another art of equal freshness, the decoration of pottery. In it they created a variety of charmingly spontaneous designs very far removed from the abstract and geometric patterns of other early cultures.

The origins of Greek art represent a fusion of two distinct legacies: the Minoan, which came to the Greek mainland and Asia Minor with the spread of Cretan colonies; and the dawning style of the Hellenes, who invaded the Greek peninsula in two great tribal streams, the Dorian and Ionian. These rural, almost barbaric tribes had a forceful and highly original power of artistic expression, crude but with unlimited possibilities. The mingling of Minoan and Hellenic cultural elements took place during the course of three centuries, from about 1200 to 900 B.C., and the process is well documented by architectural remains and works of applied art, especially pottery. The eighth century B.C. saw the complete cultural unification of the Greek world. The independent city states emerged, the Olympic games were established in 776 B.C., and a single literary language, the Greek of the Homeric poems, came into general use. The once

isolated farming communities began to trade and colonize throughout the Mediterranean, and Greece arrived at the threshold of her great achievements.

Greek art took from the decorative and luxurious Minoan style only those elements which it could assimilate to its own inherently structural approach and to its main interest in architecture and a sculpture inspired by Greek mythology, that anthropomorphic assembly of "men like gods, and gods like men." Painting in those early times was used mainly for decorating vases with forms that combined in geometric order certain Cretan motifs and patterns taken from local peasant art. Favorite designs, partially borrowed from weaving techniques, were organized in strict horizontal bands around the body of the vessel. The work of various regional groups can be easily recognized, the best known being the so-called Dipylon vases, which represented the climax of decoration in geometric style in the eighth century B.C. At the end of the eighth century and through the seventh, influences from the Middle East loosened this strict style and led it into freer forms. Certain themes appear again and again, drawn without perspective but already clearly naturalistic. Gradually the sharply defined bands of ornament give way to a single design or actual picture, painted in black and determined by the shape of the vessel, as an easel painting is determined by the canvas. Certain types of vases became standardized. The art of the potter rivaled that of the decorative painter, and after a while definite personalities emerged from the welter of workshop anonymity. By the sixth century B.C. artists were signing their vases. Although other schools continued to produce, Athens became the great center of vase painting.

By the end of the sixth century B.C., an important change in style had occurred. The body of the vessel was blackened, figures revealed the red of the underlying clay, and details began to be drawn in fine black lines. This reversal of earlier technique stemmed from a general evolution in style. It coincided with the development of sculpture, the depicting of livelier movement, more complex groups, and greater dramatization. The painted figures, once flat, show more and more roundness and volume, and space is suggested by overlapping and by the beginnings of perspective. Themes are still largely mythological, but there is a gradual increase in the number of battle scenes, feasts, and finally scenes from daily life, almost genre in type (fig. 88). By the beginning of the fifth century B.C., all the technical means are present for conveying the most delicate effects. From this time forward, the evolution of painting consists in more complete adaptation of design to the curved contour of the vessel and in ever subtler draftsmanship, through which the illusion of a third dimension is finally mastered.

Between the ninth and the third centuries B.C. the art of Greece passed through its three great phases: archaic, classical, and Hellenistic. In the final or Hellenistic phase, the relatively functional forms of ancient Greece showed

striking transformations. Originally, Greek art had expressed itself in clear, serene forms, idealizing gods and men. Even figures in motion had appeared to be balanced and permanently placed. The architect's and sculptor's ideal of tectonic harmony molded the Greek notion of the human form. But after 300 B.C. Hellenistic art used these older forms more and more dynamically, portraying violent movement, presenting genre and popular types, and reproducing all fleeting and casual gestures naturalistically. This development, though more distinctly marked in architecture and sculpture, is also reflected in vase painting by a gradual increase in the depicting of movement, by more shading, by the softer flow of draperies and garments, by more detail in individual forms and increasing dramatization.

The Greeks knew, however, still other fields of painting besides the decorating of vases: murals and even easel painting. We know these only through some rather free Roman copies and although names of such masters as Polygnotus, Zeuxis, and Apelles have come down to us through the writings of their contemporaries, together with comments on various regional schools, the lack of originals makes it impossible to draw any definite conclusions about their works. The only fact we can be certain of is that these artists mastered perspective and were able to create illusions of space exceptionally well. So it is in the work of Greek masters that we first meet those qualities that signify "painting" to the modern eye.

It was the late Hellenistic phase of Greek art which the Romans took up and perpetuated, along with some minor traditions borrowed from the Etruscans, their predecessors in central Italy. Hellenistic art quite naturally followed divergent lines, adapting to local conditions as it took root in Asia Minor, Egypt, Greece proper, and Italy. But Roman art, though not necessarily the most highly developed branch of Hellenistic art, became its most important outgrowth, partly because of the material and political power of the Roman Empire. The Hellenistic style, transplanted to Rome, was continued both by exiled Greek artists and by native Romans who copied Greek originals.

A merciless naturalism now replaced the older idealization. Roman art looked for illusion at any cost, and put dramatic contrasts in place of the serenity which had to a certain degree pervaded even Hellenistic art. In both painting and sculpture the Romans employed light, shadows, and the third dimension to recreate an easily recognizable reality. Such aims were furthered by the Roman interest in nature, country life, and genre—interests quite alien to the synthesizing and idealizing mind of the Greek.

A great number of Roman art works have survived in Rome proper and in Pompeii and Herculaneum, where they were preserved in ashes by the famous eruption of Mount Vesuvius in 79 A.D. And rich finds have been made at the sites of all the Roman colonies once scattered along the Mediterranean coasts. These

date from the second century B.C. to the sixth century of the Christian era, the majority belonging to the first and second centuries A.D.

Yet even the naturalistic ideal of Roman art underwent many changes: decorative, illusionistic, and impressionistic tendencies followed one another, interrupted at times by a short return to a modified classicism. The decorative tendencies always remained strong. The Romans were fond of framing their paintings in a fake-architecture, playful, encrusted with garlands of fruits and flowers, and yet intended to create a spatial illusion. In such frames they displayed mythological episodes, poetically told, charming little genre scenes, still lifes, and even landscapes partially copied from earlier Greek landscapes (fig. 149). Perspective vistas expanded the rooms like stage settings; landscape murals revealed a treatment of light and space reminiscent of sixteenth- and seventeenth-century landscapes. Their portrait paintings, such as those found in El Faiyum, Egypt, then part of the Roman Empire, were rendered almost impressionistically (fig. 97), suggesting to our eyes the style of the seventeenth century, while their portrait busts with their extreme naturalism remind us of the most naturalistic eighteenth-century French portrait busts.

In addition to Roman murals and portraits, one must mention the mosaics in which they presented landscapes, animals, battles, mythological events, and still lifes. Although this medium, limited to the use of small fragments of colored stone and glass, is relatively rigid, it nevertheless permitted such a richness of color nuances and light variations that we are entitled to speak of the results as "paintings." Because the Romans liked to reproduce famous Greek originals in enduring mosaics, modern scholarship has been able to form through them an approximate notion of the character of the lost Greek paintings of earlier classical times.

In its definitive and typical form, the art of Rome was sophisticated, cosmopolitan, and "international." It reflected the material and sensuous values of the Empire in a naturalistic style that became steadily more decorative, literal, and overdetailed.

EARLY CHRISTIAN AND BYZANTINE STYLE

It took the Graeco-Roman civilization several centuries to "decline." The actual decline was the gradual fading of the classical concept of life, the while the external forms were repeated through habit and tradition. And while the naturalistic ideal of Roman art went through its different phases—decorative, illusionistic, impressionistic—the young Christian religion groped for appropriate forms in which to express a new spirituality. The catacomb paintings, though Christian in content, followed the decorative painterly style of pagan wall paintings, but were cruder and less elaborate. But Rome was not the only center

of the rising Christian idea. Both Egypt and Asia Minor, with their Easternized versions of the Hellenistic style, contributed to the slowly developing archetypes of Church architecture and to early Christian painting and sculpture. The entire Near East—Syria, Palestine, Alexandria—with its textiles, mosaics, and carved ivories, was as important a starting point of early Christian art as Rome itself. Both Rome and the Near East carried forward late phases of Hellenistic art, modified of course by geographical and historical factors.

When the early Christians sought for plastic and pictorial imagery to symbolize their new outlook on the world, they at first adapted the figures and ornaments of Hellenistic art. Though they changed the content, transforming genii into angels, fruits and animal motifs into sacred symbols, and pagan half-gods into martyrs, they continued into the sixth century to make partial use of the old stylistic language.

The term Byzantine art refers specifically to that form of early Christian art which developed along the east Mediterranean shores, especially in Byzantium (Constantinople) and in Ravenna in northeastern Italy. In the fifth and sixth centuries the Byzantine style spread from Ravenna to other Italian cities. Under the influence of theocratic rule, the sacred figures of the Trinity, the angels and saints, were presented in frontal view, their postures austere and ceremonial. Mosaic and ivory relief, perfect materials for conveying the stiff hieratic abstractions of Byzantine design, came into common use. Artists developed a new linear condensation that presented human figures and animals on a flat plane. Colors, especially in mosaic tile, glowed brilliantly, full of sharp contrasts and without the gradation and tonal depths of illusionism. The Hellenistic ideal of a three-dimensional body, rendered realistically in actual space, was entirely discarded. As the Christian spirit rejected the world, so Early Christian and Byzantine art rejected all realistic interpretation of space. Its spiritual message found ample scope in the two-dimensional plane, purified of the sensuousness of the material world.

In the eighth century occurred the great controversy between those who venerated sacred images and the iconoclasts. The dispute lasted for a hundred years and during this time the anti-pictorial attitude became widespread. The result was the growth of a powerful decorative trend emphasizing geometrical patterns and organic forms in place of the forbidden human lineaments. In the ninth century the use of images was again permitted and Byzantine art revived once more, reaching a second flowering in the eleventh century. The decorative motifs introduced during the iconoclastic dispute persisted, undergoing constant elaboration. At the same time certain motifs from ancient Greek art made a surprising reappearance, while still other forms were adopted from Mohammedan art, and from the folk art brought into Europe by the earlier Teutonic invasions.

But despite the adoption of elements from other styles, Byzantine art was influenced most of all by the Church, which completely controlled artistic works, from their general arrangement down to the representation of each sacred detail. Every object depicted was fraught with divine or ceremonial meaning and was therefore subject to regulation by the Church. Human figures became standardized and impersonal, and were arranged in compositions suggesting a liturgical, almost sacramental order. In such an atmosphere of piety and prescribed symbolism, the free study of nature by the artist was impossible, and artistic independence amounted almost to sin. The resulting art became hieratic, formal, and rigidly abstract.

MEDIEVAL STYLES

The popular term "Dark Ages" is a quite misleading description of medieval culture. The values of the Middle Ages are historically and artistically as meaningful as the values of the Renaissance or of later periods. The fact that we no longer share those values does not warrant our dismissing the art based on them as "clumsy" and "primitive." Such an attitude reveals only our own failure to understand the spiritual intent of the Middle Ages and its utter lack of interest in representing "reality as it actually is."

The period between 800 and about 1400 A.D., the span that the term Middle Ages is generally intended to cover, is far too complex and too long for us to subsume all its styles under a single label. Most works originating between Charlemagne's time, the "Carolingian Renaissance" of around 800, and the Second Crusade, ca. 1150 A.D., are called Romanesque; and works dating between the twelfth and the fifteenth centuries are known as Gothic. The transition from Romanesque to Gothic was gradual. It was marked by certain changes in architectural structure which began in France and spread slowly to other European countries. In painting a corresponding change was manifested in a general loosening of line, in more fluid curves—as, for example, in the fall of drapery—in individualized gestures in human figures, and especially in a greater rapport between ornament and subject matter.

However, all the diverse periods and trends of these centuries were given a certain unity by the omnipresent influence of the Church, whose doctrines and institutions were reflected directly or indirectly in every art work of the Middle Ages. And in any case, most of them, from the grand cathedrals to the smallest illuminated letters in manuscripts, were commissioned by the Church. Finally the growth of papal authority and of monastic orders brought about such complete regulation of all artistic activities that even works commissioned by feudal lords for their own secular satisfaction radiated the spirit of an entirely religious civilization.

Throughout the greater part of the Middle Ages, architecture and sculpture were the pre-eminent arts. Churches, monasteries, and convents sprang up everywhere, and all over Europe the stone carvers, goldsmiths, and masters of other crafts competed for commissions to decorate these edifices. The products of every applied art were integrated with the dominating church structure itself, built for the greater glory of God. Quite naturally, then, we think of Romanesque and Gothic styles chiefly in terms of architecture. Round arches, arcades, and massive closed walls represent the Romanesque style; while pointed arches, flying buttresses, soaring steeples, towers, rich tracery, and especially more delicate proportions typify for us the essentials of Gothic.

In medieval times painting as such played a very minor role in comparison with the one it was to enjoy in Renaissance and post-Renaissance centuries. Painting directly connected with church structure is represented chiefly by stained-glass windows, less often by murals, and in Italy by mosaics. Of greater stylistic importance are the illuminated manuscripts—the Evangelistaries, Testaments, and other religious codices. This art form began in the fifth century in Byzantium and continued well into the Renaissance, during which time it was also used to illustrate nonreligious writings. Easel paintings began to appear in the thirteenth century and gained importance in Italy with the works of such painters as Cimabue and Giotto of Florence (fig. 47), the Sienese group led by Duccio, and various anonymous masters in the North.

Miniatures and murals differed in scale but not in style. In both, the figures lacked anatomical structure and the composition was layerlike, flat, and lacking in perspective. Since the teachings of the Church condemned any interest in the human body as such, the artist concentrated rather on details, sometimes achieving surprisingly realistic gestures and intensity of expression. Even when naturalism did increase during the Gothic period, it increased with respect to details rather than to the handling of the entire figure.

Although medieval art, thus completely under the sway of the spiritual, presented the greatest contrast to the pagan art of antiquity, ancient traditions survived in a multitude of ornamental details. Sometimes pagan deities were even identified with and actually translated into the divine Christian figures—Apollo into Christ, Minerva into Mary, and so forth. Indeed, the Carolingian Renaissance at the very opening of the Middle Ages was a conscious attempt to revive ancient art traditions on a grand scale, for Charlemagne regarded himself the successor to the emperors of ancient Rome. This classical trend, however, was mainly confined to Charlemagne's court and a small educated class whose contact with the broad stylistic movements of the time was very slight.

The singular character of medieval art was based not alone on Christian otherworldliness but also on another dynamic force. This was the great migration of peoples between the fourth and seventh centuries, when hordes of Germanic

and Asiatic tribes invaded Europe, bringing a wealth of fresh ornamental forms, new structural patterns, and creative tendencies wholly alien to the old Mediterranean traditions. Medieval art received its distinctive stamp when the primitive, almost prehistoric motifs of these invaders, embodied in wood and stone carvings, textiles, and such, were fused with ancient Mediterranean motifs, and both were modified by the spiritual attitude of Christianity.

Thus the art of the Middle Ages must be understood in terms of three sources, so unlike as to be almost hostile to one another: first, the surviving elements of antiquity; second, the other-worldliness and rich symbolism of the Christian idea; and lastly, the magic energy of the threshold cultures of the Celts, Franks, Vandals, Anglo-Saxons, and kindred peoples. The Church, supranational and universal in its claims, drew the artistic styles of the diverse ethnic groups into harmony with existing Western patterns and infused into them its own metaphysical concepts.

After Charlemagne's death in 814, his short-lived empire fell apart. The peoples of central Europe split into several nations and each began to evolve national peculiarities. These national traits appeared most strikingly in architecture, since building is a massive art, bound to the soil and deeply rooted in the folkways of each locality. Various regional schools appeared, but all reflected a single dominant tendency: in architecture the masses of stone gradually became skeletal and each structural element more and more dissolved; and in painting and sculpture in later Gothic times the human figure and its company of ornamental beasts, monsters, flowers and foliage became elongated, flexible, and undulating with waves of plastic motion.

To our eyes medieval painting may often appear strange, because we have learned since Renaissance times to look for an illusion of reality in all two-dimensional art. But "reality" is precisely what the Middle Ages rejected. The two-dimensional appearance, the ignoring of depth, the symbolic significance attached to objects, and the strong ornamental tendencies born of tribal traditions, resulted in an art that reveals its beauty and meaning only gradually. An illuminated manuscript's foliated initial that strikes us as mere decorative design may have profound religious bearing, while a human figure of great psychological expressiveness may be intended as a symbol and nothing more. In a word, medieval art is both an aesthetic creation and a deliberately complex language, and we must understand the symbols if we are to grasp the art.

EARLY RENAISSANCE IN ITALY

The Renaissance received its direction and attitudes from a complex of ideas, entirely different from those of the Middle Ages. The new art styles were simply the visual expression of changed concepts—concepts which have retained

their force down to the present, and are the moral and intellectual bases of our own civilization.

Three primary trends in Renaissance thought directly influenced the new art.

In the first place, man as an individual was once more regarded as the center of the universe, as he had been throughout antiquity. The Middle Ages had held man to be nothing more than a member of a group, an anonymous part of the obedient flocks of the Church, subject of a feudal lord, member of a guild, with a soul that belonged to God. The rediscovery of man involved recognition of him as an individual, as unique and valuable by reason of his intellectual aspirations, his creative and ethical endowments. The changed attitude was reflected in art: man was held worthy of being depicted along with sacred figures in religious compositions, and even of being studied by himself in portraits.

Secondly, nature and the things of this world regained their value in the eyes of men. The medieval religious outlook had rejected the material world and its outward manifestations, since earthly life was merely temporal, merely a period of trial for the soul, a vale of tears. The changed concept led to an objective delight in the world and all its forms as part of man's environment. Artists began to describe the human body as interesting and beautiful in itself; they also set their figures in natural backgrounds observed directly; and eventually they discovered landscape as an independent visual experience.

Finally, the rediscovery of antiquity, its mythology, literature, and philosophy, as well as its plastic arts, reopened rich sources of subject matter. Although the Middle Ages had always kept alive some classical learning in monastery libraries, it was only with the Renaissance that any considerable body of knowledge became available to the layman. Soon the myths and heroic deeds of Greek and Roman tradition were as familiar to the people as Holy Scripture, and men were free to interpret them without referring to religious dogma. Classical myths and history furnished a vision of a new way of life and contributed further to the change in attitude toward nature and human societies. Even more important, in the long run, was the fact that the renewed study of Greek and Roman history marked the beginning of objective investigation of all history. The sense of "timelessness" that pervaded medieval life gave way to a feeling that history could shed some light on man's purpose and destination on earth. For the first time since the decline of the ancient world, secular scholars and men of letters began to form a fraternity of independent thinkers and to define a body of precise standards, that is, what we today understand as scholarship. Here was the beginning of our contemporary scientific attitude.

The Renaissance is generally considered to have begun in the first decades of the fifteenth century. In the year 1401, a competition for the design of a pair of bronze doors for the Baptistery in Florence was won by the sculptor Lorenzo

Ghiberti (1378–1455); his prize reliefs combined a new realism with an almost classical approach. In the year 1418, the architect Filippo Brunelleschi (1377–1446) designed the cupola of the Cathedral Santa Maria del Fiore in Florence, embodying new aesthetic and technical principles. And, in 1426–27, the painter Masaccio (1401–1428) decorated the Brancacci Chapel of Santa Maria del Carmine in Florence with frescoes that reveal a new sense of spatial unity, of light and shadow, of the human body and emotional warmth. These three creative events were the first significant expressions of the flowering of Renaissance tendencies in art.

Yet these tendencies were not absolutely new. The Renaissance proper was preceded in Italy by an earlier or so-called Proto-Renaissance, a period still essentially Gothic, but one in which a few men of original creative power anticipated future developments. From the thirteenth century on, there were religious thinkers, painters, and sculptors who were already beginning to move away from medieval patterns of thought and art. Saint Francis, Dante, Boccaccio, Giotto, the Pisani—these thinkers and creative men differed from one another profoundly in their personal styles but their works were alike in possessing pronounced nonmedieval tendencies. In Giotto's paintings, the composition of human figures indicated an entirely new notion of volume and space as pictorial elements, while their expressiveness announced a new feeling for human emotions. Niccolo Pisano's sculpture, influenced by the style of reliefs on ancient Roman sarcophagi, revived both the form and spirit of antiquity. Architecture too reflected the classical trend. As early as the twelfth century, classical structural feeling appears in Florence in the Baptistery and in the Church of San Miniato, and in southern Italy in buildings erected under Emperor Frederick II (1152–1190). In these outstanding works, even before the fifteenth century, classical elements were fused with Gothic trends. After 1400, when the Renaissance began to spread throughout Italy, the revival of the ancient heritage was no longer just a factor fostering the new spirit, but rather the chief sign of it.

The new humanism did not actually shatter the religious beliefs of Christianity itself, for the influence of the Franciscan and Dominican orders, founded in the thirteenth century, was still great. But the Church was no longer accepted as the sole arbiter of spiritual and intellectual values, and these were now beginning to flourish outside the Church as well.

At the same time, modern capitalism had begun to take root as a result of the rapid growth of international trade, a development relatively unhampered by the many feuds between Pope and Holy Roman Emperor, between city states, or between factions within towns. The rise of trade and of credit relations embracing larger and larger areas of Europe stimulated the civic pride and urbanity of the citizens of the free city-states, displacing the Christian humility

which they had felt toward temporal authority. They began to feel and think as individuals, and even to appreciate the distinction between mere artisans and artists who were "informed both by genius and a sense of propriety." Names of painters and sculptors and of *bottegas* (workshops) were now recorded for posterity, another sign of the entirely altered status of the artist. The rulers and tyrants of many free cities and smaller principalities, men as cultured as they were despotic, competed with the popes in commissioning ambitious art projects for the sake of glory in the eyes of posterity.

In three generations, Italian artists mastered perspective and anatomy, the basic techniques of illusionistic representation. What Masaccio began, Leonardo da Vinci completed. This mastery of the appearances of reality was accompanied by theoretical studies of ancient monuments and of general principles of art, as, for example, in the treatise *Della Pittura* by Leone Battista Alberti (1404–1472). And the awakened interest in nature, with its ideal of lifelike transcription and naturalistic detail, signified more than just newly conquered subject matter for art. Nature was approached scientifically. Explorations of the earth and of the heavens had begun to push out the horizons and reveal undreamed-of realms in the universe. No longer governed by Aristotelian theories or restricted to fields sanctioned by the Church, empirical investigation and an independent natural science began to add startlingly to human knowledge.

In a world undergoing such a rapid humanizing process, painting and sculpture could not be kept at an awe-inspiring distance. The artist tried naturally to create a link of understanding between his pictures and the men who were to behold and enjoy them. The gold backgrounds of thirteenth- and fourteenth-century paintings gave way to transcriptions of typical environments, interiors, landscapes, groups of bystanders, and so forth. Pictures developed into carefully framed views, and artists used every kind of perspective device and realistic detail to make the spectator feel himself a participant in the scene.

The scenes themselves lost their remote, unworldly, or isolated character. The Virgin and Child, for example, or a group of saints, appeared more like actual human beings, either through the presence of other persons or because they were placed in a familiar and worldly setting. Biblical and mythological scenes were transformed into public spectacles, a tendency that increased with each generation—from Giotto to Masaccio, to Gozzoli, to Ghirlandaio.

But despite the spread of humanist thought and the broadening of artistic expression, the style of the early Italian Renaissance was by no means uniform. In the first decades of the fifteenth century, the desire to counteract the weight of Gothic tradition led naturally to an exaggeration of realism. This was followed by a swing toward the calm eloquence of ancient art and classical principles of composition. The pendulum swung back again slightly in the generation just before the High Renaissance, when certain medieval elements were revived

and such artists as Botticelli tried to imbue religious and mythological themes with a certain awesome and spectacular solemnity.

In addition to these general differences, each Italian school of art developed its own forms of expression. Throughout the fifteenth century, Florence was the center of early Renaissance art, but Padua, Ferrara, Bologna, Venice, and later Perugia and Urbino, developed distinct schools of their own. The North Italian schools, which had closer contact with the Netherlands and Germany, revealed a more objective interest in nature and discovered landscape earlier than the Florentines. The Venetians very early exploited, and almost monopolized, the vitalizing powers of color and light in their panels, canvases, and frescoes. The new medium of oil color, imported from the Netherlands by Antonello da Messina (ca. 1430–1479), gave Venetian artists a new and richer chromatic range, while Venice's huge import of rugs, ceramics, and textiles from the Orient further stimulated her artists' historic interest in nuances of color and light.

HIGH RENAISSANCE, MANNERISM, AND BAROQUE

By 1500 the Renaissance had firmly established the realistic, postmedieval concept of basing painting on a complete knowledge of anatomy, a matured science of perspective, and a humanist approach to pagan antiquity. Within three generations of unparalleled creativeness, climaxed by the genius of Leonardo da Vinci, artists achieved complete freedom in reproducing reality. From the various regional schools of Italy the new approach toward nature and the human body spread to the North, where it influenced and was influenced by the art of the Netherlands.

At the beginning of the new century, a new ideal gave a fresh impetus to Italian Renaissance art, capturing the imagination of all artists from Raphael to Titian. This was the ideal of *concinnitas*, the logical composition and perfect balance of figures and objects in relation to one another and to their encompassing space. Its strong emphasis on the harmony of proportion guided painting, sculpture, and architecture equally, and it seemed to hold greater plastic interest for artists than the most realistic portrayal.

The new movement, called the High Renaissance, centered in Rome, where the traditional gift for grand organization was represented by such masters of structural composition as Raphael and Michelangelo; Venice, led by Giorgione, Titian, and others, added, as her own special contribution to *concinnitas* the orchestral play of glowing colors and shades of light. The ideal of balance influenced the artist's fundamental conception, the way he staged his story and disclosed personalities in his portraiture. Unity in space and permanence in time were the guiding values of this movement. Artists selected only such

themes and episodes as seemed visually coherent and chronologically complete. They posed figures to express the deep and lasting human relationships and to tell stories they thought would be timeless. Facial expressions were felt to be the visual equivalent of states of mind or of character. On the great canvases and murals of the High Renaissance, men and women were noble archetypes conceived in terms not of religious ideals or of folk realism but rather of life as high drama. The casual or commonplace aspects of existence were therefore considered unfit to evoke such exalted images of human existence.

The popes in the sixteenth century considered themselves the successors of the ancient Roman emperors, as centuries earlier Charlemagne had done. Artists thought of their art as the legitimate descendant of that of the ancient Romans, which was then not clearly distinguished from the Greek, and they strove to perpetuate as many traditions as possible out of that splendid past. They painted personages, not persons, and endowed them with noble bearing, obviously idealized bodies, and the elevated look of important characters engaged in important events. Almost all figures were grand and heroic, or companions to the grand and heroic. Even minor events were staged monumentally, as if presented for public view on official occasions. The charming intimacy of treatment which the early Renaissance had introduced into religious narrative scenes was now rejected as unimpressive, or reserved for subsidiary scenes in larger compositions. As against the crude reality of life, the High Renaissance created a panorama of splendid images, composed of exemplary parts according to ideal specifications, faultless and almost abstract embodiments of moral and intellectual virtues, archetypes of legend and history.

In their different ways, High Renaissance art and medieval art both rejected the discordant actualities of this world. But where medieval art rejected the world, High Renaissance art rejected only the discord. The result was an upsurge of sensuous magnificence without parallel in Western art; and the hands of genius gave an amazingly lifelike air to creations which, in spite of realistic details, were actually untrue to life.

It was impossible to maintain for long this elevated public interpretation of existence. There were no more than three decades of true High Renaissance between the last typical early Renaissance works and the first examples of mannerism, the highly emotional and animated style that followed. Even Raphael in his last works shows a change from strict balance and static harmony to fluid interpretations and evanescent scenes. This fluidity, based on positive, sometimes even artificial movements and contortions, soon began to displace the balanced compositions of the first decades of the sixteenth century.

Mannerism shortly thereafter sanctioned fluctuating movement and became interested in transient impressions; further, it began to re-explore with burning eagerness the naturalistic description which had so engaged the imagination

of the early Renaissance. It showed a marked preference for violent action (see fig. 159). In the treatment of nudes, mannerism exaggerated the play of muscles, in portraiture the tension of facial expression, and in landscapes it hit upon agitation in picturesque scenery—thunderstorms, lightning, floods, and wild mountain peaks. These characteristics appear in group compositions by such masters as Parmigianino, Vasari, Tintoretto, and El Greco, and persist for almost a century. They mark even the portraits of Bronzino (see fig. 107) and the landscapes of Annibale Carracci (see fig. 161).

The feeling for the typical values of the High Renaissance was confined to Italy, the heir of antiquity. The Netherlands and Germany produced scarcely any works that can properly be called High Renaissance. But during and even before the mannerist period a certain rapport between Italian and Northern art is clearly discernible. Mannerism developed in Italy after 1530; its dramatic naturalism and concern for light found a keen response in the Netherlands, where naturalism and an interest in the effect of light had long been a part of the aesthetic approach. Thus the spontaneous trend of Northern art combined with the conscious acceptance of the influence from Italy to make typical mannerists out of many Flemish and Dutch painters. Prominent among the Romanists, as they were called in the North, were Jan van Scorel and Mabuse (Jan Gossaert) (figs. 8 and 197).

The relationship between mannerism and baroque is complex and largely one of degree. Briefly, mannerism differed from High Renaissance in substituting a variety of flowing movements and a profusion of realistic details for a unified, static, well-balanced composition. Baroque, in turn, replaced the Renaissance unity of balanced repose with a fresh unity of organized movement, a dynamic order based on controlled action. Mannerism's varied and often confusing waves of movement are easily distinguished from the single, dominating movement which in later baroque art governed every element in the painting (see fig. 34).

The central principles of composition of these three styles may be summarized as follows: High Renaissance—centralization through static balance; mannerism—fluid decentralization; baroque—unification through dynamic movement. No sharp line can be drawn between mannerist and baroque, and works by such painters as Tintoretto and Caravaggio obviously combine characteristics of both. The two styles overlap even chronologically. By 1520, mannerist and baroque tendencies were already beginning to show in the work of some of the great High Renaissance artists. Michelangelo, "father of the baroque," toppled the carefully balanced Renaissance scheme in his frescoes, especially in the monumental ceiling of the Sistine Chapel (fig. 9) and hardly less in his sculptures and architectural projects. The Sistine Chapel ceiling foreshadows, in 1512, all the qualities which were later to dominate baroque: space forcefully

conquered, figures and groups caught in whirling and sometimes opposing movements, and a deliberate upsetting of traditional Renaissance balance in order to give arresting prominence to one outstanding element in the composition.

In baroque art the elements in a painting lost what we might call their aesthetic self-sufficiency, and were given no more treatment than was required by their role in the painting as a whole. Masses were condensed, and, when necessary, contours were blurred.

Baroque and mannerism became general European phenomena. In Italy, their cradle, sculpture and architecture gave most lavish expression to these tendencies. Among Italian painters over whom they held sway, Paolo Veronese (fig. 91), Caravaggio (figs. 38 and 81), Domenichino (fig. 22), and Guercino are typical. In Spain, El Greco's work (figs. 110, 160) tends more toward mannerism, while Velásquez' paintings (figs. 15, 40) are typically baroque. Generally, it is no mere accident that the appearance of such Spanish masters as Francisco Pacheco, Francesco Herrera, Arteaga y Alfaro (fig. 189), Esteban Murillo (fig. 188), and Francesco de Zurbarán coincided with the rise of mannerism and baroque: it was then that Spanish art made its closest contact with the development of art elsewhere in Europe. The strict principles of the Italian High Renaissance would have been wholly uncongenial to its passionate spirit.

At about the same time the baroque movement in the North was led by the climactic figure of Peter Paul Rubens, with such followers as Van Dyck (fig. 115) and Jacob Jordaens (fig. 93). Unlike the Renaissance, which had set up certain heroic proportions and gestures as the only ones fit for artistic treatment, the baroque masters—Italian, Spanish, and Flemish—reveled in extreme expressiveness and individualization, with emphasis on dramatic surprise.

Regardless of their individuality all baroque artists were gradually overwhelmed by the realities of a changing world. For this was the time of Descartes (1596–1650), the beginning of empiricism in science and a new conception of the affinity between art and the endless multiplicity of living and material things. The first upsurge of naturalism in the Renaissance had still been tied to the Platonic conception of material phenomena as only faulty copies of true and "universal" images somewhere beyond space and time. But with the passage to baroque the reality of concrete things displaced the reality of unseen eternal archetypes. Each painter was now obliged to look at objects through his own eyes, and make his own choice of worthwhile figures and attitudes. The outdated mellow heroic image gave way to crowds of interesting and original figures seen from unusual angles. The touchstone was no longer "Is it appropriate?" but "Is it original?" Despite the different means employed by baroque masters of various schools to capture the dramatic turns of life, they shared one

important innovation, namely, the use of light as an interpretive medium. Up to that time light had been largely a matter of illumination; it now became a recognizable medium, its rich tonal range capable of a nearly independent orchestration within the pictorial idea. It might be the silvery-gray light and somber shadows of Velásquez, or the Italian ensemble of sharp, almost theatrical contrasts, or again the rubescent glow of Rubens' burnished colors. The clearly delineated forms of Renaissance art were now subordinated to the baroque interplay of light and color. And the plastic lucidity cherished by the earlier period gave way to volumes and masses in which light and shadow provided the articulation.

From the time of Michelangelo's death we can trace two strongly divergent trends in aesthetic feeling in Italy. One was based essentially on the work of Michelangelo and the Venetian masters and expressed the dynamic and subjective baroque art previously discussed. The other, rooted in archaeological research and in theoretical reasoning rather than in emotion, was the academic, classicist baroque.

The split appears most sharply in architecture. Entire nations—England and France, for example—began building according to the most fixed academic rules, based on the work of the great Italian Renaissance architect Palladio and indirectly on the laws set down by the Roman Vitruvius. Literature was similarly subjected to the scholar's book of rules, though such geniuses as Corneille and Racine were able to write moving tragedies even within these strict conventions. Sculpture and painting were not quite so overwhelmed by the absolutism of the academies, though such Italianized French masters as Nicolas Poussin (fig. 162), Claude Lorrain (fig. 163), and Eustache Le Sueur composed their canvases with the same acknowledgment of rules and sense of heroic dignity that dictated the classicist façades and columns of contemporary architecture. The landscapes of these painters as well as their figure compositions were constructed in careful layers like the planes of a bas-relief, and framed by bending trees and dignified edifices. Pensive, chaste, they avoided overt emotion either in plastic treatment or in the representation of human forms and faces. They strove, through an almost geometrical organization and prescribed visual standards, to recover the great tradition of the Renaissance. Raphael was their god. They produced a style that was characterized by structural order and delicately balanced composition, but one that was cooler, less urgent, and heroic on a much smaller scale than that of the Renaissance. In a world that already had expressed its emotional and intellectual struggles in the dynamic forms of turbulent baroque, this classicist baroque was marked by the melancholy charm and elegiac regret of reminiscence, the "backward glance of old age."

THE FIFTEENTH AND SIXTEENTH CENTURIES IN THE NETHERLANDS AND GERMANY

The fifteenth century saw not only the Renaissance in Italy but also new tendencies in the art of the Netherlands and soon after in that of Germany. It is somewhat misleading, however, to call these Northern movements a Renaissance. Greek and Roman art were decidedly not direct influences in northern Europe, partly because the North had never had ruins, antique statues, or any Latin lingual tradition. The other chief characteristics of the Italian Renaissance, namely the new interest in man and in nature, appeared in the North with the same force as in the South. These were not specifically Italian phenomena, but part of the general European shift to secular interests. In fact, the new delight in seeing the things of this world with unprejudiced eyes and in recording their countless aspects down to the last leaf-vein was even greater among the Northern people than among the Italians. On the other hand, the break with medievalism was slower and less complete than in Italy, for the good reason that northern Europe had been the birthplace of the Gothic style and that it had taken root and flowered there far more vigorously than in the South.

The Netherlands in the fifteenth century may not have possessed greater wealth than the Italian city-states but they certainly had more political stability. Because their trade centers and industries were therefore secure, literacy increased among the middle classes, and the material evidences of culture, from precious vessels to Oriental rugs, might be found as often in a burgher's house as at the court of the dukes of Burgundy. Here again the North differed from the South, where differences in wealth produced much sharper contrasts between the highest and lowest levels of society.

The dukes of Burgundy were lavish patrons of the arts. The late medieval works that they commissioned, including illuminated manuscripts, tapestries, and enamels greatly influenced Flemish painting in the fifteenth century. Here already was that amazing talent for minutest observation, for fresh, naturalistic description and the most subtly integrated colors. Local schools of painting developed in the great cities of Ghent and Bruges, Tournai, Louvain, and Antwerp, but though distinct, they showed fewer differences among themselves than did the various Italian schools.

The German schools of the same period, despite many cultural and ethnic affinities with those of the Netherlands, diverged markedly from them. The painters of Cologne, Westphalia and the Upper Rhine, Swabia and Bavaria, were provincial by comparison with the Flemish and were still bound to medieval traditions. This is understandable, for life in the small towns of Germany in the fifteenth century was cramped, ingrown, and without the stimulating proximity of such a truly international court as that of Burgundy. Nor did the

great trade routes that brought international commerce as well as spiritual change to small towns, develop as early in Germany as in the Netherlands. Then again, the literate and urbane Netherlanders had already had some training in looking at art, and by their greater appreciativeness stimulated the Flemish artist to explore and exploit his medium. The German artist of the same period, still regarding himself primarily as a craftsman, produced for fellow townsmen who continued to look at art with the eyes of late medieval piety. It was not until shortly before 1500, when, significantly, the great German artist Albrecht Dürer made his decisive journeys to Italy and the Netherlands, that German art found common ground with Flemish and Italian art.

In the North there was somewhat less of the kind of passion for perspective, spatial visualization, and grand composition which possessed Italian art; but the feeling for nature and the sense of a vital closeness to earth were much greater. Landscape as background had played a large part in Northern painting as far back as 1430, as, for example, in the work of the van Eycks (fig. 152) and such German painters as Konrad Witz (fig. 158), but it is absent from Italian painting of the same period. The Flemings painted the human face as it was, making no attempt to turn it into the personification of an ideal. Nature, man, and even the saints and divinities were all depicted in frank and intimate terms by the down-to-earth Northerners. Throughout most of the fifteenth century, religious subjects remained, aside from portraits, their chief themes; mythological themes, which were a folk tradition in Italy, became known rather late in the North. When narrating a story from Scripture, Northern artists did not build the material into a unified and formal spectacle in the Italian manner, but broke it into a number of intimate groups. This practice produced a discursive, multifocal picture in which groups and private emotional reactions were more vividly realized than individual characters. The practice of distributing protagonists, all equally significant, throughout the canvas or panel, rendered each area of the picture as important as the next. Such a pictorial solution runs exactly counter to the formal presentation of Italian pictures, where a clear scale of values indicated the proper places of all characters and masses. Italian art organized an accentuated and monumentalized reality; Northern art appropriated reality entire and created its informal designs less by organization than by accumulation.

If we disregard local differences among the schools of Ghent, Bruges, Brussels, Tournai, Louvain, and Antwerp, the art of the fifteenth-century Netherlands can be broadly characterized according to the three generations who did their work in this period. The first generation, led by the brothers Hubert and Jan van Eyck continued the descriptive realism taken over from late medieval Burgundian miniaturists and even intensified it by the increasing use of oil glazes. Oil painting, however, was not invented by the van Eycks, but developed gradually, first in connection with tempera, later as a pure medium in itself. The

second generation, led by Rogier van der Weyden (fig. 65) and Dirk Bouts (fig. 49), achieved a greater freedom of composition and gave a higher pitch to emotional expression. The third generation, with Hugo van der Goes (fig. 6), Justus van Ghent (fig. 50), and Hans Memling among its representatives, showed for the first time in the North the influence of the Southern Renaissance, transmitted directly through certain Flemish masters in Italy.

At the end of the fifteenth century, the art of the Netherlands split into two clearly differentiated styles, that of the national school and that of the "Romanists." The national school, which included Quentin Massys (fig. 67), Joachim Patinir (fig. 156), and, later, Pieter Breughel the Elder (fig. 68), pursued the established tradition of close realism, bringing to bear on it even more precision and dramatic conviction. In marked contrast were the Romanists, such Flemish painters as Mabuse (Jan Gossaert) (fig. 8), Barend van Orley, and later Frans Floris, and such Dutch painters as Antonio Moro and Jan van Scorel. Most of these had studied in Italy and acquired such a taste for her art that they consciously rejected their own national backgrounds in favor of Italian plasticity and clarity of design. They also borrowed architectural and sculptural motifs from antiquity and tended to add more and more antique elements to their pictures. It was this Northern infatuation with detail, in combination with an acquired taste for the style of the Italian High Renaissance, that led to mannerism.

German art of the fifteenth century, at least until after the middle of the century, found its strongest expression in sculpture. Whether the style of that sculpture be considered late Gothic or the beginning of the new movement, it represents a striking visual conquest of the world in the force of its unadorned realism and its simple and loving faith. Unforgettable indeed are the faces and dramatic figures that these fifteenth-century German sculptors carved on wooden altars. In painting, however, these qualities are less pronounced. The blending of the German Gothic and the Renaissance elements took place step by step. Losing their Gothic spirituality, figures became more earthy, though they were still set in the traditional background of gold or neutral blue, sprinkled with stars. Yet in the 1430's a few such South German artists as Lucas Moser and Konrad Witz (fig. 158) had, with a surprisingly uninhibited realism, freed the human figure from neutral backgrounds and set it against appropriate interiors and landscapes. Although far behind the Italians and the Flemish in matters of anatomy and perspective, German art possessed an earnest craftsmanship and a disarming lack of interest in formality and decorum. Its over-all effect is a touching and naïvely poetic charm. Even as late as the early sixteenth century, a feeling for graphic precision and the special qualities of black and white turned German art to expression in terms of line. The result was a distinctly linear art,

and one which lagged behind the contemporaneous Italian and Flemish modes in the employment of color and light.

The period of the greatest German masters, Albrecht Dürer (fig. 7), Matthias Grünewald, Lucas Cranach the Elder (fig. 33), and Hans Holbein the Younger (fig. 113), coincides with the Italian High Renaissance. The new philosophical and religious ideas which were sweeping Italy were stirring Germany too. Her masters, like the Italians, were not alone masters of paint, but towering personalities who wrestled with religious and philosophical problems. Grünewald, the mystic, Dürer, whose scientific speculation recalls Leonardo da Vinci's, and Lucas Cranach, who fought for the Reformation—all took active part in the spiritual revolution of their age. But it is nevertheless true that the German painter was looked upon more as a craftsman than what we would today consider an artist. Cranach and Holbein were the sons of painters; Dürer the son of a goldsmith. This background of a family workshop tradition may explain a certain narrow and even provincial strain in their work. The linear form was as natural to these German artists as painting, or even more so, a fact that accounts for the splendid blossoming of woodcut and copper engraving between 1450 and 1530. The only major exception to this is Matthias Grünewald who in his demonic mysticism was primarily a painter, making full use of color and authentic light.

German art of the fifteenth and early sixteenth centuries is profoundly identified with its subject matter. Often drawn to tragic themes, to the morbid and catastrophic, it tends to reflect their most extreme aspects, sometimes with crude brutality. Occasionally, however, other topics are depicted with lyrical or even sentimental charm. Compared with Flemish naturalism, the German concept is intensely literal and strongly influenced by the emotional overtones of its themes; meanwhile Burgundian and Flemish art was wholly absorbed in conquering reality and projecting it accurately on the panel.

Both currents of Northern naturalism were in complete contrast to contemporaneous Italian art, in which ideas and physical traits were personified and heroic types were glorified and placed, idealized and monumental, in carefully organized settings.

THE SEVENTEENTH CENTURY IN HOLLAND AND FLANDERS

The Low Countries, which had been a Spanish province since the time of Charles V (1500–1558), were finally set free in the great War of Liberation that started in 1568 and lasted eighty years. This prolonged political and military upheaval merits mention here because it led to the division of the Netherlands

into two distinct national cultures. The northeastern portion, Holland, achieved independence from Spain, and following the conclusion of the Union of Utrecht in 1579, it began its expansion into a great naval and colonial power, wealthy, bourgeois, and Protestant. The southwest portion, including Flanders and parts of Burgundy, which were to constitute modern Belgium, remained in the Spanish orbit and, like Spain, kept in continuous contact with the great ruling dynasties of Central Europe. The fact that it remained courtly and Catholic also served to give it a more international outlook. This decisive split was reflected unmistakably in the development of the arts in the two countries. The Flemish portion naturally maintained a closer community with the cultural ideas of the South and with Italian art, while Protestant Holland evolved on much more independent lines.

The differences between the newborn nations were epitomized by the greatest genius of each, the Flemish Rubens and the Dutch Rembrandt. Both areas shared in the conquest of landscape, genre, and still-life painting, and both were rich in masters of portraiture. But in Catholic Flanders, under the stimulus of the Counter Reformation, artists continued to pour their creative energies into religious painting, and under the influence of Italy and international court society, into grand mythological canvases. In Holland, however, the already democratic genre style grew more earthy; landscapes and marines acquired intimacy; and still-life pictures ceased to be merely decorative. The Dutch emphasis on group portraits is even easier to understand when we recall the many craft guilds and other democratic organizations of that country.

Flanders' direct contact with Italian art accounts for the strong baroque trend in Flemish art that reveals itself in the great plasticity and rich handling of masses. Here perhaps is the crucial difference between these two branches of Northern art. Flemish baroque with its rosy exuberance and its splendidly painted concourses, crowded with almost tangible bodies, represents the climax of baroque as an international trend. The art of Holland, on the other hand, was rather that of the analytical eye studying its daily surroundings for visual truths—the changing revelations of light, colors constantly dissolving into elusive shades, and the textures of living and inanimate things. In other words, the artists of Holland continued the Northern naturalistic tradition of the fifteenth century, though employing new means. When in the seventeenth century they introduced the new approach, using light, tonal values, and atmosphere to convey visual experience, they laid the foundations of all later European painting.

From this point of view it is possible to appreciate Dutch and Flemish sixteenth-century Romanism and even the Northern variety of mannerism as necessary transitions toward the art of the seventeenth century. The steps between mannerism and the mature baroque of a Rubens can be traced in such painters as Antonio Moro, a disciple of Jan van Scorel, Frans Floris, and Paul Bril.

The personality of Rubens and the incredible number of canvases that he painted himself or partially executed and partially supervised in his workshop overshadow the contributions of his Flemish fellow painters. As with Shakespeare and Balzac, the sheer quantity of his work becomes a quality in itself: his vast output reflects every aspect of Flemish baroque. It unfolds equally in his expansive religious representations, mythological interpretations, historical canvases, impetuously brushed landscapes, and stately portraits. Clearly it is to Rubens that many of his contemporaries, even such dynamic personalities as Jacob Jordaens and Sir Anthony Van Dyck, Frans Snyders and Jan Fyt owe their mastery of baroque expression.

Dutch art extended the variety of acceptable subjects far beyond the Flemish, adding seascapes, church interiors, group portraits, and especially the whole broad compass of genre. With the increase of themes came an increase in specialization among practicing artists, a specialization made possible by the fact that during this century an almost incredible proportion of Holland's entire population was devoted to painting. (Another elucidating instance of this little country's passion for aesthetic ventures is its wholehearted application to tulip-growing.) It is possible to mention only a few of the artists who excelled in special fields. Among the leading landscapists were Jan van Goyen (fig. 164), Salomon van Ruisdael and his nephew Jacob (fig. 166), Meindert Hobbema (fig. 167), and Aert van der Neer; marine scenes were the special province of Willem van de Velde and Jan van de Cappelle among others, and animals in landscape were the favorite topic of Philip Wouvermans, Aelbert Cuyp (fig. 165), and especially of Paulus Potter; outstanding among still-life painters were Willem Claesz Heda, Jan Davidz de Heem, Willem Kalf (fig. 218), Jan van Huysum (fig. 219), and Rachel Ruysch. Portraiture also flourished, but the works of such fine painters as Thomas de Keyser and Bartholomaeus van der Helst were inevitably overshadowed by those of Rembrandt and Frans Hals.

The most popular themes among Dutch painters were landscape and genre. Genre artists differed in the social levels they preferred to paint and in the choice of entourage and setting for their figures; but all enjoyed conveying candid narrative through light, atmosphere, and texture. Gerard Terborch described men and women of society; Pieter de Hooch (fig. 192), and Gabriel Metsu (fig. 193) delighted in light-pervaded domestic scenes; and Adriaen van Ostade and Jan Steen indulged in full descriptions of rustic brawls and jolly peasant feasts.

These names are but a few from among those whose works exemplify seventeenth-century Dutch style. All the qualities of this style are sublimely realized in the work of the master Jan Vermeer van Delft (fig. 199). Though few in number, his canvases are at once typical of the period and yet unique in their objective perfection, sensibility, and detachment. Vermeer actualized a

world without the least trace of associative and subjective emotion. His characteristic lighting is serene to the point of making us "hear silence" as it flows over fabric, rug, metallic vessel, human face, or bare wall. Changing surface and textures into a subtle radiance of color values, he handles light the way a jeweler handles precious gems and crystals.

Vermeer's lucid detachment contrasts with the frank subjectivity of the two greatest Dutch masters, Frans Hals and Rembrandt. Hals's subjectivity emerges in a loose, audacious brushstroke that seems to be exactly suited to the unchecked liveliness and immediacy of his approach. Essentially a portraitist (fig. 114) and student of human types, never taken aback by the ugly or grotesque, Hals combined a sturdy naturalism with keen psychological insight. In later life he retained his gift for spontaneously grasping the truth about men and women, but it came to serve a calmer and more reflective attitude. The brush techniques of Hals and of his Spanish contemporary Velásquez were later to provide the stimulus for the impressionist handling of paint in the nineteenth century (see Realism and Impressionism).

While Vermeer employed light to elucidate the hidden complexities of color, Rembrandt, the unique genius of Dutch painting, used it to dramatize a scale of color that grew increasingly economical and restrained. The color scale of Rembrandt's maturity seems actually to be dissolved or dematerialized by light. His almost metaphysical illumination, his sparing use of artistic resources and means, together with his extraordinary imaginative vision, are the marks of his individual and solitary genius. These qualities are not typical of Dutch or of seventeenth-century art. Rembrandt's work, self-generated and self-sufficient, cannot be used to describe a general style. Naturally he did not become the leader of a school, and such artists as Aert de Gelder, Govaert Flinck, Ferdinand Bol, and Carel Fabritius emulated only specific traits of his work.

THE EIGHTEENTH CENTURY

The reign of Louis XIV ushered in not only a new phase of French art, but a whole new European style. France's supremacy in politics and economic advances, together with her great number of eminent artists, created a French taste that soon became *the* taste among the élite and the wealthy who had become the sponsors of art everywhere in Europe. Eventually this new French manner became more than a taste, it became a style: Louis's royal palace at Versailles was copied in every European country and principality, the petty nobility impoverishing themselves to reproduce it, albeit on a scale thriftily close to miniature; the works of French painters were eagerly adopted as models for design, color schemes, and choice of themes by other European artists, who soon became "colonials" of French art. And this was an art sensuous and escapist,

intended to beguile the eye, shunning serious thought, great emotions, and the urgent problems of humanity. Painting as a consequence grew so decorative and playful that the line between art and mere applied arts wavered and occasionally disappeared.

The course of baroque art through the latter part of the sixteenth century and the whole of the seventeenth had followed two divergent lines. One was the expansive, painterly, Michelangelesque style accepted by most painters throughout Europe; the other was cool static academism or classicist baroque taking its sanctions from theory, "reasons," and archaeological research. These two trends competed for aesthetic authority, but it was the looser, more dynamic form derived from true baroque that prevailed for at least two-thirds of the eighteenth century. Only during the last third of the century did the classicist style of the academies triumph in France, England, and Germany.

The long reign of Louis XIV embraced many successive changes. At the very beginning, when Hyacinthe Rigaud (1659–1743) painted "Le Roi Soleil," the Sun King, he still worked in terms of ceremonial Roman-baroque pomposity— called "the Style Louis XIV." Twenty years later, Antoine Watteau, court painter to Louis XIV and chief genius of eighteenth-century French art, changed all this formal stateliness into an unbounded play of graceful forms. He set mythological themes in the charming scenes of contemporary court life, composing *fêtes champêtres,* the costumed pastorales with which the aristocracy amused itself. On his canvases the motifs of antique myth became pretexts for describing the frivolous and sentimental amours of court circles (fig. 78). However, Watteau's ties with the traditions of Rubens, with Flemish baroque in general, lifted his work far above the level of flattering décor to which many of his successors stooped in their desire to please a pleasure-loving court society. Always a painter's painter, Watteau gave more thought to design and color problems than to the themes of his pictures, and in this respect, at least, he does not typify the style of his time. This was scarcely the attitude of the painters who followed him in the rococo period of Louis XV. The typical masters of rococo— Nattier, Lancret, Pater, Boucher (figs. 35 and 120), and Liotard—cultivated an exquisite taste, a flair for witty versions of courtly love affairs, and above all a sense of decorative fitness. Many of the illustrative panels they painted were in fact commissioned by the nobility as an integral part of the interior decoration of their palaces. It was these qualities of pictorial flattery which earned François Boucher his enormous popularity as the leading exponent of the Style Louis XV, the rococo.

One other painter must be considered on a level above the rest and nearer to the eminence of Watteau. This was Jean Honoré Fragonard, representing the transition from the Style Louis XV to the Style Louis XVI. His work was more intimate and based on direct observation—comparable, indeed, to the style of

the contemporaneous comedy of manners. Fragonard (figs. 16 and 194) recorded his contemporaries in their daily dress and informal aspects more often than in mythological disguises. He projected his relatively candid scenes in loose flecks of color applied almost impressionistically.

The work of Jean Baptiste Siméon Chardin (figs. 95, 133, and 220) is diametrically opposite to this world of court influence, costumed elegance, and gay masquerade. His honest scenes of family life and genre, the faces he paints, even his still lifes, are illuminated by a beauty of a very different kind. Chardin painted average people, without pretensions or false social ambition, neither softening nor exaggerating homely visual truths. And like his style, his color approach differs from that of his contemporaries. For Chardin is in the tradition of the great seventeenth-century Dutch masters in his precise visualizations of surface and texture—although his feeling for the mellow union of colors and values is typically French.

Viewed in historical perspective, Chardin was a singular phenomenon in eighteenth-century French painting. Yet change of one kind or another was in the air. After Chardin there appeared an entire group of artists who gave expression to the new ideas current in France during the last third of the century: the logic of the new "age of reason," the personifying and sentimentalizing of nature, the stern virtues of ancient republican Rome—in brief, all those trends which were to become cults before and during the time of the French Revolution.

These tendencies, which flowered as classicism or neoclassicism, were partially anticipated by the works of Jean-Baptiste Greuze. A later group—Pierre Paul Prud'hon, Mme. Vigée-Lebrun, and others—painted in an astonishing conglomeration of styles, part romantic, part classicist, with traces of rococo playfulness. In this invertebrate manner, they painted sentimental genre pictures, allegories, and "poetic" family scenes. Despite their lack of pictorial directness and visual immediacy, they were, as can be seen from their sketches and less complex portraits, excellent draftsmen.

The eighteenth-century Italian artist was not so completely under aristocratic influence as his French counterpart, and hence his work was less finical and embraced a broader span of social levels. The *joie de vivre* that marks the whole century enlivened all Italian art, painting no less than the frothy stage comedies of Carlo Goldoni (1707–1793) or the irrepressible memoirs of a Giovanni Jacopo Casanova (1725–1798). From Sebastiano Ricci (fig. 55) to Giovanni Battista Tiepolo and Francesco Guardi (fig. 170), Italian artists brought the same mood of gaiety and levity to all their themes, whether traditional scenes from Scripture, contemporary festive gatherings, romantic intrigues, or lovely little scenes of life in Venice, which was the center of social elegance in the eighteenth century. They composed these intensely social episodes with even more exuberance than had their fellow Venetian, Paolo Vero-

nese, two centuries earlier (fig. 91). They developed both secular and religious scenes with the most intricate effects of perspective, and reveled in the dazzling pinks, pale greens, pastel blues, and creamy whites typical of eighteenth-century color schemes. Backgrounds of fantastic architecture like stage-settings served to frame lively figure groups—saints in religious frescoes, heroes in historical episodes, comedians in theatrical scenes, or just their neighbors in one of Venice's innumerable carnivals. What appears as a certain fuzziness of technique in minor artists becomes in Tiepolo's work a scintillating whirl of color nuances and splattering forms. This virtuosity reached its climax in Tiepolo's famous ceilings, which, with their extreme perspectives and violently foreshortened figures, almost deceive the eye into believing it is actually seeing the heavens through an open dome or skylight. Other painters, such as Pietro Longhi, produced amusing genre pictures; and Rosalba Carriera excelled in pastel portraits. But the most important were the four who recorded the "golden sunset of Venice's decline," namely, Giovanni B. Piranesi, Antonio Canale (called Canaletto), Bernardo Bellotto, and above all, Francesco Guardi. These painters had to meet a demand for "souvenir" art from travelers, especially from Frenchmen and Englishmen who went to Italy on that Grand Tour without which no gentleman's education was complete. These tourists cherished pictorial reminders of memorable visits, *vedute* of Italy's great cities, and particularly of Venice. Canaletto and Bellotto made charming and topographically rather accurate records of Venice's most beautiful landmarks. But on Guardi's canvases the piazzas and canals of Venice half dissolve in a lambent light, the solid masses of her buildings crumble into flecks of color and flakings of golden light, the very air vibrates with chromatic change. These atmospheric miracles, despite their rococo connotations and memories of the Italian stage, use color and light almost in the manner of modern impressionism.

After expanding its visual creativeness in the fifteenth and early sixteenth centuries, Germany contributed very little to European painting, and did not make contact with international movements until this period. Sculpture and architecture were more congenial to her than painting, and in these fields her eighteenth-century works were as climactic as the classics of literature and the masterworks of music she produced in the same period. The decorative paintings in South German and Austrian churches and monasteries followed the same lines which in France and Italy had been used to depict a worldly society. In easel painting Germany, comparatively poor, with many small principalities and a narrow town life, scarcely responded to the animation of the international rococo style. Aside from a few earnest portraitists and such touchingly sincere and able draftsmen as Anton Graff (1736–1813) or the copper engraver Daniel Chodowiecki, Germany produced no painters to compare with her eighteenth-century architects and sculptors.

It is typical of the differences between England and France that we name the three successive generations of French eighteenth-century art after the reigning monarchs, Louis XIV, Louis XV, and Louis XVI; but generally give the corresponding periods in England, not the names of the several Georges who reigned at the time, but those of three cabinetmakers and designers, Chippendale, Hepplewhite, and Sheraton. This difference between English and French style-names goes deep. Until the fall of the monarchy, of l'ancien régime, France was completely under aristocratic and royal influence. The bourgeois men of wealth or distinction lucky enough to reach the top rung of the social ladder bowed to the taste of the royal ruling class with an eager servility which Molière satirized brilliantly in *Le Bourgeois Gentilhomme.* In England, however, the social changes accompanying the rise of urban industrialism were gradual and widespread. By the eighteenth century the wealthy merchant class had already acquired independence and social prestige; good taste and the leisure to cultivate it were no longer a monopoly of the court but were shared by Whig and Tory alike. Unlike almost all French artists from Watteau to Boucher, English artists were not obliged to cater to a single taste. Thus, if born an individualist, an English artist was in a better position to remain one.

When we recall that no work of specific national artistic idiom had been produced in England since the illuminated books at the close of the Middle Ages, the appearance of a typical British style in painting in the eighteenth century is all the more surprising. At the beginning of the sixteenth century, Hans Holbein the Younger had brought the substance of German art to Britain when he had painted his memorable portraits of the court of Henry VIII; and a hundred years later Sir Anthony Van Dyck introduced Flemish art concepts through his patrician portraits. English portraitists of the eighteenth century continued the Van Dyck tradition, translating his decorative elegance, well-bred naturalism, and psychological insight into the language of their own age. English eighteenth-century art, in fact, was essentially an art of portraiture; the landscapes of Richard Wilson, Gainsborough, and others, and William Hogarth's edifying narratives were not typically British in tradition.

Hogarth (fig. 145), the first of the major English painters of the century, abandoned the fresh, impressionistic approach of his early canvases in favor of a highly ingenious form of visual narration. He created moralizing scenes of almost theatrical character, which, circulated everywhere in England as copper engravings, achieved great popularity. Though Hogarth himself developed some very subtle theories of aesthetics, the beholder's interest centered on the content and its didactic value rather than on any direct visual experience. The mere fact that so many English painters of this age, including Hogarth, Sir Joshua Reynolds, and William Blake, wrote aesthetic treatises supports the view that their feeling for art was first passed through a screen of intellectual,

literary, and nonvisual preconceptions. Such a cerebral response to art was entirely alien to their French contemporaries.

Despite this intellectualized approach, these British artists were genuine painters and sound judges of the masterworks of the past which they studied so thoroughly. They finally absorbed the various influences and converted them into a distinctly English style. Reynolds' eclectic style owes much to Raphael, Titian, Rembrandt, and Van Dyck; Gainsborough's landscapes and portrait backgrounds recall both seventeenth-century landscapes and the manner of Claude Lorrain and Nicolas Poussin; and Romney's portraits revived the polish of Van Dyck accented with a dash of Frans Hals—yet all these borrowings were incorporated in a recognizable national idiom. These English portraits and historic scenes were quite distinct from contemporaneous French work; they were closer to the life of the time, yet seemed to place a greater distance between the canvas and the spectator (as the Anglo-Saxon face is more reserved in public than the French); less sparkling than the Gallic but more informal and casual; less temperamental but distinctly well bred—in a word, British.

Painting in America was just coming into its own in the eighteenth century. While Southern society still preferred to import its cultural accessories—books, furniture, paintings—from England, the spreading influence of democratic New England encouraged an interest in likenesses and even a certain demand for representative family portraits. It is unjust, in fact wrong, to consider American painting a mere colonial offshoot of English painting. American painting obviously developed from quite different sources. For one thing, it is the only branch of art in Western civilization which as late as the eighteenth century started literally from scratch—from the skills of plain artisans, sign painters, coach painters, and limners. Again, its few connections with European traditions in colonial times, before and after 1700, were rather through Holland than England, for Dutch colonists flourished along the northeastern coast, and Manhattan was originally a Dutch community. The early colonial painters sought simplicity and directness of visual statement, with no concern for problems of space, color, or light. Prospective patrons demanded only one thing, a good likeness. It was not until after 1800 that landscape painting attracted any significant interest.

It was John Smibert (1688–1751), Hogarth's fellow student, and Peter Pelham (1684–1751) who added the first trace of British influence to the Dutch and the native influences prevailing among the few limners at work in the Northern states. A surprising number of serious and talented artists appeared soon afterward, from Robert Feke (1724–1769) and Joseph Badger (1708–1765) to Charles Willson Peale (fig. 135) and John Trumbull (1756–1843). Whether they were British-born artists settling in America, or Americans study-

ing in England, these painters fused European art traditions with native American craftsmanship. Occasionally they introduced manners and gestures savoring of the Old World, and imitated certain characteristics of European society portraiture, but they did so with restraint, upholding their generally democratic attitudes. Throughout the eighteenth century, American painting more or less retained its lively realism and its concern with making good likenesses. Painters like John Singleton Copley (fig. 118) held to a typical American realism and widened the gap between it and contemporaneous British refinement and decorativeness. Later, however, Copley moved to England and there succumbed to British influence. Charles Willson Peale rejected British influence altogether and clung stubbornly to a stark American plainness which brought him much closer to his predecessor Smibert than to his contemporaries in England. Benjamin West's highly eclectic work presents problems too complex to be considered in a summary of an entire group.

Briefly, American art of the eighteenth century, prior to the Federal period, concentrated almost entirely on portraiture; convincing resemblance and functional accuracy were its pictorial goals. Since it was not particularly interested in the more professional, purely aesthetic problems of its European initiators, American painting of this period used a forthright, unpretentious craftsmanship, with some slight assimilation first of seventeenth-century Dutch and later of eighteenth-century English influences.

CLASSICISM AND ROMANTICISM

Classicism and romanticism in painting are not original styles in the same sense as are, for example, High Renaissance or impressionism. The latter expressed a radically new way of looking at things, a revolution in seeing that paralleled the revolution in thinking that marked their times. In the periods known as classical and romantic, however, the changes in philosophical, literary, and sociological thought effected no fundamental changes in visual concepts. What actually took place in painting was merely a change in subject matter and in the style of rendering, a change stimulated by the new imagery of literary, philosophic, and political thought. Pictorial art responded to the new revolutionary ideas, but did not match them with any originality of visual experience or artistic techniques. In other words, the classicist and romantic styles are largely literary derivations, interesting in the history of ideas, but not decisive in the evolution of painting.

Classicism—or, as it is sometimes called, neoclassicism—blossomed between 1780 and 1820, and must be seen chiefly as a reaction against the ornate hedonism of eighteenth-century rococo, which had by that time become the played-out playfulness of a minority taste. This reaction began in France but soon

spread through every part of Europe. Its philosophical sanctions and basic theories were supplied by the writings of the French Encyclopedists, of Diderot (1713–1784) and d'Alembert (1717?–1783) and Voltaire (1694–1778). These champions of "reason and moral responsibilities" brought out their epochal *Encyclopédie Française* between 1751 and 1776 and thus gave the Enlightenment its scriptural authority. The English equivalent, the *Encyclopaedia Britannica,* embodying similar ideas, appeared between 1768 and 1771. For artistic authority, classicism drew on the writings of French, English, and German archaeologists, of whom the most influential was Johann Joachim Winckelmann (1717–1768). Such scholars provided the classicist artists with aesthetic warrants for their belief in the perfection of antiquity.

It was the second time in European history that a great wave of rediscovery turned all eyes to ancient Greece and Rome. But the basic need of the later eighteenth-century revival was very different from that of the Renaissance. The Renaissance, reacting from medieval spirituality, found in ancient art the most enchanting example and evidence that this our world was really as wonderful as it was beginning to appear. To the dazzled eyes of early Renaissance men, Greek and Roman art became the triumphant symbol of everything human, organic, and tangible as against everything abstract, unworldly, and formalized. But the classicists of the eighteenth century were reacting against a world that glorified sensuous pleasures in the interests of certain limited classes and limiting ideas. As the Enlightenment proposed new principles of reason and a more democratic equality, the scholars and artists found in ancient Republican Rome the prototypes of these new virtues and proposed freedoms. The stern and simple heroes of Roman liberty became the models of revolutionary morality even before the French Revolution, and the art of ancient Rome became symbolic of national aspirations and the struggle for civic rights. Pictorially, Roman and Greek art were looked upon as the final realization of perfect beauty, severity, and exalted simplicity—in brief, as the classical idea.

Of equal if not greater importance for the rebirth of interest in antiquity were the excavations of ancient Roman ruins, especially those begun in 1748 at Herculaneum and Pompeii. Their findings became familiar to the whole world through copper engravings and popular atlases of antiquities.

Romanticism, like classicism, can also be traced back to the writings of the French Enlightenment. Romanticism, however, rejected order and rationalism, and found the guides to a higher life in such concepts as Rousseau's emotionalism (1712–1778) and his faith in a "return to nature" and in putting sovereign emphasis on sensitiveness, passion, subjective experience, and human feelings in general. The first harbingers of the romantic movement had already appeared in England by the eighteenth century in the poetry of William Collins, Thomas Warton, and Thomas Gray; their verses faintly heralded the return to imagina-

tion, and the melancholy moods of ecstatic visions that later romanticists expe-
rienced in the presence of exotic, sublime or pastoral landscapes. The great
German poets of the *Sturm und Drang* period expressed a similar view of the
world as a projection of man's inner states.

The return to nature found visual expression in the development of the
rambling garden as against the formal French *parc,* in romantic bark huts and
summer houses, often put up alongside of pseudoclassical friendship temples,
and in the revival of a romantic medievalism in neo-Gothic architecture. This
romanticism went so far as to design and build "ruins" for the sake of their "de-
lightfully tragic" effects.

In painting, the picturesque came finally to be prized above every other
quality. The few landscapes done by Gainsborough and even later those by
Turner reflect this romantic interpretation of nature. It was the picturesque
quality in the seventeenth-century landscapes of Claude Lorrain (fig. 163),
Salvator Rosa, and even of Rembrandt, that appealed to this generation. The
roving imagination chose as its fitting abode such items of landscape as ruined
castles, windswept moors, the stormy "trackless deep," mysterious waterfalls in
haunted glens, lightning-blasted trees, the rainbow over the black abyss; in short,
whatever stimulated the literary and story-loving fancy became the standard
furnishing for romantic landscape.

To summarize these trends, by the middle of the eighteenth century, when
the prevailing international taste was that of Louis XV and the French court
painters led by François Boucher, countercurrents were already rising and de-
veloping into classicism and romanticism. Stemming from a common rebellion
against the domination of baroque and rococo, both of these movements cham-
pioned a return to a pure and natural emotionalism, but by methods so divergent
as to be utterly antagonistic.

For a single generation, classicism enjoyed universal popularity. The passion
for antiquity was favored by the French Revolution, and afterwards by Na-
poleon's ambitious emulation of the Roman Empire. Though the romantic
current was driven underground during this archaeological revival, it was not
destroyed, for it welled up in full strength at the end of the Napoleonic era.

The triumphant classicists painted themes from ancient history and mythology
in compositions characterized by sharp angularity and with little interest
in space. They constructed their pictures in distinct layers or sequences, relief-
like, without regard to depth as an element of organization; and their cool colors
and steady, unflickering lighting were descriptive rather than painterly.

The two great names in classicism are French: Jacques Louis David, whose
studies in Rome influenced the direction of his art, and Jean Auguste Dominique
Ingres, his junior by thirty-two years. Their lives spanned the entire evolution
of classicism. To both of these artists, linear clarity and precise form defined the

very essence of painting, color being simply another means for delineating form. David is known chiefly for grand historical pageants, ranging from Greek and Roman episodes to the coronation of Napoleon I. Ingres gave this large historical manner a more gently poetic tinge. With their extraordinary drafts-manship, these two artists also created some of the finest portraits in existence (figs. 121 and 123). For David, the theatrical gesture and expressive pathos of the classicist ideal became a revolutionary language through which he cham-pioned the new cause of freedom. Ingres, who called himself a "convert to the religion of Raphael," employed the same vocabulary of gestures to convey a lofty idealism. In the hands of minor followers, these trends naturally lost their broad allusiveness, and eventually hardened into a trite academism. The in-terest in content soon smothered any interest in capturing honest visual expe-rience, and classicist painting gradually declined into theatrical or sentimental storytelling.

The classicist trend flourished outside of France, too. The metaphysically in-clined Germans, influenced by their own philosophy and poetical creations, went to fantastic extremes with their "poetic" inventions and formal "classical" com-positions, some of which were no more than pictorial translations of ancient sculptural groups. Their conception of ancient Greeks as a marmoreal species led them to paint a pallid world of frigidly pure figures. The chilly erudition of such painters as Anton Raphael Mengs (1728–1779), Angelica Kauffmann (1741–1807), Johann Heinrich Wilhelm Tischbein (1751–1829), and Jakob Asmus Carstens (1754–1798) was the result of their doctrinaire theories and lack of spontaneous visual sensibility.

In England, the generation of elegant portraitists who followed Gainsborough all paid some lip service to classicism, painting their sitters in classical costume and toning down their unmistakably romantic attitudes. The admixture is clear in George Romney (1734–1802), John Hoppner (1759–1810), and Sir Thomas Lawrence (1769–1830). The two major figures of this period, Joseph M. W. Turner (fig. 171) and John Constable (figs. 174 and 175) cannot be summed up by any single formula: their landscapes are felt in the romantic mood, but are rendered with strong overtones of classical traditions. Unlike most of their contemporaries, Turner and Constable possessed an independent vision and a visual energy too authentic for any narrow definition. By the same token they were the only British painters of the period whose works point in some respects toward the future rather than toward the past.

American classicism, so clearly defined in architecture by the work of Thomas Jefferson (1743–1826), Charles Bulfinch (1763–1844), and Benjamin H. Latrobe (1764–1820), did not produce an equally clear style in painting. Dur-ing the Federal period, which roughly corresponds to the classicist period in Europe, the leading figures were Ralph Earle (1751–1801), Gilbert Stuart

(fig. 119), and John Trumbull (1756–1843). But American painting was still so young that the works of these artists appear to be individual expressions rather than examples of a prevailing style. American patrons and buyers were so frankly matter-of-fact that even at the height of European classicism they generally preferred the realism of earlier American painters. Under such conditions the influence of European art was accepted reluctantly, and the few recognizable traces of it at the end of the century are French more often than English. Gilbert Stuart, who sometimes used his brush as broadly as the early Hogarth, never emphasized free rendering at the expense of verisimilitude—a veracity that we find most striking in his famous portraits of George Washington. On the other hand, Benjamin West, who was Europeanized enough to succeed Sir Joshua Reynolds as president of the Royal Academy in England, fused so many influences in his work that he can hardly be labeled a classicist. He was even declared an enemy of classicism when, against the advice of his colleagues, he painted the figures of his "Death of General Wolfe" in contemporary uniforms instead of the togas and chitons of antiquity—a bit of realism which scarcely warranted the complaint that he was a revolutionary.

Romanticism in the nineteenth century succumbed eventually to the same anecdotal, literary fallacies and nonvisual intrusions as had classicism, but its original expression in painting had been more organic and forceful. The romantic rebellion against the heroic symmetry and cool discipline of classicism went further than theory and discussions, and actually materialized in the works of three very great artists: Théodore Géricault (1791–1824), Eugène Delacroix (figs. 43 and 122), and the Spaniard Francisco José de Goya y Lucientes (figs. 17, 79, and 134). Goya, who preceded the other two chronologically, was a powerful but wholly undogmatic revolutionary and may be called with equal accuracy the last baroque or the first romantic painter. His emotionalism is extreme, yet always authentic. His paintings and etchings, masterpieces of human insight and expressions of high tragic vision, both interpret life and comment upon it ironically. Goya anticipated all the romantic trends by his boundless imagination and his highly original use of light for psychological rather than purely descriptive revelations.

Like Goya, the French painters Géricault and Delacroix combined an emotional approach with almost brutal realism, a quality unthinkable in the classicist works of their contemporaries. The baroque spirit of Rubens and of late Venetians like Tiepolo sprang to life once more, and color, which had been altogether neglected in classical art, now regained its primacy through these two artists. In place of the classicist's carefully arrayed figures and tranquil composition, Géricault and Delacroix aimed at unrestricted movement. Their vigorous group compositions and wonderful figure studies, both of human beings and animals, helped bridge the distance between baroque and the impressionism

that was to develop two generations after their time. Romanticism spurned the dull commonplaces of daily life for the sake of climactic exaggerations and magnificent extremes. Unfortunately, later French romanticists ignored the splendid visual disclosures of Géricault and Delacroix and projected their romantic defiance in maudlin or sensational fantasies. What had been forceful dramatizations of life degenerated into theatrical arrangements. And, as with classicism, the French romanticism that had begun as a crusade for imagination and the life of passion spent itself on mellow little sentiments and artificially sweetened daydreams.

English romanticism, apart from the landscapes of Turner and Constable, was even more literary than French romanticism. In fact, a whole series of painter-poets appeared. Of these, William Blake (1757–1827) was the most famous, though today his poetry far outshines his paintings and etchings. In the middle of the nineteenth century, and somewhat later than their romantic counterparts on the Continent, came the so-called Pre-Raphaelites: William Holman Hunt (1827–1910), Edward Burne-Jones (1833–1898), and others, led by the poet-painter Dante Gabriel Rossetti (1828–1882). For all these artists, the story content with its literary imagery and discursive emotion tended to inhibit any direct visualization. One feels that the English romantics, apart from the landscape artists, might have done better if they had written their stories instead of trying to paint them, and many of them actually did so. Blake as a major poet and Rossetti as an important minor poet were able to transmit their visions more convincingly in words than in color and line.

Romanticism in Germany fell on fertile soil. Unlike the thin-blooded and artificial German classicism, romanticism was congenial to the German temperament and appeared as a genuine style in the works of Philip Otto Runge (1777–1810) and Caspar David Friedrich (1774–1840), Moritz von Schwind (fig. 207), Carl Spitzweg (1808–1885), Alfred Rethel (1816–1889), and many others. German romantic painting was closely connected with the literary romanticism which brought European fame to such writers as Wilhelm Heinrich Wackenroder, Ludwig Tieck, E. T. A. Hoffmann, and the brothers August Wilhelm and Friedrich von Schlegel. Cryptic references to paintings are scattered throughout romantic poetry, while the artists enrich their canvases with countless literary allusions. The heroic themes of classicism, which still lingered in French and English romantic art, disappeared entirely from the German. The favorite themes were delicate family portraits, atmospheric interiors, poetic genre scenes, and tender fairy tales. But it is in landscape, full of gentle emotion, and seen through the eyes of the new middle class, with its longing for nature, that German romanticism appears at its best.

It was from these sources that American romanticism took its inspiration. Like the German romanticists, the artists of the Hudson River School, Thomas Cole

(1801–1848), Albert Bierstadt (1830–1902), and especially George Inness (fig. 169), copied nature faithfully, and, again like the Germans, conveyed their faith in nature through honestly natural landscapes that glowed with a genuine human feeling. Though far removed from the wild energies of a Géricault or Delacroix, these landscapes are still romantic, possessing what Delacroix called the most essential quality of an art work, musicality.

REALISM AND IMPRESSIONISM

Although the terms realism and impressionism are here associated chiefly with French painting of the nineteenth century, they characterize movements that include literature and music—literature from Flaubert (1821–1880) to Zola (1840–1902), and music from Debussy (1862–1918) to Ravel (1875–1937). Realism and impressionism actually represent two phases of one comprehensive style.

There are very good reasons that France, of all the countries of Europe, should have been the birthplace of this new trend—although it should be added that the motivation, both spiritual and intellectual, was almost universal. Nineteenth-century Europe—in fact, the whole world—was altered by scientific developments and technical inventions, from the steamboat to the telegraph, and every level of society experienced profound political and economic dislocations as a result of the Industrial Revolution. However, it was only in France, just before the industrial era, that artists had created a body of work and a tradition that were entirely alien and almost in direct contradiction to the ideas and techniques that were to move the world after 1850.

This earlier French art, extending from the late eighteenth century through the greater part of the nineteenth, had produced the two schools of classicism and of romanticism. Yet, though classicism from David to Ingres, and romanticism from Géricault and Delacroix to later followers, were radically different in style, they had one vital tendency in common, namely the preference for what were considered important subjects and interesting stories or events. They shared a conviction that only certain elevated, exotic, or unusual subjects were fit themes for painting, and generally looked upon the world as divisible into the significant and the commonplace. Both schools considered everything ordinary or prosaic as unfit for artistic treatment. The classicist style was favored by French officialdom under the influence of the French Academy, while the rich bourgeoisie gave its enthusiastic support to romantic themes, especially those far removed from the routines of daily life.

With the realists Jean François Millet (1814–1875) and Gustave Courbet (1819–1877) new horizons were opened. Both of these painters turned sympathetic eyes on the underprivileged populace, and found aesthetic interest in

the average man going about his business in his ordinary environment. They discarded both the idealization of neoclassicism and the flamboyance of romanticism. Although Millet freed his subject matter from the idea of "importance," he nevertheless treated his peasants and laborers with a sentimentality not entirely honest, as if he felt the need to convince his patrons that a coarse peasant was really as beautiful a theme as a duchess. His methods remained more conventional than his subjects. Courbet's vision was more direct, and he introduced new means of painterly expression, dense color, dark shadows, heavy contrasts, a variety of expressive and sometimes even crude devices that helped realize his innovations in painterly approach as well as in subject matter. Courbet's method was only one attempt among many to solve the problems that had begun to rise from the changed sense of reality. Jean Baptiste Corot (figs. 176 and 177) diffused a wide range of contrasting tones over his subtle canvases. And even before Corot, the English painters Constable and Turner, realizing how light and air change our impressions of form and outline, had already tried to represent space and distance through nuances of color and tonal values as well as linear perspective. Without entirely sharing the aim of the impressionists, they anticipated some of the impressionist devices. Another element was added by the painters of the Barbizon School, a group of eight Frenchmen that included Theodore Rousseau (1812–1867) and Charles François Daubigny (1817–1878). Their contribution to the idea of *le paysage intime* was less an innovation in style than in theme. Turning to ordinary and typical landscape, the Barbizon School presented the countryside without sentimentality or artificial idealization.

So, inevitably, as the nineteenth century progressed, the "story" element, so prominent in historical and genre painting, lost its hold. Even the newly discovered realistic themes, the "social significance" of peasants and workers or of just plain people also receded after playing their part in freeing art from the conventions of classicism and romanticism. Artists became increasingly concerned with painterly values, and themes were chosen as occasions for the artist to record his instantaneous sensuous impressions. The growing delight in "pure" painting led to increasingly "aesthetic" representations of sight sensations and pigmental effects. Art moved toward the ideal of *"l'art pour l'art."*

The causes and sources of this movement, which increased the visual sensitivity while subduing the purely human overtones of painting, are too complex to be summed up in a formula. It is possible that the tremendous speed with which urban populations have increased in the framework of industrialism has brought about a general feeling of crushing anonymity; so many faces crowd the modern city that the result is a vast facelessness, a vanishing of the individual in the whole. Significantly, the novel as an independent and major form of expression was born of this metropolitanism. This seems to be especially true of

the long novel, whose loose organization and discursiveness is perfectly adapted to dealing with a great number of characters, each of which may be made to appear and disappear at will. In fact, such novels may be said to have taken over the discursive time element that had been an aspect of pictorial art in earlier ages, when sacred and mythological stories had been spread out along walls for people to "read." With the coming of impressionism, pictorial art became less an occasion for "reading" a painting than for experiencing an immediate and momentary effect through the eyes.

The decisive step in this direction was taken by Edouard Manet (1832–1883), probably the greatest painter of a century that abounded in great painters (figs. 19 and 77). It is futile to discuss whether or not Manet should be classed as an impressionist. His work, together with that of those who first actually called themselves impressionists—Monet, Renoir, and Pissarro—marked the turning point in nineteenth-century painting. Manet began his career in the realist manner, yet he worked consciously in the tradition of Velásquez, Frans Hals, and especially of Goya, whose *impasto* (thick laying on of paint), is sometimes also called impressionist. It was only at the end of the eighteen-sixties that Manet changed to the lighter tones and looser brush techniques of the impressionists.

Before summarizing the aims of the impressionists, we should recall that the term impressionism refers especially to painting, literature, and music, and can be used only with large reservations in referring to sculpture. There was realistic sculpture in the second part of the nineteenth century; but if we ascribe impressionism to the works of Rodin (1840–1917), Constantine Meunier (1831–1905), and Paolo Troubetzkoy (1866–1938), we think of the surface treatment of their figures, the skins of their sculptures, rather than of the sculptures themselves. The analogy with impressionist painting ends there, for sculpture in its very nature is structural, limited, tangible, concrete; by contrast, one of the chief characteristics of impressionism, whether pictorial, literary, or musical, is the essential repression of structural elements.

The impressionists made common cause with the realists against the artificialities of academic classicism and against all emotional and anecdotal romanticism. But behind this common front their artistic aims remained divergent. The world of impressionism consists of light and reflected or refracted colors. These colors are juxtaposed or contrasted directly, with none of the dark shadows used by the realists. Shadows are broken into spots and flecks of reflected color, which seem to spill over from the objects into every surrounding shade or neutral area, as if, for example, the colors of a bouquet of flowers had bled off into each area of the surrounding space. Such chromatic variations stimulated the impressionist painters so intensely that they never tired of painting the same subject under different light and atmospheric conditions. They pursued the prism of pure color as it springs from sunlight in the open air and strikes the surface of

vegetation or objects. The ideal thus set up was one of plein-airism (painting in open air), rather than the traditional concentration on the local, indwelling color of the objects themselves. Thus their subjective, sensuous vision contrasted sharply with the realism of earlier innovators, who still strove to reproduce the actual appearances of reality with all their definite shapes and self-contained color. The impressionists ignored the specific nature of an object, looking only at its surface appearance under constantly changing conditions of light. They felt no interest in building a three-dimensional structure, in space, volume, and mass. With their vibrant, instantaneous brushstrokes and the tension of contrasting color patches on a two-dimensional surface, they eliminated sharp outlines and dissipated clear forms. Every impressionist canvas strikes the eye as a fleeting experience, something keenly remembered but not to be found again in a street or a landscape if one were to return to it the next day or the next season.

THE TWENTIETH CENTURY

From 1400 to 1900 painters searched along many paths to find pictorial equivalents for the brief unstable sequences of light and broken form that appear daily before our eyes and then vanish never to return. Impressionism was the sum of their efforts. Here at last was truth, the eye's ultimate truth, immediate, unique, uncontaminated by story content, literary attitudes, or emotional associations. The impressionist fulfilled at last the deep human need just to look at something without being forced to ask, What does it mean? or, What are they doing? And having reached perfection, the movement began to reverse itself almost immediately, the pendulum to start on its return sweep.

The first artists to overcome impressionism had nothing in common but their struggle to advance somehow beyond the visual dead-end perfection of impressionism. Paul Cézanne (1839–1906), Paul Gauguin (1848–1903), Vincent Van Gogh (1853–1890), and Georges Pierre Seurat (1859–1891) struck out boldly from the impressionist conventions, and blazed the trail for twentieth-century art, though Gauguin cannot be compared with the other three in originality and influence.

Seurat's goal was a rationalized technique for recording what seemed permanent as against what seemed momentary, and he believed that he had found a scientific method for resolving the endless nuances and color shades into the basic colors of the spectrum. Using this method he assembled the mosaic of his colors into structurally clear planes (fig. 74). Seurat, Paul Signac (1863–1935), and other neoimpressionists, as they were called, described a world of regularly ordered surfaces in place of the "colored snowstorms" with which the impressionists had composed their visual world. Though their surfaces and planes were

articulated by a structural relationship, the neoimpressionists were, however, still painting mere surfaces or, at best, shallow "caves of space."

Cézanne, the greatest among these innovators, went much farther (figs. 73, 86, and 180). He was not satisfied by the impressionist rendering of visual reality as streams of reflected and refracted light particles rebounding haphazardly from random surfaces. Cézanne sought to make "something solid and enduring like the art of the museums," as he put it, though he was certainly not thinking of an easy academicism. He wished to convey the solidity of a tangible world along with the colors and translucencies of a seen world, like a child at a door who cannot enjoy what he is seeing until he has stepped out into the scene before him and penetrated it with his own body. So Cézanne brought back the element of physical extension to the world of impressionist texture. He set about building his pictures like an architect, and gave to nature's casual and often disorderly forms the relationships of "cones, spheres, cubes, and cylinders," to quote his own words again.

A very different aesthetic intention appears in the work of Van Gogh, especially during the last three years of his tragic life, when all his visual impressions were subjected to the stress of his emotional experiences (figs. 137, 179, and 224). Expressive emotional exaggeration became a language in itself, and, as will be seen, the beginning of a major twentieth-century trend. Van Gogh did not repudiate the special sensibility he had learned from the impressionism of his earlier years, but he did not hesitate to twist his purely visual impressions if emotional urgency required him to do so.

In their different ways, both Cézanne and Van Gogh strove to encompass far more than mere optical truths. It should be remembered that the generation of Cézanne, Gauguin, Van Gogh, Seurat, on whose work the various art movements of the twentieth century are based, still enjoyed a certain psychological privacy from society. The artists of that generation were still relatively free to deal with their purely artistic problems much as they were free to deal with mere questions of technique, in their own serene or tragic yet relatively secluded worlds. But the two generations that followed have been subjected to the crushing pressures of the twentieth century's social, economic, and political cataclysms, and have been forced into a closer and more conscious identification with the Zeitgeist. Whether they liked it or not, their works are more explicitly laced with contemporaneous problems than were those of their nineteenth-century predecessors. Today it is scarcely possible for any artist to clear a "historical space and silence" around his private labors, as most artists of the latter half of the nineteenth century were able to do.

To speak of modern art as a single or unified movement is an error, and a common one. Art movements in the twentieth century are at least as many and diverse as the concepts of Cézanne, Van Gogh, and Seurat. The first, which

appeared around 1905, was that of the *fauves* or "wild beasts," as they were called by their contemporaries. This group of French artists, including Henri Matisse (figs. 208, 226), Georges Rouault, André Derain, Raoul Dufy (fig. 227), and later Maurice Vlaminck, combined Gauguin's idea of the picture as a flat plane with Cézanne's architectural approach to organization—and then added some of Van Gogh's intense accents. Their works differ widely but have in common freedom of organization and lack of interest in copying reality literally. Patterns, violent color relations, brilliant accents, a relative independence of visual testimony—such are the typical *fauve* qualities. Henri Matisse is the outstanding exponent of this school, which later split into groups with widely divergent forms of artistic expression.

Cubism, which was created about 1908 by Pablo Picasso (figs. 29, 228) and Georges Braque (fig. 229), broke openly and defiantly with the tradition of illusionism by translating the visible world into an independent order of geometric, or to be more accurate, stereometric forms. While Cézanne had simplified forms into cones, cubes, and other stereometric shapes, he had not discarded the inherent substance of reality. Cubism went far beyond Cézanne. It evolved a new cosmos by taking objects apart and reassembling them according to its own autonomous principles. To the cubist recognizability meant less than the inner relationships of forms he perceived beneath the exteriors of objects and shapes. These structural potentials he extracted and revealed as full of lyric serenity or explosive tension, according to his imaginative will.

Another corollary was futurism, a short-lived Italian movement led by F. T. Marinetti (1876–1944) and Umberto Boccioni (1882–1916). Futurism attempted to visualize motion pictorially by projecting on canvas the successive stages of a movement. This technique really borrowed from the camera what the camera can do much more effectively, and it produced at best a few such clever canvases as the "Nude Descending a Staircase" by Marcel Duchamp (1887–), "Pan-Pan Dance" by Gino Severini (1883–), and "Dog on Leash" by Giacomo Balla (1871–1958).

A far more significant trend was expressionism, which was based essentially on Van Gogh's work. The expressionist frankly uses his visual experience to give release through form and color to his subjective tensions, and yet he does not wholly deny or ignore visible reality. Such an intrusion of private emotions or of responses to metaphysical forces would have been unthinkable to the impressionist, who saw with his eyes and not with his mind. The expressionist rather conceives and unfolds a whole cosmos of his own. He subjects his thematic material to his demonic or spiritual drive, freely distorting or crowding the picture elements, sometimes into form-shattering torrents, sometimes into cascades of color and light. Expressionism has yielded rich national variations. Compare the Germans, from Franz Marc (1880–1916) and Emil Nolde (fig. 58)

to Oskar Kokoschka (fig. 138) and Max Beckmann (fig. 231), with the earliest expressionist, the Norwegian Edvard Munch (1863–1944), or with the Frenchman Georges Rouault (1871–1958), the Russian-American Max Weber (1881–1961), and others of the same school. The national idioms vary significantly in the kind of temperament and the degree of subjectivity they reveal.

The final step away from nature was taken by the abstract or nonobjective school, which began to declare itself about 1910 in the works of Wassily Kandinsky (fig. 232), Jean Arp (1887–), and Piet Mondrian (fig. 233). These men rejected the visible, organic world so completely that they dropped even those traces of our common perceptual and emotional experience to which the most extreme cubists and expressionists still appealed. Nothing appears on the canvas but a "pure design," an arrangement of color and form sequences entirely unrelated to the perceivable world. Whatever the visual materials of his picture— color, depth, linear or three-dimensional patterns, or pure line alone—the nonobjective painter presents an aesthetic structure without illusionist, verbal, or cultural overtones. The beholder is asked to understand—much as a listener may "understand" music—a new kind of nonimitative beauty for which there is no precedent in nature, a higher algebra of color and forms. That a completely nonrepresentational, nonobjective structure of design can, by the mere composition of colors and shapes, convey unambiguously a definite mood or a distinct experience, as music does by a rhythmical succession of tones, seems no longer a matter of doubt. For in the last two generations we have learned to read nonobjective art in its own plastic, linear, and color sequences. The only question that remains is the one of limitation: when and where may the connection between a content imagined by an artist and its nonobjective representation on the canvas become too loose, too tenuous. Obviously, when this connection becomes too slight, the artist ceases to communicate, and may be the only one to feel any inevitable relationship between his original aesthetic idea and its final form. Abstractions sometimes become unintelligible essentially because they possess no basic pictorial grammar for conveying various sorts of emotions. The oft-cited parallel between music and abstract art should also serve to remind us that musicians have been developing the theory of tones for hundreds of years and can use their medium with considerable agreement on at least a few of its harmonic elements. Abstract artists have not yet organized the aesthetic elements of their form—signs, symbols and design—into anything like a generally understandable medium of communication. Whether they can, or will, is still an unanswered question.

Thereafter the pendulum began its return swing again. Abstract art had completely eliminated not only any concern for content but content itself. The reaction to it was a highly figurative style called surrealism, which started some years after the abstract movement, but has followed a parallel course since about

1930. Surrealism's return to content—a new content—was unequivocal, and had its intellectual forerunners in literature, from Charles Baudelaire (1821–1867) to Arthur Rimbaud (1854–1891) and Stéphane Mallarmé (1842–1898). The new content was meticulously realistic. But unlike previous types of realism, it described all objects as plunged into the "convincing unreality of dreams, reverie, and madness." The program was frankly one of "liberating the unconscious." The realism referred to the imagined condition of objects rather than to objects themselves—hence the name surrealism. From the pioneer Giorgio de Chirico (fig. 139) through Yves Tanguy (1900–1955) and Pavel Tchelitchew (1898–1957) to Salvador Dali (1904–), with his folding watches and combination woman-bureau-skeletons, the subconscious has dictated all sorts of surprising associations of real objects in unreal situations. Nightmare forms lurk in trivial articles—a solitary eye glances up from the bottom of a teacup, a blouse on a clothesline is a decapitated humorist—and the workaday world is filled with the paralyzing magic of the artist's subconscious associations. Unfortunately, a good deal of artificial literary stimulation has substituted for genuine subjective experience among many surrealist painters, much as literary romanticism contaminated the genuinely romantic movement in early nineteenth-century painting. It makes little difference whether a work of art relies on Walter Scott or Sigmund Freud for its nonvisual and ersatz inspiration, the resulting picture will be derivative and without conviction. Yet, despite surrealism's dwindling authenticity, this modern form of romanticism, with its masterly draftsmanship, must be given its due as a genuine expression of the twentieth-century mind.

The third decade of our century saw the climax of all of these developments. Today, when the larger public is just getting acquainted with trends that originated between 1907 and 1925, the artists themselves are beginning to reinstate nature. No painter working seriously today, however, can be untouched by the great visual revolutions of cubism, expressionism, and abstract art. The influence of these movements cannot be wiped out. They impart a firm structural pattern and a new set of tonal values to the work of those who are now attempting to reflect but not to "imitate" the world of reality. The belief in the possibility of objectively true reproduction in art has vanished. In art, as in everything that lives, the past never returns.

Index